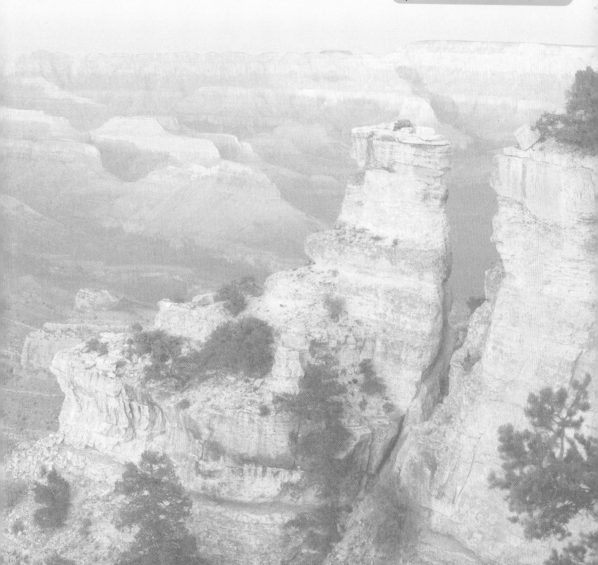

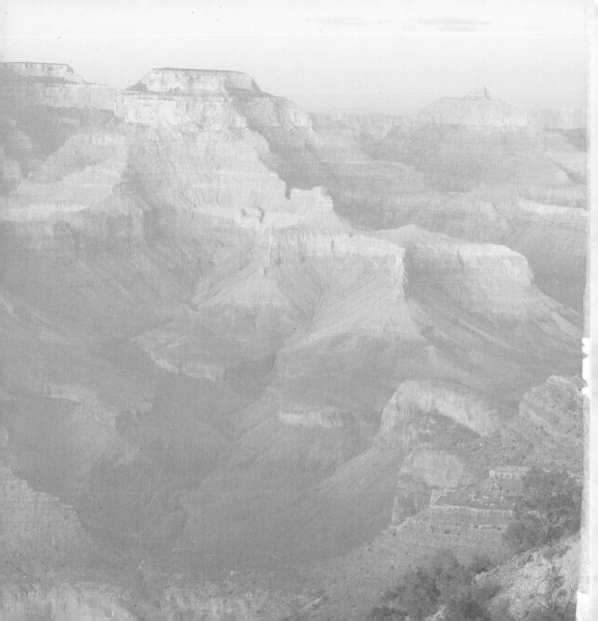

Amazing Places
to See in
North America

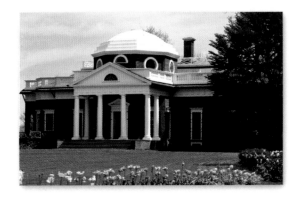

Eric Peterson

David Lewis

Laura Sutherland
with Family Travel Forum

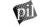

Publications International, Ltd.

Eric Peterson, a Denver-based freelance writer and Colorado native, has contributed to numerous guide-books about the western United States. His recent credits include *Frommer's Colorado, Frommer's Texas,* and *Frommer's Yellowstone & Grand Teton National Parks.* He is the author of the books *Ramble: A Field Guide to the U.S.A., Roadside Americana,* and *The Great American Road Trip.*

David Lewis is a Denver-based freelance writer and editor who served for a decade as a reporter and columnist for the *Rocky Mountain News.*

Laura Sutherland is a widely acknowledged authority on family travel and has published several books on the topic, including *Best Family Ski Vacations in North America* and *Tropical Family Vacations.* She also writes for a number of publications and Internet sites. Laura lives in Santa Cruz, California, with her husband and two children.

Family Travel Forum (www.familytravelforum.com) is a global community of families who share expert reviews, vacation tips, and travel tales through a network of websites.

Facts verified by **Marty Strasen** and **Barbara Cross.**

ISBN: 978-1-64030-489-5

Manufactured in China.

8 7 6 5 4 3 2 1

Contents

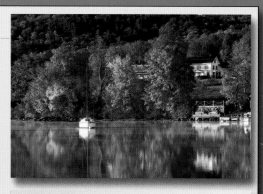

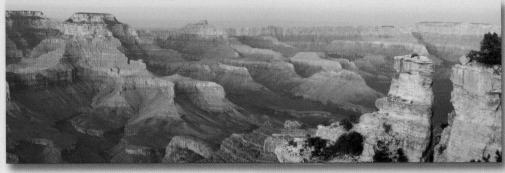

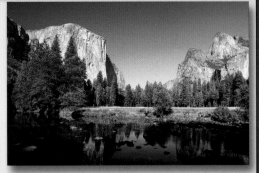

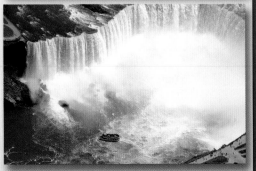

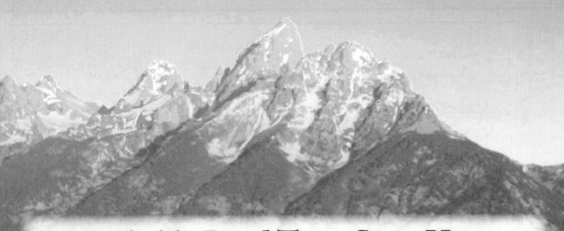

Remarkable Road Trips Start Here

No matter which direction you head from any point in North America, you're sure to end up somewhere spectacular. The continent is packed with extraordinary natural beauty; astonishing relics of history; and modern-day masterpieces of engineering, architecture, and art. Whether you want to stay close to home or venture thousands of miles away, astounding attractions await at every bend of the road.

And that's where *Amazing Places to See in North America* comes in. This book illustrates more than 250 of the most fascinating and awe-inspiring sights in the United States, Canada, and Mexico and groups them by geographic region. Many of the profiles are geared to children's interests. A camera icon at the top of the page indicates that attraction is perfect for making memories with the kids. With so many great travel ideas, the toughest decision might be which way to go first. Just be sure to check before visiting to confirm specifics.

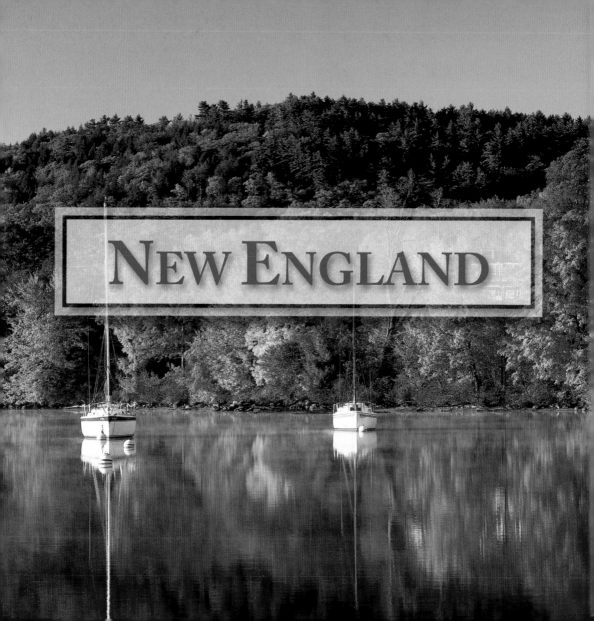

Boothbay Harbor

Boothbay Harbor, which lies along Maine's mid-coast, is a **GREAT PLACE FOR WATCHING WHALES AND PUFFINS,** canoeing, kayaking, hiking, biking, mackerel fishing, and camping. You can cruise to Monhegan Island or see sites such as the Maine State Aquarium; the Maine Maritime Museum; or Burnt Island Light, a lighthouse built in 1821.

This rugged area is **one of Maine's most beautiful destinations.** The picturesque harbor is exactly how many people envision the state: Fishers haul in lobster traps, and masts

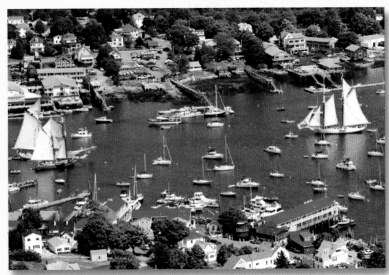

Boothbay Harbor celebrates sailing each June with Windjammer Days.

gently rock in the distance. You can rent cove-side cottages, dine in fine restaurants, and browse quaint waterfront shops.

Acadia National Park

Situated off the coast of Maine, Acadia National Park **covers nearly half of Mount Desert Island.** Originally named Isles des Monts Deserts by explorer Samuel de Champlain in 1604, the island also boasts the towns of Bar Harbor,

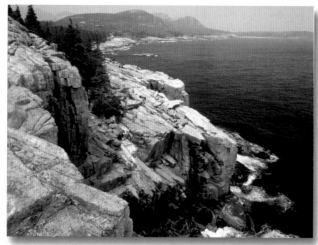

Southwest Harbor, Mount Desert, and Tremont.

From the coastline, you can see the island's barren mountaintops, sheared off by ancient glaciers. **CADILLAC MOUNTAIN, A GRANITE-TOPPED PEAK RISING 1,532 FEET, IS THE HIGHEST MOUNTAIN ALONG THE NORTH ATLANTIC SEABOARD.** Glaciers created other unique features of Acadia. Look at a topographic map of Mount Desert Island, and you will see that it looks as if it had

The spectacular scenery that is Acadia National Park includes 26 mountains. Its rugged terrain and dramatic coastline make for some memorable sights.

been gouged by giant bear claws—deep ravines, Long Pond, Echo Lake, Jordan Pond, Eagle Lake, and the seven-mile-long Somes Sound (said to be the only true fjord on the East Coast) all run in parallel lines north to south.

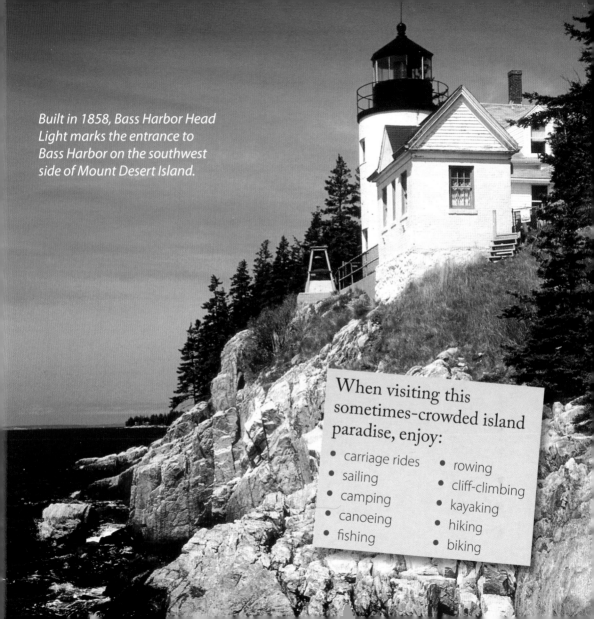

Built in 1858, Bass Harbor Head Light marks the entrance to Bass Harbor on the southwest side of Mount Desert Island.

When visiting this sometimes-crowded island paradise, enjoy:

- carriage rides
- sailing
- camping
- canoeing
- fishing
- rowing
- cliff-climbing
- kayaking
- hiking
- biking

Penobscot Bay

Penobscot Bay lies just southwest of Maine's Acadia National Park and is **perfect for those who want to explore the real outdoors.** Choose among recreational sports such as sailing a three-masted schooner; fishing for trout, smallmouth bass, or landlocked salmon; or hunting bear, moose, deer, grouse, or snowshoe hare.

The nearby towns of Camden, Bar Harbor, and Castine provide for more relaxing pursuits of fine dining, charming shopping, and admiring local art. Penobscot Bay will also **SATISFY YOUR TASTE FOR AUTHENTIC REGIONAL CUISINE.** Make room for dinners of lobster and lobster cakes, steamed mussels, corn on the cob, and New England clam chowder, and breakfasts of pancakes and waffles covered with regional maple syrup and blueberry jam.

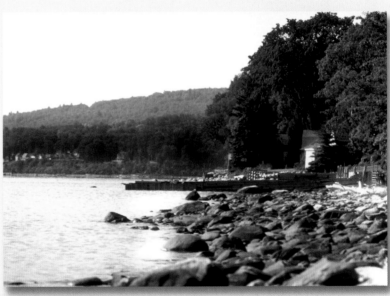

The rocky shoreline of Penobscot Bay harbors quaint Maine towns with an authentic Down East feel.

White Mountain National Forest

New Hampshire's White Mountain National Forest is the heart of the White Mountains. **Mount Washington rises fiercely above the dense woodlands to 6,288 feet,** which makes it the **HIGHEST MOUNTAIN IN THE NORTHEASTERN UNITED STATES.** On a clear day, you can see into New Hampshire, Maine, Vermont, Massachusetts, and Canada from its peak.

The vast majority of White Mountain National Forest's **800,000 acres** are in New Hampshire, with the eastern edge creeping into Maine. Hiking trails, including the Appalachian Trail, which stretches from Maine to Georgia, crisscross fir, pine, beech, birch, and maple forests. But make no mistake—this is nature's domain. It may be an easy drive from urban America, but it seems a million miles away.

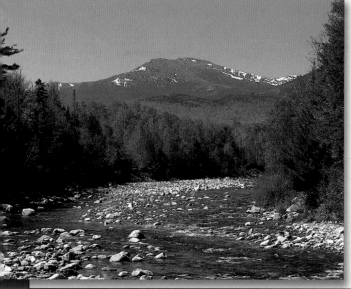

The majestic splendor of Mount Washington overlooks the White Mountain National Forest in New Hampshire.

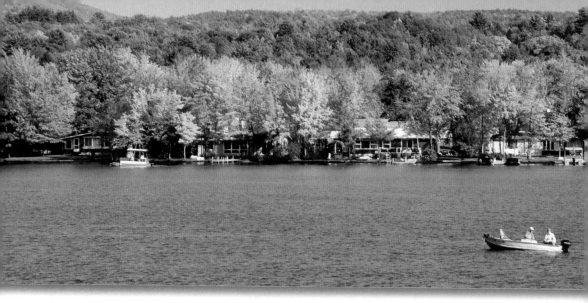

Lake Winnipesaukee

At 26 miles long and 15 miles across at its widest point, Lake Winnipesaukee is **New Hampshire's largest lake.** This glacial phenomenon has been a summer vacation hot spot for more than a century, attracting visitors from all over New England, including Boston, which is just a two-hour drive away.

Dozens of islands add to the lake's scenic splendor, as do the surrounding Ossipee and Sandwich mountain ranges. At Lake Winnipesaukee, **you can hike, snowshoe, fish, and scuba dive.** Also popular is the **CANTERBURY SHAKER VILLAGE,** which hosts a museum preserving the history of the local Shaker community. The site was declared a National Historic Landmark in 1993.

Odiorne Point State Park

This state park includes Odiorne Point, the largest undeveloped stretch of shore on New Hampshire's 18-mile coast. Its **SPECTACULAR OCEANFRONT IS BACKED BY MARSHES, SAND DUNES, AND DENSE VEGETATION.** An extensive network of trails, including a paved bike path, winds through the park. There are also picnic areas, a boat launch, and a playground.

Kids will love visiting Odiorne's Seacoast Science Center to learn about the many creatures they're likely to spot in the tide pools. All kinds of **sea urchins, starfish, mollusks, and crabs inhabit the shoreline's intertidal zone,** and when the tide is low, there are many opportunities to see them.

Kids can get up close and personal with the mysteries of the ocean at the Seacoast Science Center, located within Odiorne Point State Park. The center's touch tank invites visitors to do some hands-on exploring.

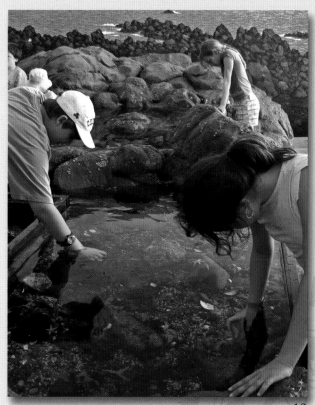

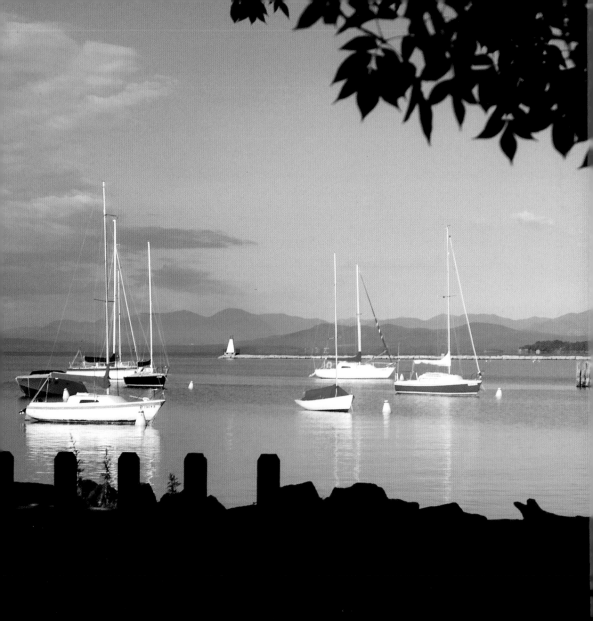

Lake Champlain

Samuel de Champlain explored so much of New England that it was only fair to name the spectacular Lake Champlain after him. He discovered the lake in 1609 while in the Champlain Valley, which lies between Vermont's Green Mountains and the Adirondack Mountains of New York. Lake Champlain has since **served the needs of merchants and mariners, scalawags and soldiers, smugglers and spies, and patriots and traitors.** The lake has seen its share of naval conflict, too: **WARFARE ON ITS WATERS CLIMAXED IN 1814,** when troops led by U.S. Commodore Thomas McDonough defeated the British Navy in a fierce fight. During the 19th century, canal boats and steamboats carried coal, timber, iron ore, and grain across the lake. Today, industry has given way to recreation.

Lake Champlain has become **a year-round playground featuring boating, hiking, skiing, snowshoeing, snowmobiling, ice climbing, and rock climbing.** Bicyclists take advantage of the Lake Champlain Bikeways' 35 loops and 10- to 60-mile tours.

Bounded by Vermont, New York, and Quebec, the lake's **Alburg Peninsula** juts southward from Quebec, making it **ONE OF THE FEW PLACES IN THE UNITED STATES THAT CAN ONLY BE REACHED THROUGH CANADA.** A more familiar north crossing extends through Ticonderoga, New York. Just east of the town is Fort Ticonderoga, a sterling 18th-century fort with a museum and guided tours.

Ben & Jerry's Factory

Vermont's top tourist attraction is Ben & Jerry's ice cream factory in Waterbury—the heart of the Green Mountains. Ben Cohen and Jerry Greenfield began making their ice cream in the neighborhood in 1978; today, they sell their products all over the world.

Children won't get bored, because there are fun activities to occupy them. **ALL AROUND THE BRIGHTLY PAINTED FACTORY GROUNDS ARE UNUSUAL ITEMS FOR KIDS TO CLIMB ON,** as well as a small playground and picnic tables.

The tour offers a glimpse of the ice cream-making process, but everyone's favorite part comes at the

Gone, but not forgotten. The many ice cream flavors retired by Ben & Jerry's have been given a final resting place.

end, when **a sample of the flavor of the day is offered.** Be sure to visit the Flavor Graveyard, where colorful tombstones honor dearly departed flavors such as "Fred and Ginger" and "Holy Cannoli."

Green Mountains

The Green Mountains of Vermont are full of surprises. The historic range is **a great place for caving, hiking, skiing, and gawking at the splendid natural beauty.** The 250-mile-long Green Mountains become the Berkshires to the south, in Massachusetts; to the west is Lake Champlain; and to the east are the White Mountains of New Hampshire. The 400,000-acre Green Mountain National Forest is the public's entry to the mountains. The national forest was formed in 1932 after floods and fires exacerbated by excessive logging threatened the region.

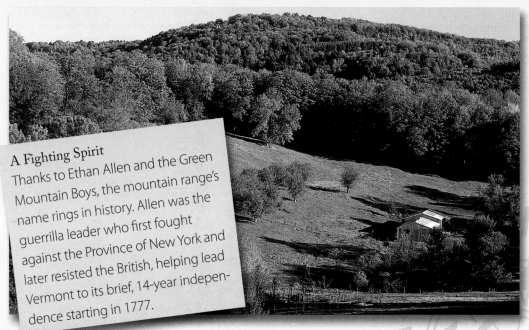

A Fighting Spirit
Thanks to Ethan Allen and the Green Mountain Boys, the mountain range's name rings in history. Allen was the guerrilla leader who first fought against the Province of New York and later resisted the British, helping lead Vermont to its brief, 14-year independence starting in 1777.

Vermont Institute of Natural Science

The Vermont Institute of Natural Science Nature Center, just outside of tiny Woodstock, is **THE LEADING NEW ENGLAND CARE CENTER FOR INJURED RAPTORS**—owls, falcons, hawks, eagles, and vultures, about 25 species in all—that can no longer survive in the wild. The center receives birds from all over the United States and houses them in specially adapted high-ceilinged cages. Guests can **enjoy bird-watching along the center's picturesque nature trails.**

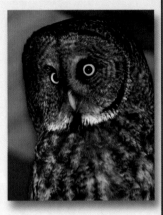

While in Woodstock, don't overlook the Billings Farm & Museum, a working dairy farm since the 1870s. Next door is the Marsh-Billings-Rockefeller National Historical Park. Vermont's first national park offers guided tours of the Marsh-Billings-Rockefeller Mansion and its grounds and gardens.

Left: *Bald eagles are among the birds of prey cared for at the VINS Nature Center.* Above: *Visitors to the center can see raptors, such as this great gray owl.*

Harvard Square

Harvard Square in Cambridge, Massachusetts, is a great place to go if you want to **feel young, hip, and smart.** Teeming with Harvard professors, students, and wannabes, "the Square" can give visitors the sense that they are attending Harvard without the inconvenience of having to take exams.

The center of Harvard Square is a former subway kiosk converted into a Harvard-worthy newsstand. The kiosk is surrounded by steps leading down to what is called **"the Pit," a pocket-size park.** Restaurants, shops, and what may be the highest density of bookstores in the United States fill the remainder of the square.

The Square wasn't always just a hangout. In 1630, it was the village of Newtowne, the first planned settlement in Anglo North America. Newtowne's street plan remains in use today, as do buildings that date from the early 1700s.

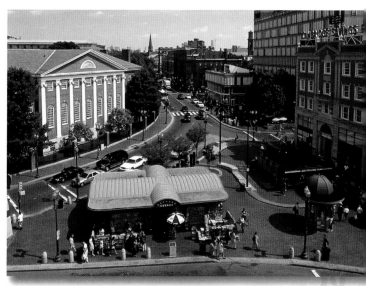

An old subway kiosk, now converted to a noteworthy newsstand, stands at the center of Harvard Square.

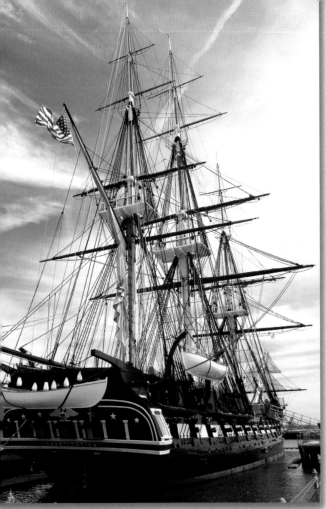

The Freedom Trail ends at the USS Constitution, which became known as "Old Ironsides" during the War of 1812.

Freedom Trail

Follow the red brick line along the 2.5-mile Freedom Trail in Boston and you'll be able to **TAKE IN 300 YEARS OF AMERICAN HISTORY.** The 16 sites along the trail describe the city's early patriots, their notion of liberty, and the journey to independence.

The idea for the Freedom Trail came in 1958 from William Schofield, who was an editorial writer for the *Boston Herald-Traveler*. He hatched the idea of creating a marked line that would transform Boston's mazelike streets into something that tourists could follow. His campaign succeeded and inspired other "trails," including the Constitutional Walking Tour of Philadelphia and Boston's Black Heritage Trail.

The Freedom Trail begins at the Boston Common, near the Boston Public Garden. **Boston Common** is one of the nation's oldest public parks, and it has a long-standing tradition as **a place where demonstrators can exercise their right to freedom of speech without needing a per-**

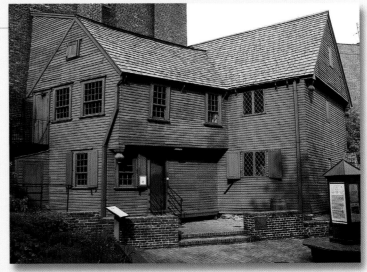

Paul Revere's house is the oldest building in downtown Boston. It opened in 1908 to the general public and is one of the first museums in the United States to be situated in a historic home.

mit. The 50-acre park was a British troop encampment during the American Revolution and hosted hangings until 1817. Today's Bostonians prefer to think of the park as the centerpiece of the city's Emerald Necklace chain of parks. From there, the trail moves to the Massachusetts State House; Park Street Church; and the Granary Burying Ground, where John Hancock, Samuel Adams, and Paul Revere are buried. It continues on to sites including the Paul Revere House; the Old South Meeting House, where Sam Adams signaled the start of the Boston Tea Party; and Bunker Hill Monument, where the ragged colonials held off the British Army.

Fenway Park

Fenway Park reigns as a temple of baseball, despite the decades of misfortune for its principal occupant, the Boston Red Sox. Built in 1912, Fenway is **not only Major League Baseball's oldest park but also its most eccentric.** The stadium's capacity is just 36,108 people, a few of whom can now sit on top of the landmark Green Monster, the 37-foot wall in left field. The right-field foul pole is known in Boston as "Pesky's Pole" because in the 1940s weak-hitting shortstop Johnny Pesky hit one of his few home runs just beyond it. Between 1918 and 2003, Fenway didn't see a title, but Boston fans were finally rewarded (and the ghosts were exorcised) in 2004 when the Red Sox won the World Series.

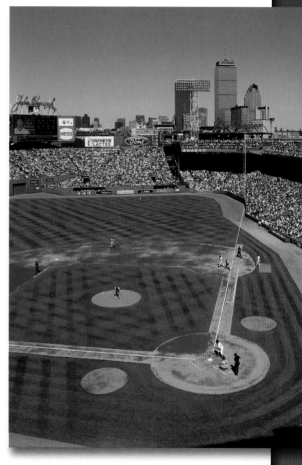

Boston Children's Museum

A 40-foot-high red-and-white wooden milk bottle marks the entrance to the Boston Children's Museum, **WHERE HANDS-ON DISCOVERY AND UNINHIBITED EXPERIMENTATION ARE FOUND ON FOUR FLOORS OF FUN.** The museum's centerpiece is the New Balance Climb, an elaborate three-story sculptural maze of brightly painted towers, colorful tubes, and wobbly walkways. Other educational and fun attractions include:

- **The Science Playground,** where children learn about physics by pushing golf balls down an intricate set of wooden tracks, make gigantic soap bubbles, and climb underneath oversize aquariums to observe turtles from a fresh perspective.

- **Kid Power,** where children learn about leading healthy, active lives. Kids can climb the walls and literally light up a dance floor.

- **PlaySpace,** an area for preschoolers and toddlers that has a tree house with hidden pathways and a "messy" area with a see-through painting wall.

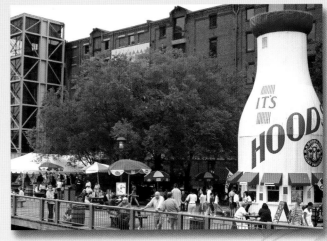

The famous 40-foot-high Hood milk bottle greets visitors at the entrance of the Boston Children's Museum. The bottle actually houses a snack stand.

Plymouth Rock

People flock to Plymouth, Massachusetts, to watch whales, relax on the beach, kayak, and see **THE FAMOUS TEN-TON GRANITE BOULDER**, Plymouth Rock.

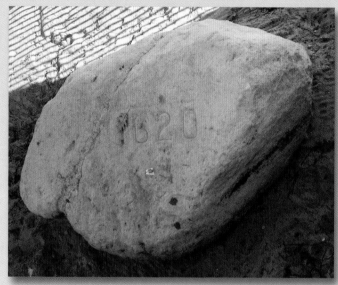

Plymouth Rock is hallowed in American history as **the place where the Pilgrims first set foot in America.** They went on to form the first permanent European settlement in New England. While traveling across the Atlantic, the Pilgrims wrote the Mayflower Compact, the New World's first governing agreement, and signed it in Provincetown Harbor.

Plymouth Rock marks the site where the Pilgrims are thought to have landed in 1620.

However, the legend that the Pilgrims landed at Plymouth Rock may be just that, because the first mention of the site came nearly a century after the *Mayflower* landed. No matter—this is the accepted spot where leaders John Carver, William Bradford, and some 100 other Pilgrims landed and started Plymouth Colony.

Walden Pond

Henry David Thoreau moved to Walden Pond in Concord, Massachusetts, to get a little peace and quiet and to write. He wrote an account of his time in the cabin he built by the pond and called it *Walden; or, Life in the Woods.* His little book, often credited with creating the conservation movement, changed the world.

In Thoreau's day, the land around the pond was one of the few woods left in the area, which was surrounded by farmland. Today, Walden Pond is part of Massachusetts's Walden Pond State Reservation, which includes the 61-acre pond plus another 2,680 acres known as "Walden Woods." The park preserves Thoreau's temporary homesite; the original chimney was discovered in 1945, and a replica of the house was built there.

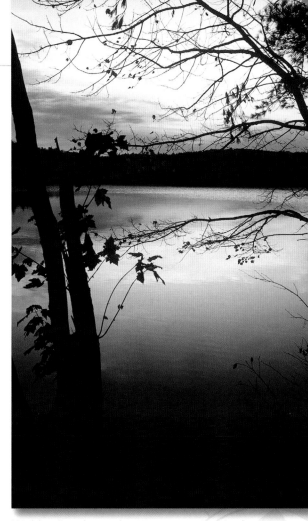

Walden Pond, seen here at sunset, inspired author Henry David Thoreau's most famous work, Walden.

Martha's Vineyard

Martha's Vineyard provides an old-fashioned beach vacation with **miles of pristine beaches,** clean salty air, lavish beachfront homes, and rolling farmlands. A favorite summer resort for more than a century, its picturesque towns are filled with ice-cream shops, sea captains' stately houses, art galleries, and winding lanes edged with plum trees and blackberry bushes.

Passengers can take in the view of the many Cape Cod-style houses that dot the scenic shores as they take the ferry to Martha's Vineyard.

Martha's Vineyard, which is right off the coast of Massachusetts, is **New England's largest island**. Lazy days can be had at State Beach, known for its gentle surf and wide expanse of sand. Those seeking more active water play should head to Katama Beach on the island's south shore, where surfboards, kayaks, sailboards, and sailboats can be rented for fun in the sun.

Old Sturbridge Village

Families who want to experience life in times past will be enthralled by Old Sturbridge Village, just an hour's drive west of Boston. The largest outdoor living-history museum in the northeast, Old Sturbridge Village **brings to life an 1830s New England rural community,** down to the smallest details.

Its 200 acres contain 40 exhibits, including a working farm; a district school; authentically restored homes, gardens, and meetinghouses; and blacksmith,

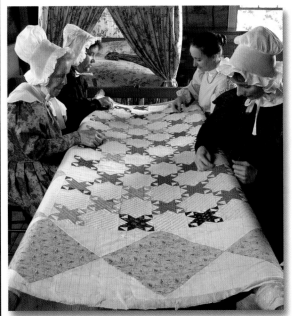

pottery, and tin shops. Costumed artisans go about their work as they would have in 1830: Shoemakers stitch shoes, tinsmiths decorate lanterns, and blacksmiths forge farm equipment. **CHILDREN CAN PLAY HISTORIC GAMES, SUCH AS HOOPS AND GRACES OR CUP AND BALL,** on the common.

Costumed artisans hand-stitch a quilt at Old Sturbridge Village, where visitors can step into the past and visit the early 1800s.

Salem

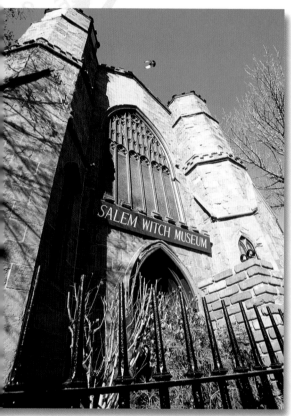

Salem, Massachusetts, calls itself **"Witch City"** and is so named for that harrowing seven-month period in 1692 when the townspeople put 19 innocent people to death. Today, Salem offers numerous places devoted to witches and their kind—witch museums, palm readers, cemetery tours, ghost tours, and more.

The Salem Witch Museum, housed in a 19th-century Romanesque-style stone building, has the look of a haunted castle. It **BRINGS VISITORS BACK TO EARLY SALEM** through a dramatic presentation that uses stage sets with life-size figures, lighting, and narration. It also gives visitors **an excellent overview of the Salem Witch Trials.** Other witchy attractions include the Salem Wax Museum with characters from the witch trials, the Witch Dungeon Museum, and the New England Pirate Museum.

Witches are now welcome in Salem, where each October the Salem Witch Museum is visited by an assortment of scary folk during the town's Haunted Happenings festival.

Stonington Borough Lighthouse

The town of Stonington is the oldest borough in Connecticut (Stonington Borough), settled in 1753 and chartered in 1801. Both the lighthouse and the town represent the history and architecture of an archetypal Connecticut town.

The Old Lighthouse Museum is in the **restored 30-foot granite tower.** The beacon was first built on Stonington Point in 1823, and although the original lighthouse eroded and was dismantled, materials from it were saved and used to build the current lighthouse, which was completed in 1840. The museum is **A GATEWAY**

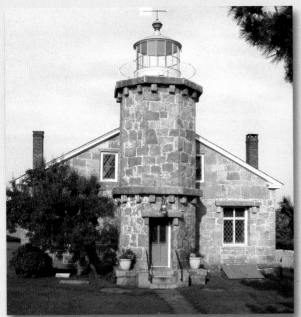

TO CONNECTICUT'S PAST. Six rooms of exhibits illustrate the history of this coastal region, which is notable for its beautiful Stonington stoneware. The museum also features furniture and portraits that give visitors a peek at the lives of the early blacksmiths, potters, farmers, fishers, merchants, and shipbuilders of the area.

In 1927, the Stonington Borough Lighthouse was converted to a museum honoring the maritime history of this quaint coastal village.

Mystic Seaport

Mystic Seaport is in Mystic, Connecticut, a three-hour drive from New York City and two hours from Boston. The seaport is **one of a string of Connecticut sea-related enterprises,** including the Naval Submarine Base New London and the Mystic Aquarium & Institute for Exploration.

Mystic became a shipbuilding center in the 17th century. Historians say shipbuilders along the Mystic River constructed more than 600 sailing vessels between the late 1700s and the end of World War I. But by then the great wooden sailing ships had been outstripped by steam-powered vessels. Mystic's maritime enterprises, like those in most of New England, began to vanish.

Then three visionary Mystic citizens—a doctor, a lawyer, and an industrialist—devised a plan to turn Mystic Seaport into **A LIVING EDUCATIONAL INSTITUTION DESIGNED TO PRESERVE SEAGOING CULTURE.** Following this model, Mystic Seaport expanded in the 1940s. Historic buildings—including the Buckingham-Hall House, a coastal farmhouse; the Nautical Instruments Shop; the Mystic Press Printing Office; and the Boardman School one-room schoolhouse—were moved from their original locations in New England and put together to form Mystic Seaport, a model New England seagoing village. Mystic Seaport became one of the first living museums.

The project's leaders swiftly assembled **one of the largest collections of maritime history:** There are more than two million maritime artifacts, an impressive

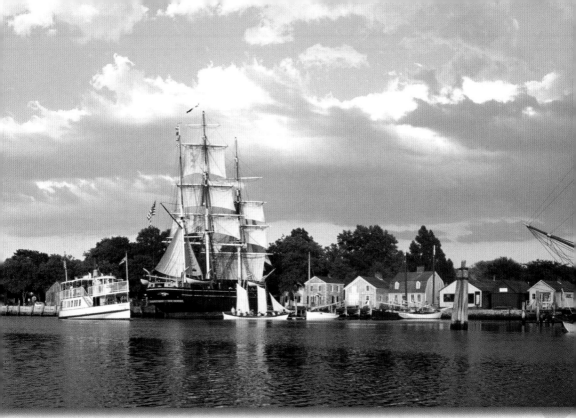

The Charles W. Morgan *is a whaling ship built in 1841 and used until 1921. Mystic Seaport acquired the ship in 1941.*

selection of maritime photography with more than one million images and 1.5 million feet of film, and an unparalleled collection of almost 500 wooden sailboats. These collections are on display at Mystic Seaport's Collections Research Center storage and preservation facility.

Newport Mansions

Newport is a small city on Aquidneck Island, Rhode Island, in Narragansett Bay. Each year, 3.5 million visitors come to the city of 30,000. Why? Many of the tourists who cross Newport Bridge are drawn by **THE WORLD'S MOST SPECTACULAR COLLECTION OF MANSIONS,** most from the 19th-century Gilded Age of the Astors, Belmonts, and Vanderbilts. Be sure to see:

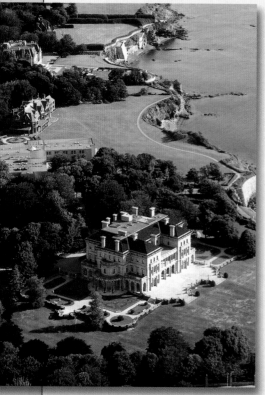

- **Beechwood, the home of Caroline Schermerhorn Astor.** Astor renovated the home in 1881 for $2 million, an inconceivable amount at the time.

- **The Breakers, Cornelius Vanderbilt II's summer home.** Built in 1893, the Breakers has 70 rooms finished in alabaster and rare marble. It is also open for tours.

Overlooking the Atlantic Ocean, The Breakers is among the most elaborate of Newport's exquisite mansions. It was named for the waves that crash into the rocks below the estate.

Benefit Street

If you're touring Providence, Rhode Island, and its antique treasures, the best place to start is Benefit Street, also **known as the "Mile of History."** Benefit Street was established in 1756 and became home to Providence's well-to-do merchants. Today, almost all the buildings along the "Mile of History" have been restored, giving the street the architectural flavor of colonial times.

While many of the building interiors are off-limits to the public, **VISITORS CAN TAKE IN THE HISTORICAL AMBIENCE OF THIS COLLECTION OF HOMES AND BUSINESSES.** One exception is the John Brown House Museum, just around the corner from Benefit Street, which is open for tours. Providence's John Brown was a politician who completed the mansion in 1788. John Quincy Adams proclaimed the house "the most magnificent and elegant private mansion that I have ever seen on this continent."

Block Island

Block Island is a tear-shape isle only three miles wide and seven miles long with about 7,000 acres of Victorian homes, rolling hills, sandy cliffs, verdant valleys, timeless beaches, and 365 small ponds. The island lies 12 miles off the coast of Rhode Island and about 18 miles northeast of Long Island, New York. But Block Island feels farther away because **THIS RETREAT OFFERS A KIND OF TIME TRAVEL, WHERE YOU CAN RELAX AND THINK BACK TO WHEN YOU HAD TIME TO SKIP ROCKS INTO THE OCEAN AND DIG YOUR TOES INTO THE SAND.**

If you need to explore, visit the Block Island North Light, built in 1867 on Sandy Point, and Block Island Southeast Light, built in 1873 (Southeast Light is the tallest lighthouse in New England). Both have museums.

The Mid-Atlantic

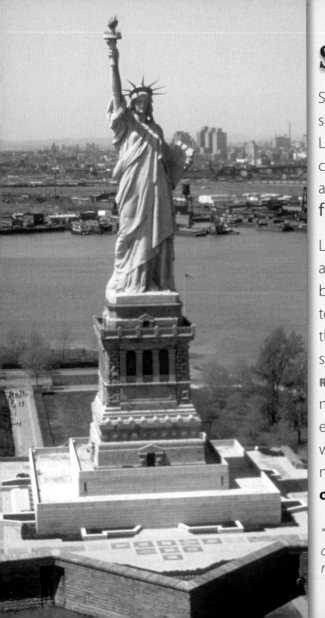

Statue of Liberty

Standing high over New York Harbor since 1886, the majestic Statue of Liberty has been the focal point of countless photographs—and probably as many tears. **She stands for freedom, hope, and possibility.**

Lady Liberty weighs about 225 tons and stands more than 151 feet high but reaches greater heights thanks to the 65-foot-high foundation and the 89-foot-high granite pedestal. The statue is **CLASSIFIED AS A "NEOCLASSICAL REALISTIC SCULPTURE,"** but artistry may not be what comes to mind when you examine her 42-foot arm, her 35-foot waist, and her size 879 sandals. She is not only a work of art—**she is a feat of engineering.**

"Liberty Enlightening the World" is a tourist attraction, a symbol, an icon, and a monument to Franco-American relations.

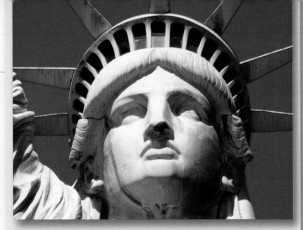

The statue is a massive iron pylon with a skeletal structure (engineered by Gustav Eiffel of Eiffel Tower fame) clad with copper skin sculpted by Frederic Auguste Bartholdi. **Liberty was first erected in France, then dismantled and shipped to Bedloe's Island in New York Harbor.** The transfer required 214 crates, and it took American workers four months to reassemble her.

The multilevel pedestal holds exhibits, memorabilia, tributes to the artisans and engineers who created her, pictures, original pieces replaced in a renovation (including the original flame), murals, and much more.

LADY LIBERTY: THE TALE OF THE TAPE

Height from base to torch	151 feet, 1 inch
Ground to tip of torch	305 feet, 1 inch
Heel to top of head	111 feet, 1 inch
Length of hand	16 feet, 5 inches
Index finger	8 feet
Head from chin to cranium	17 feet, 3 inches
Head thickness from ear to ear	10 feet
Length of nose	4 feet, 6 inches
Length of right arm	42 feet
Thickness of right arm	12 feet
Thickness of waist	35 feet
Width of mouth	3 feet
Length of tablet	23 feet, 7 inches
Width of tablet	13 feet, 7 inches
Thickness of tablet	2 feet

Central Park

Central Park is the jogging, picnicking, bicycling, and recreational center of life in Manhattan. Landscape architect Frederick Law Olmsted and his partner Calvert Vaux designed the park in 1857 to be **an island of tranquility in the middle of the roiling city.**

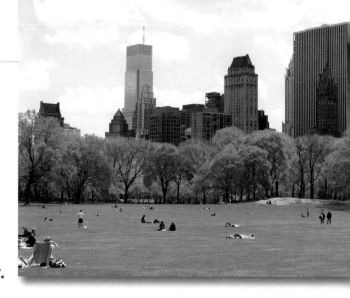

Today, Central Park hosts activities from alfresco dining while listening to the Metropolitan Opera to strolling through formal gardens or exploring the zoo. There are also spots to fish, play tennis, ice-skate, swim, and roller-skate. The park offers horseback riding and famous horse-drawn carriages. In the summer, the Public Theater presents a Shakespeare in the Park series, rock bands play concerts, and children can ride the carousel. All this activity can make you hungry, but there are many superb restaurants nearby.

On the park's east side, you'll find the Obelisk (formerly called Cleopatra's Needle) and the Metropolitan Museum of Art; on the west side are the American Museum of Natural History and Strawberry Fields, the section of the park named after the song "Strawberry Fields Forever" in memory of John Lennon. The west entrance

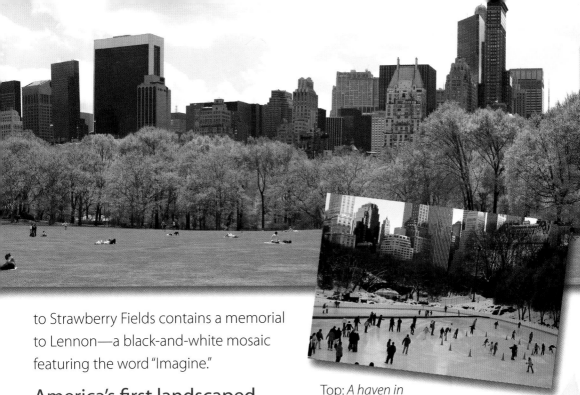

to Strawberry Fields contains a memorial to Lennon—a black-and-white mosaic featuring the word "Imagine."

America's first landscaped public park
is big enough for all this and much more; it covers 843 acres and is 2.5 miles long and half a mile wide. Central Park has a 6.1-mile loop for cars that has parallel paths for horses, joggers, and cyclists during the week, but the park is closed to motorists on weekends.

Top: *A haven in the midst of the concrete and crowds of metropolitan New York City, Central Park is visited by 25 million people annually. It contains 21 playgrounds, 125 drinking fountains, and more than 9,000 benches.* Inset: *Skaters at the Wollman Rink in Central Park can enjoy a superb view of the city's skyline. At 33,000 square feet, the ice-skating rink can accommodate more than 2,000 skaters at one time!*

Times Square

New York City's Times Square is a **BLARING, ELECTRIFYING, EXHILARATING, INTOXICATING, SPOTLIT "CROSSROADS OF THE WORLD."** And it's quite popular—Times Square welcomes 35 million visitors annually to its stores, hotels, restaurants, theaters, and attractions.

Times Square's first electric billboard went up in 1917, and the square has been synonymous with glitz ever since. Today there are more high-technology signs, but the famous electronic newswire still lights up the base of One Times Square, and the ball still drops at the top of the building each New Year's Eve, a tradition since 1907. **Times Square remains the heart of midtown Manhattan,** in part because the area is a gateway to the city's main theater district, known as Broadway. The area is crowded and crazy, but it's also tourist- and family-friendly.

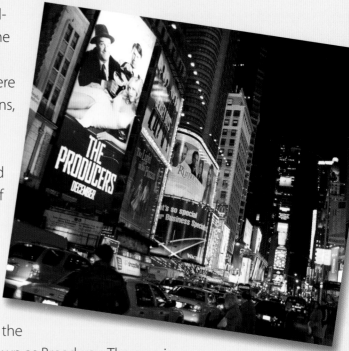

National September 11 Memorial & Museum

The deadly terrorist attacks on September 11, 2001, killed thousands, shocked the nation, and left the city of New York altered forever. Where the Twin Towers of the World Trade Center once stood, there are now two massive reflecting pools, part of the National September 11 Memorial & Museum. Great waterfalls pour into the pools, with the victims' names inscribed around them. Public discussion about a memorial began soon after the attacks, with construction following in 2006. The Memorial Plaza opened in September 2011, exactly ten years after the attacks. The museum, which opened a few years later in 2014, includes physical artifacts from the tragedy, audio and video recordings, and photographs of the victims.

CO ELIGIO BOURDIER SEBASTIAN GORKI DEBORAH A. KOBUS NOBUHIRO HATTORI

ros ALEJANDRO CASTAÑO JONI CESTA KATSUV

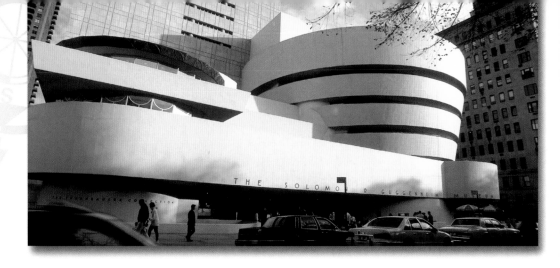

The Solomon R. Guggenheim Museum

"I need a fighter, a lover of space, an agitator, a tester, and a wise man … I want a temple of spirit, a monument!" said Hilla Rebay to Frank Lloyd Wright. Rebay was the art adviser to Solomon R. Guggenheim, and the collaboration of these three led to the creation of the fabulous Guggenheim Museum in New York City, now **known for both its collections and its adventurous architecture.**

The Guggenheim Museum remains an iconoclast. Viewed from Fifth Avenue, its exterior is an inverted cone with wide bands rising upward like a child's giant top. Inside, the museum contains an atrium and a spiral ramp where visitors view artwork from a perspective that can be dizzying. Despite its impressive permanent collection of works by Kandinsky, Klee, Calder, Picasso, Rousseau, and many more, visitors sometimes find it a relief to return to the atrium.

The Metropolitan Museum of Art

Any list of the world's most important art museums includes New York City's Metropolitan Museum of Art, better known as "the Met." The museum **BOASTS ONE OF THE WORLD'S GREATEST COLLECTIONS OF—JUST ABOUT EVERYTHING.**

The museum's two-million-square-foot building is **a treasure of painting, sculpture, and decorative art collections,** including exhibits of American art divided into 24 breathtaking period rooms. The Met also features unsurpassed collections of Dutch Masters, Impressionists, and Post-Impressionists from Monet to Mirot, Modigliani, and Matisse. Its massive antiquities collections include ancient Near Eastern art; Greek and Roman art; Asian art; and the art of Africa, Oceania, and the Americas. These and other permanent collections, plus the special temporary exhibits, pull in more than five million people each year.

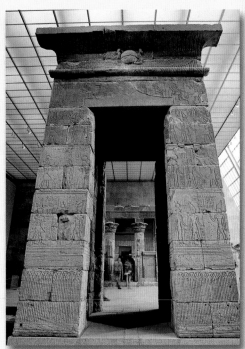

The Temple of Dendur was relocated from the Middle East, where it was threatened by the construction of the Aswan High Dam, and rebuilt stone-by-stone at the Met.

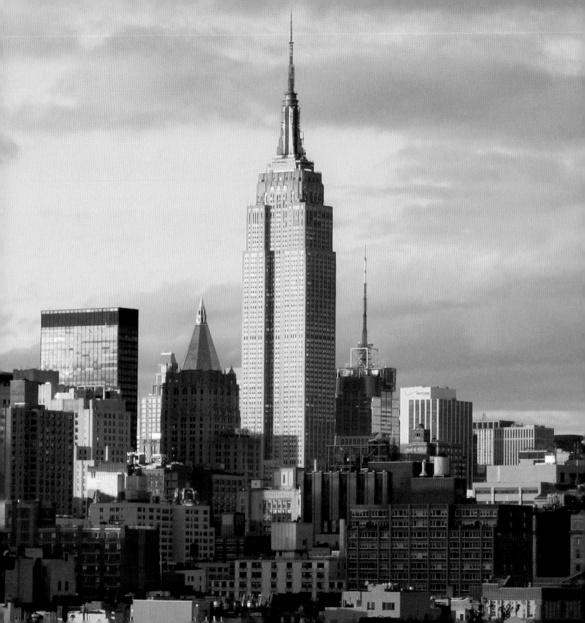

Empire State Building

ON A CLEAR DAY, YOU CAN SEE 80 MILES FROM THE OBSERVATION DECK of the Empire State Building, all the way to Massachusetts, Connecticut, New Jersey, or Pennsylvania. Of course you also can see much of New York, the Empire State. Each year almost four million tourists walk through the building's chrome-and-marble lobby and stand in line, sometimes for many hours, to ride an express elevator to the top. And it's worth the wait.

Climb the Himalayas, and you will see more territory. But when it comes to urban views of the world, the Empire State Building is preeminent. This is not only because of the building's height but also because of its proximity to **the dazzling New York City skyline.** The building overlooks such landmarks as Rockefeller Center; the United Nations; Central Park; the Statue of Liberty; and, seemingly close enough to touch, another art deco icon, the Chrysler Building.

SOME FAST FACTS ABOUT THE EMPIRE STATE BUILDING:
- It takes up about one-third of the block between 34th Street and 33rd Street and Fifth Avenue and Herald Square.
- The building measures 1,453 feet, 8.5625 inches from its base to the top of its lightning rod.
- It is the tallest building in New York and once was one of the ten tallest in the world.

Rockefeller Center

Midtown Manhattan's Rockefeller Center is **A COMPLEX OF 19 COMMERCIAL BUILDINGS** a few blocks south of Central Park. The center is a shopping mall, an art deco icon, a winter wonderland, and the only place on earth where you can nurse a cocktail and watch ice-skaters leap and twirl beneath a big, golden statue of Prometheus.

The center of the complex is **30 Rockefeller Plaza, a 70-story building that towers above the skating rink and the adjacent central plaza.** Stop by Radio City Music Hall, the largest indoor theater in the world, where the Rockettes have been knocking out audiences since 1932. Those seeking a fine dining experience may want to try a meal at the famous and glamorous Rainbow Room. Though the iconic restaurant closed in 2009, it reopened in 2014 after renovations.

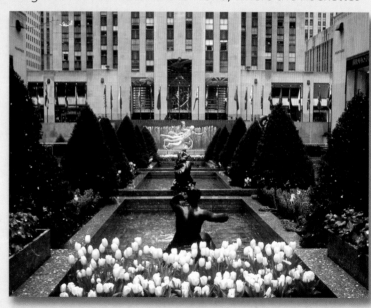

Brooklyn Bridge

The Brooklyn Bridge opened on May 24, 1883, linking what would become the boroughs of Brooklyn and Manhattan in New York City. It was **AN ACCOMPLISHMENT OF MYTHIC PROPORTIONS REQUIRING NEW TECHNOLOGIES AND NEW ENGINEERING.** In its day, the Brooklyn Bridge was the longest suspension bridge in the world, with the length of the main span measuring 1,595 feet. Its towers were once the tallest structures in the city.

The design was imaginative: Artists said the Gothic-influenced Brooklyn Bridge demonstrated that **aesthetics and technology could coexist.** It so inspired the poet Hart Crane that he chose his apartments for their view of the bridge. His masterpiece is the book-length poem "The Bridge."

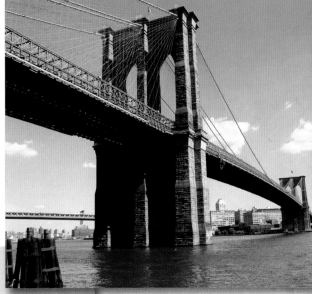

The Brooklyn Bridge, designed by architect John Augustus Roebling, towers over New York City's East River.

An Inspirational Span

"O Sleepless as the river under thee,
Vaulting the sea, the prairies' dreaming sod,
Unto us lowliest sometime sweep, descend
And of the curveship lend a myth to God."
—Hart Crane, excerpt from the poem "The Bridge," 1933

St. Patrick's Cathedral

St. Patrick's Cathedral lies in New York City across from Rockefeller Center. Technically, the cathedral was completed in 1879 after 20 years of construction. But the cathedral is the seat of the Archbishop of New York, so an archbishop's house and the rectory were added between 1882 and 1884. The cathedral's dramatic spires were completed in the 1880s, as well. Later, the great rose window and immense bronze doors on the Fifth Avenue side were added.

MORE THAN 5.5 MILLION VISITORS COME TO ADMIRE THE CATHEDRAL EACH YEAR. They especially come to see the St. Michael and St. Louis altar, designed by Tiffany & Company, and the St. Elizabeth altar, designed by Paolo Medici of Rome. St. Patrick's welcomes visitors from 6:30 A.M. to 8:45 P.M. daily, as long as they respect the serenity others seek there.

St. Patrick's is the largest Gothic-revival-style cathedral in the United States.

Cooperstown

Three standout museums have earned Cooperstown the nickname "The Village of Museums." Each museum is a fine example of its genre: American art (the Fenimore Art Museum); the rural life of times past (the Farmers' Museum); and America's favorite pastime, baseball (the National Baseball Hall of Fame). The National Baseball Hall of Fame is by far the biggest draw, as more people visit every day than actually live in the village.

The three-floor museum of baseball memorabilia is packed with rare old photographs, displays, and timelines that trace the history of the game and showcase its most important players, stadiums, and leagues. You'll see Babe Ruth's record-making bat, Willie Mays's glove, Lou Gehrig's locker, and the first known baseball, found in an old trunk outside Cooperstown. The Sandlot Kids' Clubhouse, a popular hands-on discovery area designed for young visitors, has interactive features, such as discovery drawers filled with museum artifacts.

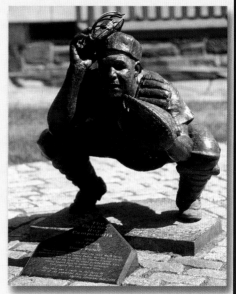

Outside the Baseball Hall of Fame are statues of Johnny Podres pitching to his Brooklyn teammate Roy Campanella (above) in a World Series game.

Atlantic City Boardwalk

Just off the mainland of southeastern New Jersey lies Absecon Island, whose marshes and sandy beaches lay undisturbed until 1854. Then the Camden and Atlantic Railroad Line was built there, and Atlantic City was born. Un-

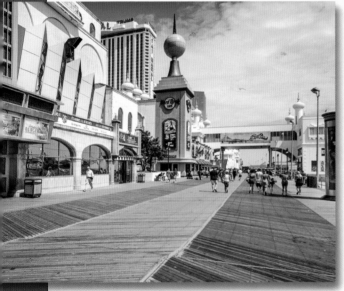

fortunately, the hordes of vacationers dragged volumes of sand through too many marbled lobbies.

In 1870, Alexander Boardman, a railroad conductor, proposed constructing a wooden walkway to sift out the sand, thus creating the Atlantic City Boardwalk. **ATLANTIC CITY BUILT AND REBUILT THE BOARDWALK UNTIL THE FIFTH AND FINAL VERSION IN 1896.** It is more than 4 miles long and 60 feet wide and features steel pilings and 40-foot steel beams. The Boardwalk helped make Atlantic City an attractive host for innovative events such as the first Miss America Pageant, in 1921. The legalization of casino gambling came in the late 1970s, and today, like Las Vegas, the Boardwalk is open 24 hours a day.

Cape May

Cape May is a peninsula at the southernmost tip of New Jersey; it's also **the nation's oldest seaside resort.** Whalers settled Cape May in the 17th century, and today it's a magnet for visitors from New Jersey, New York, and eastern Pennsylvania. Because a fire swept the little town in 1878, it was rebuilt in the Victorian style of the day, setting the architectural tone for what remains a charming, old-fashioned resort.

Cape May is the gateway to the 30 miles of sandy Atlantic Ocean beaches along the Jersey Cape that connect the resort towns of Ocean City, Sea Isle City, Avalon, Stone Harbor, and the Wildwoods. You'll find plenty of enticing attractions here, including **PICTURESQUE GARDENS AND EARLY-AMERICAN MUSEUMS.** You can also charter fishing boats, rent speedboats, kayak, or parasail. And with 30 miles of pure, white sand, it's possible to find some quiet, too.

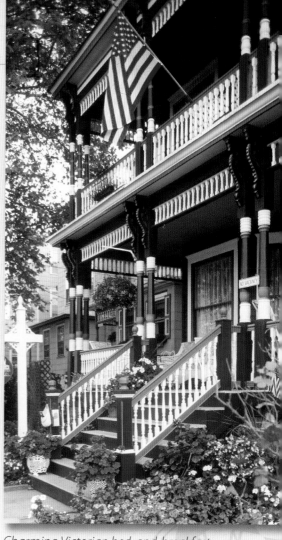

Charming Victorian bed-and-breakfast inns are popular with visitors to Cape May.

New Jersey Pine Barrens

The New Jersey Pinelands National Reserve, better known as the Pine Barrens, is big—really big. **THE 1.1-MILLION-ACRE NATIONAL RESERVE IS ABOUT THE SIZE OF GLACIER NATIONAL PARK IN MONTANA.**

The barrens comprise **impenetrable bogs and marshes with forests of low pine and oak, sporadic stands of cedar, and hardwood swamps.** Under the barrens, the Kirkwood-Cohansey aquifer contains more than 17 trillion gallons of water—its acidity seeps into the barrens' bogs and swamps and stains the water a tea color.

Tourists love hiking, biking, boating, picking cranberries, and visiting the historic villages of Batsto and Double Trouble. The Pine Barrens has its share of history and legends, such as the Jersey Devil, said to have the head of a horse, large wings, and claws. Jersey Devil tours are offered for the courageous.

Pittsburgh's Three Rivers

One of the best ways to see Pittsburgh is by taking the **Duquesne Incline** (right), which, **SINCE 1877, HAS PROVIDED PUBLIC TRANSPORTATION TO THE TOP OF MOUNT WASHINGTON,** a steep hill on the city's south side. Take the incline at night,

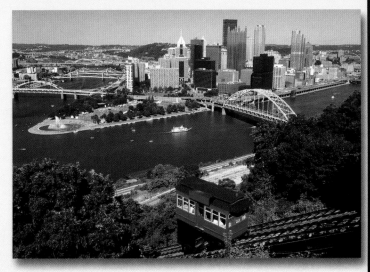

and go to the observation deck overlooking downtown Pittsburgh's Golden Triangle. **Fifteen major bridges span the waters of the Allegheny and Monongahela rivers as they flow together to become the Ohio River.** You'll be rewarded by the view and will land in the middle of Pittsburgh's Restaurant Row.

Opposite Mount Washington, going north across the rivers, is the Andy Warhol Museum, the Carnegie Science Center, PNC Park, and Heinz Field. While you're on the north side of the rivers, check out the National Aviary. It's a warm refuge on a chilly Pittsburgh day.

Carnegie Science Center

There is so much for children to do at this imaginative science museum in Pittsburgh that they may never get to **Exploration Station,** the enormous fourth floor filled with **INTERACTIVE EXHIBITS DESIGNED JUST FOR KIDS.**

Many children become sidetracked in **Highmark SportsWorks,** an entire building that **EMPHASIZES THE PHYSICS OF SPORTS WITH VIRTUAL REALITY RIDES.** Kids can run a race on a real track or design their own roller-coaster ride on a special computer then "ride" it in a simulator. At the **Miniature Railroad & Village** display, adults marvel at the **HISTORICAL ACCURACY OF THE PETITE PITTSBURGH NEIGHBORHOODS,** while kids are spellbound by its special animated features.

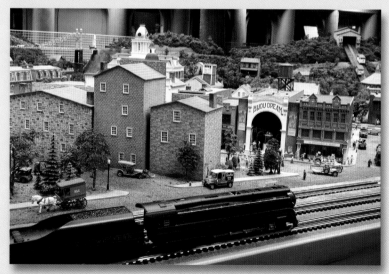

First stop...Fun! The Miniature Railroad & Village has been a popular attraction of the Carnegie Science Center for the past 50 years. Look closely at the amazing detail that goes into each display.

Philadelphia's Old City

The heart of Philadelphia is its Old City neighborhood, where the metropolis began. And the heart of Old City is **Elfreth's Alley, THE OLDEST RESIDENTIAL STREET IN AMERICA,** where people have lived since 1702. Three hundred years ago, traders and merchants lived in the Georgian- and Federal-style buildings on the narrow street. Blacksmith Jeremiah Elfreth owned most of the property along the alley and rented his houses to shipbuilders, sea captains, and landlubbers such as pewter smiths.

Today, **Old City is a vibrant neighborhood that is filled with theater companies, art galleries, restaurants, shops, and bars.** Christ Church, the Betsy Ross House, and Independence Hall are a short stroll away. Architecture fans should head to Elfreth's Alley Museum, which offers guided tours of homes that were built between 1710 and 1825.

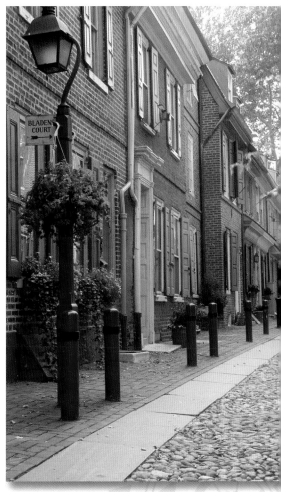

Independence National Historic Park and Independence Hall

If you really want to see America, start where the country started: Independence Hall. Philadelphia's Center City, the area between Fifth and Sixth streets, and between Market and Chestnut, is home to the body and spirit of U.S. history.

Independence Hall, which is now part of a 45-acre park (along with 20 or so other buildings), **IS WHERE AMERICA'S INDEPENDENCE WAS BORN.** Once called the Pennsylvania State House, this simple

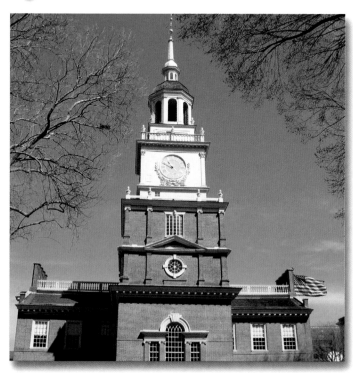

Construction on the Pennsylvania State House, now called Independence Hall, began in 1732 and was completed 21 years later.

building saw the foundations of the Declaration of Independence laid and brought to fruition.

The comely two-story redbrick building now has a steeple with a clock in it. But long ago, that steeple housed the 2,080-pound **Liberty Bell.** It chimed often (supposedly annoying the neighbors), but most notably, it was **RUNG ON JULY 8, 1776, TO ANNOUNCE THE FIRST PUBLIC READING OF THE DECLARATION OF INDEPENDENCE.** Now the bell is perhaps best known for its cracks—and its silence. The bell no longer hangs in the Independence Hall steeple because it has its own home on the park grounds.

Liberty Bell Inscription:
"Proclaim liberty throughout all the land unto all the inhabitants there of-Lev. XXV, v.x. By order of the Assembly of the Province of Pensylvania [sic] for the State House in Philada."

The Independence National Historic Park covers three large city blocks. Follow the paths (quaint alleys) to the many historical buildings and fascinating sites, such as Ben Franklin's final resting place in the Christ Church graveyard. It's hallowed ground you're walking on, so take your time, and try to see as much as you can. It's a visit you'll always remember.

Gettysburg

Gettysburg, Pennsylvania, never asked to be a crossroads of history, but it became one nonetheless. Gettysburg, of course, was **the site of one of the most pivotal battles of the Civil War.** The clash during the first three days of July 1863 led to the eventual defeat of the Confederacy.

Gettysburg National Military Park is in the heart of Pennsylvania Dutch country. But, **IT WILL FOREVER BE REMEMBERED AS THE PLACE WHERE GENERAL GEORGE GORDON MEADE'S UNION FORCES TURNED BACK THE CONFEDERATE ARMY OF GENERAL ROBERT E. LEE,** and as the location where President Abraham Lincoln gave his famous address four months later. Gettysburg offers visitors a surprising array of historic battlegrounds, monuments, and activities such as hiking and biking. Gettysburg includes the national park, the adjacent borough, and the next-door Eisenhower National Historic Site.

Located about an hour and a half from downtown Washington, D.C., the Gettysburg area is a versatile vacationland. It provides visitors with the opportunity to take a solemn pilgrimage to the hallowed site where 50,000 soldiers were killed, wounded, captured, or went missing in action

Serving as a lonely guard, this cannon is a reminder of one of history's most terrible battles. It sits on Little Round Top at Gettysburg National Military Park.

during the Civil War. Gettysburg is also a charming tourist town with such attractions as the Gettysburg Heritage Center, the Jennie Wade House Museum, the Lincoln Train Museum, and the Gettysburg Battle Theater.

But the foundation of Gettysburg is really the 6,000-acre battlefield and its more than 1,400 markers and monuments. It is well worth the trip to see the now-peaceful hills and fields where the tide of the Civil War changed.

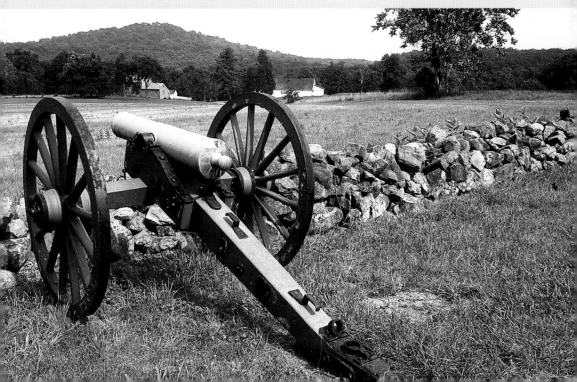

Pennsylvania Dutch Country

As you drive through this peaceful realm, you'll pass classic barns and silos, horse-drawn buggies, wooden covered bridges, and a pretty patchwork of farm fields and villages. You might even see girls in bonnets and boys in hats walking to their one-room schoolhouse. You won't see many in cars, of course, and some Amish children aren't even allowed to have bicycles because their elders fear they might venture too far from home. That's just one of the many things that sets apart the Pennsylvania Dutch Country.

Plan to stop at one of the region's pretzel bakeries, such as the Sturgis Pretzel House in Lititz, which has been baking the snack since 1861. Here you can make your own pretzels and eat them right out of the stone oven. At Central Market in Lancaster City, you can purchase regional foods, flowers, and Amish crafts at the oldest publicly owned, continuously operating farmer's market, which dates back to the 1730s.

Winterthur Garden and Enchanted Woods

Many people visit Winterthur, the lavish former home of Henry Francis du Pont in northern Delaware, to see its **COLLECTION OF ART AND ANTIQUES AND ITS ELABORATE FORMAL GARDENS.** Most popular with families, however, is its **Enchanted Woods, a three-acre fairy-tale garden.** Children delight in the legend that fairies brought broken stones, old columns, crumbling millstones, and cast-off balustrades to this hilltop area to create a magical place.

The Tulip Tree House is located in a hollow tree that leads to the Faerie Cottage, which, with its stone walls and thatched roof, is right out of a storybook. Nearby, a giant egg-filled bird's nest large enough for children to climb into is woven out of sticks. Kids also enjoy the estate's **Touch-It Room, an imaginative play area** with a child-size parlor, a small general store, and an area featuring old-fashioned toys.

The 60-acre Winterthur Garden offers a number of beautiful formal gardens to meander through.

Baltimore Inner Harbor

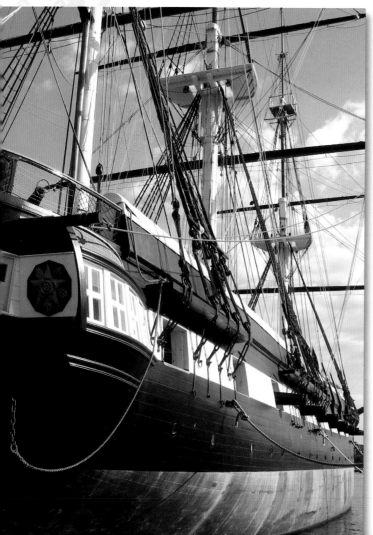

Baltimore calls itself "The Greatest City in America," and although some might dispute that, a visit shows why Charm City has every right to burst with pride.

Baltimore's showpiece is its fantastic Inner Harbor. Not long ago, the city's harbor could have served as urban decay's exhibit A. Then, beginning in the early 1960s, a succession of city administrations focused on rehabilitating the

The last Civil War vessel remaining afloat, the USS Constellation is on display for visitors to tour in Baltimore's Inner Harbor. More than 200,000 people have toured the historic ship since 1999.

old waterfront. They succeeded beyond anyone's wildest dreams, luring many top-notch attractions. These range from the Baltimore Orioles' new-yet-classic Camden Yards ballpark to the National Aquarium, the Maryland Science Center, Port Discovery for kids, the Baltimore Maritime Museum, the Baltimore Civil War Museum, the Civil War–era USS *Constellation* (the Navy's last all-sail warship), and much more.

The Inner Harbor satisfies trend-seekers, too. Shopping centers such as the groundbreaking Harborplace, which occupies 275,000 square feet in two pavilions, ensure plenty of retail bliss is found.

Baltimore Inner Harbor is also **HOME TO THE TALL SHIPS,** and the best way to see them is the Tall Ship Tour. Another must-see is the Top of the World Observation Level on the 27th floor of Baltimore's World Trade Center.

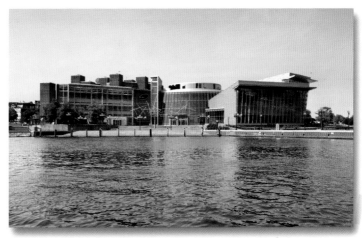

The Maryland Academy of Sciences houses the museums of the Inner Harbor, including the venerable Maryland Science Center, the state's oldest scientific institution. Children will enjoy its Kids Room and many other hands-on activities.

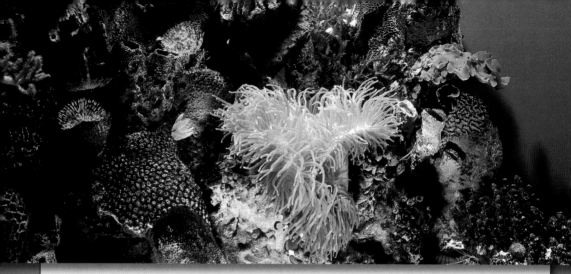

National Aquarium

The National Aquarium, on the end of Baltimore's Pier 3, anchors Baltimore's Inner Harbor. The huge attraction has **more than 17,000 fish and other creatures on display.** Not to be missed are its Dolphin Discovery exhibit, which hosts a colony of bottlenose dolphins, and the 4-D immersion films. .

The Atlantic Coral Reef exhibit is a 335,000-gallon tank that surrounds you with hundreds of tropical fish swimming around the world's most accurate fabricated coral reef. The Tropical Rain Forest exhibit includes endangered animals such as poison dart frogs and the scarlet ibis, while Jellies Invasion allows you to see these mysterious, translucent animals. And Shark Alley gives you an up-close and personal look at large sharks.

Assateague Island

Off the coasts of Maryland and Virginia is an island with endless white sand beaches sparkling in the sunshine. Assateague Island is **37 MILES LONG AND IS POPULATED WITH WILD HORSES THAT HAVE GALLOPED ALONG THE BEACH SINCE THE 1600s.**

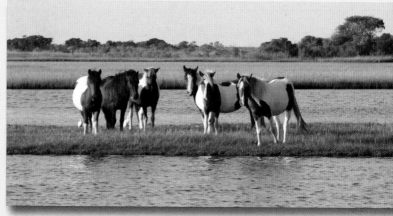

The horses on Assateague are descendants of domestic horses that reverted back to the wild. They are only about 12 to 13 hands tall—the size of ponies.

The surf is gentle, and stripers, bluefish, weakfish, and kingfish are plentiful. Assateague Island is a barrier island, so it has an ocean side, a bay side, and an interior. **THE CENTER OF THE ISLAND IS A BIRD-WATCHER'S PARADISE OF PONDS AND MARSHES,** home to wintering snow geese, green-winged teal, northern pintail, American wigeon, bufflehead, red-breasted merganser, bald eagles, ospreys, red-tailed hawks, kestrels, and merlins. Three stunning public parks share the island's 39,727 acres: Maryland's Assateague State Park; Assateague Island National Seashore; and, mainly on the Virginia side, Chincoteague National Wildlife Refuge, which has 14,000 acres of pristine forest, marsh, dunes, and beaches.

Annapolis

Think Annapolis, Maryland, and all things nautical come to mind. First settled in 1649, the city soon became an important colonial port. But after the Revolutionary War, shipping moved to the Port of Baltimore, and Annapolis's business shifted to small-boat harvesting of oysters, crabs, and fish from the shallow waters of Chesapeake Bay.

Today, the town is **known as the sailing capital of America and home to the U.S. Naval Academy.** Sailing is definitely a favorite pastime for Annapolis residents, and many major national and international sailing events, as well as weekly racing events for the locals, take place in the bay.

Annapolis Harbor is a fascinating place for entire families to explore and is sure to spark the imagination of fledgling sailors.

Schooners, sailing sloops, and cruise boats offer a variety of trips, narrated tours, and even Sunday brunch. You can also take a guided kayak tour of downtown Annapolis or paddle alone on the many creeks that feed the bay. There are even sailing schools that feature family programs.

Chesapeake Bay

Chesapeake Bay, **the largest estuary in North America,** is shared by Maryland, Virginia, and Delaware. The bay stretches almost 200 miles from the Susquehanna River to the Atlantic Ocean and ranges from 4 miles wide to 30 miles wide.

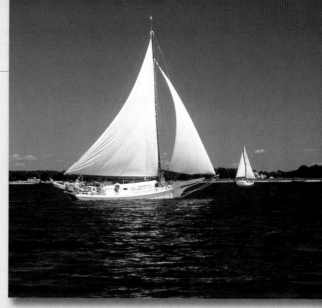

The beautiful bay was once the valley of the Susquehanna River, which helps explain why the bay is surprisingly shallow—**MOST OF IT IS LESS THAN SIX FEET DEEP.** Nonetheless, the Chesapeake Bay was the site of the American Revolution's critical naval Battle of the Chesapeake in 1781. It was also the site of the standstill Civil War battle between the ironclads CSS *Virginia* and USS *Monitor*.

Skipjacks were introduced to the Chesapeake in the late 19th century to dredge for oysters. Today, some of these versatile old vessels provide tours of the bay.

Recent conservation and restoration efforts have benefited Chesapeake Bay. The devastating pollution of the bay's waters has remained a threat since the 1970s but no longer greatly detracts from its natural beauty. The bay area today is **A FEAST OF ART EXHIBITIONS, WATERFRONT FESTIVALS, REGATTAS AND RACES, SPORTFISHING CONTESTS, AND BOAT SHOWS.**

National Mall

The National Mall in Washington, D.C., is one of the world's great public places. Its **146 ACRES OF RENOWNED MONUMENTS, IMPRESSIVE INSTITUTIONS, AND GRAND GOVERNMENT OFFICES** draw visitors from across the country and around the world.

By strict definition, "the Mall" means the greensward and adjacent buildings from the Washington Monument to the U.S. Capitol. When you visit, however, there's no need to stick to this definition; instead, enjoy how the Mall connects the White House, situated to the north; the Potomac River, National World War II Memorial,

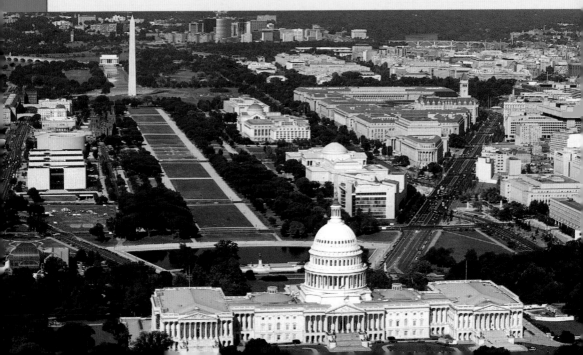

and Lincoln Memorial, to the west; the Jefferson Memorial, Franklin D. Roosevelt Memorial, and Tidal Basin, to the south; and the U.S. Capitol, to the east.

Any one of the dozens of the Mall's world-class museums or memorials is worth its own exploration. Among other attractions, the Mall includes:

- The National Archives
- The U.S. Botanic Garden
- The U.S. Holocaust Museum
- The National Gallery of Art
- The Korean War and Vietnam Veterans memorials
- Constitution Gardens
- The Reflecting Pool

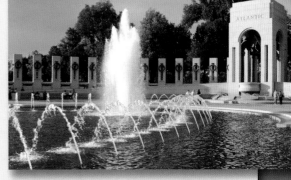

The National World War II Memorial honors the 16 million who served in the U.S. armed forces during World War II and the more than 400,000 who died.

The Mall also encompasses the riches of the Smithsonian Institution, which gives visitors a tour of national treasures. **THE SMITHSONIAN HAS A NUMBER OF MUSEUMS ON THE NATIONAL MALL ALONE;** it's so big that the original "Castle," built in 1855, is now merely its office and visitor information center.

U.S. Capitol

The U.S. Capitol is **AN ICON OF 19TH-CENTURY NEOCLASSICAL ARCHITECTURE THAT HOUSES THE COUNTRY'S LEGISLATIVE BRANCHES AND STANDS AS A SYMBOL OF THE UNITED STATES.** The building's cornerstone was laid on September 18, 1793, and it's been burnt, rebuilt, expanded, and restored since then.

When Congress moved from Philadelphia to Washington, D.C., in 1800, only the north wing of the building was complete. Then in 1814, British troops torched the building during the War of 1812, but a serendipitous downpour spared its complete destruction. The chambers of the Senate and House, as well as those for the Supreme Court, were ready for use by 1819. By 1850, an expansion was necessary to accommodate the growing legislature. The wings were lengthened, and the current stately cast-iron dome replaced the rickety wood-and-copper dome.

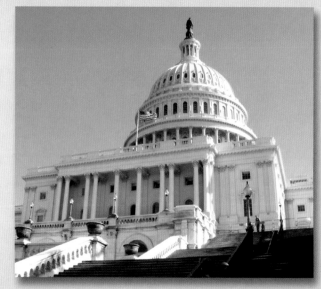

The U.S. Capitol's cast-iron dome was designed by architect Thomas U. Walter and constructed from 1855 to 1866. The Statue of Freedom was placed atop the dome in 1863.

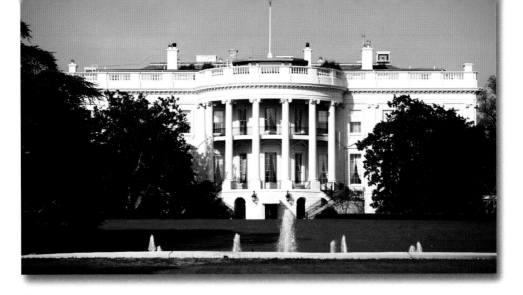

The White House

The White House is most amazing for its open-door policy: It is **THE ONLY RESIDENCE OF A HEAD OF STATE IN THE WORLD THAT'S OPEN TO THE PUBLIC, FREE OF CHARGE.** And although visitors can't tour all 132 rooms, they can see some of the more famous ones, including the East, Blue, Green, and Red rooms. (Public tours of the White House are available for groups of ten or more; however, requests must be submitted through your member of Congress six months in advance.)

Tours typically convene in President's Park South, the 52-acre park better known as the Ellipse. The Ellipse is home to several monuments and memorials as well as events such as the famed Easter Egg Roll in the spring and the lighting of the National Christmas Tree in December.

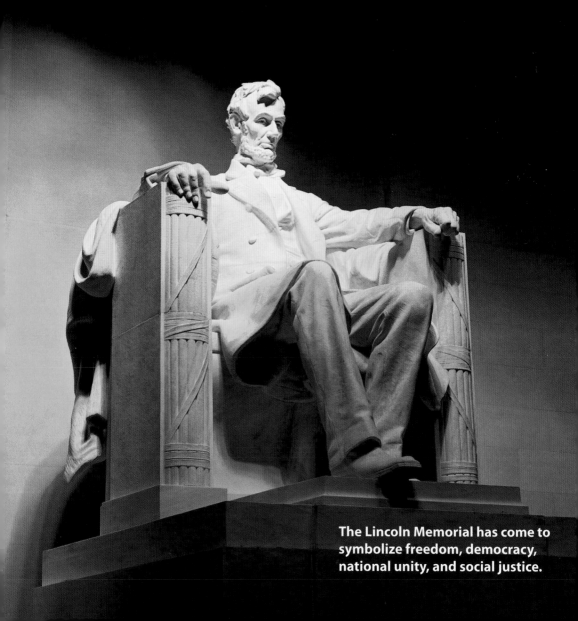

The Lincoln Memorial has come to symbolize freedom, democracy, national unity, and social justice.

Lincoln Memorial

The Lincoln Memorial **LEADS VISITORS TO CONTEMPLATE WHAT LINCOLN ACCOMPLISHED AND WHAT HE STOOD FOR.** No poet (including Walt Whitman) and no biographer (including Carl Sandburg) has expressed this as well as Lincoln himself in his addresses at his second inauguration and at Gettysburg. Both speeches are carved into the walls of the memorial.

Building the Lincoln Memorial was a prolonged process. Congress formed the Lincoln Monument Association in 1867. The original design was for a 12-foot statue of Lincoln surrounded by 6 large equestrian and 31 pedestrian statues. But a lack of funding derailed the initial project, and construction on the current memorial didn't begin until Lincoln's birthday in 1914 (it was completed in 1922). The Lincoln Memorial is unlike any other structure on the National Mall. **The choice of a neoclassical Greek rather than a Roman design stirred dismay.**

The base covers roughly the same area as a football field. The statue measures 19 feet wide by 19 feet tall—its size was sharply increased when sculptor Daniel Chester French realized it would be overwhelmed by the memorial building's size. **THE BUILDING HAS 36 DORIC COLUMNS, ONE FOR EACH STATE DURING LINCOLN'S PRESIDENCY.**

The memorial has attracted crowds since its creation and has hosted historic gatherings, including Marian Anderson's 1939 Easter Sunday concert—an early turning point in the Civil Rights Movement—and Martin Luther King Jr.'s "I Have a Dream" speech culminating the historic March on Washington for civil rights in 1963.

Thomas Jefferson Memorial

Located in East Potomac Park on the eastern shore of the Tidal Basin, the Thomas Jefferson Memorial, with its graceful dome, is a striking site. Known as a writer, philosopher, diplomat, and Renaissance man, the third president of the United States left behind a legacy of political ideas and actions that have passed the test of time with flying colors. A statue of Jefferson stands at the center of the rotunda under the dome, and the surrounding walls are inscribed with words from his most lasting and eloquent writings, including personal letters and the Declaration of Independence.

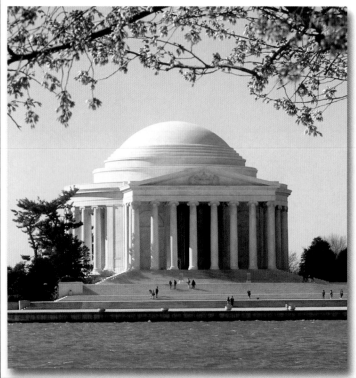

The Thomas Jefferson Memorial was dedicated in 1943 on the 200th anniversary of Jefferson's birth.

Franklin Delano Roosevelt Memorial

On the west side of the Tidal Basin, the Franklin Delano Roosevelt Memorial pays respect to the nation's 32nd president. Dedicated by President Bill Clinton in 1997, **THE MEMORIAL CONSISTS OF FOUR OUTDOOR "ROOMS," EACH DEPICTING ONE OF FDR's FOUR TERMS IN OFFICE, AND ICONIC FDR QUOTES ARE CARVED INTO THE GRANITE WALLS.** The memorial includes quiet areas bounded by shade trees, waterfalls, and pools. The FDR Memorial is not only about the man, but also the tumultuous times, most notably the Great Depression and World War II, through which he guided the nation.

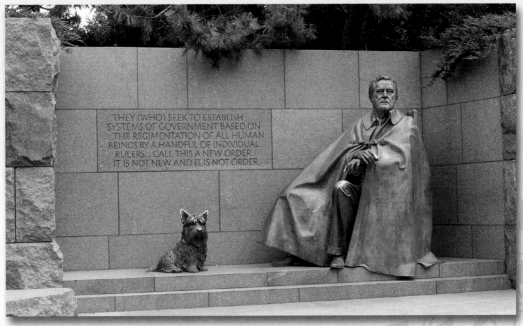

Washington National Cathedral

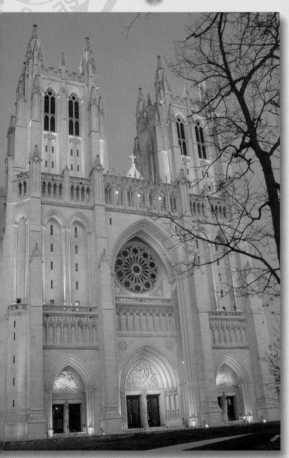

The National Cathedral is the sixth-largest cathedral in the world.

Pierre L'Enfant, Washington, D.C.'s first city planner, conceived of a national church in 1791. In his writings, L'Enfant described his vision of a cathedral **"INTENDED FOR NATIONAL PURPOSES, SUCH AS PUBLIC PRAYER, THANKSGIVING, FUNERAL ORATIONS, ETC., AND ASSIGNED TO THE SPECIAL USE OF NO PARTICULAR SECT OR DENOMINATION, BUT EQUALLY OPEN TO ALL."** However, it took some time for L'Enfant's vision to come to pass. The foundation was laid in 1907, but the grand structure with more than 250 angels and more than 100 gargoyles was not finished for 83 years.

The National Cathedral has been a focal point for spiritual life in the nation's capital since it opened in 1912. Every president has attended services here while in office. Many people have gathered at the church to mourn the passing of leaders or mark momentous events in world history.

Arlington National Cemetery

Nearly four million visitors come to Arlington National Cemetery each year. Most come to pay respect to their loved ones, to honor the leaders interred here, or to thank the more than 300,000 people buried here, many of whom were soldiers killed in the line of duty. **Soldiers and veterans from every war the United States has fought are buried here** (those who died prior to the Civil War were reinterred in Arlington after 1900).

There are three un-known soldiers—from World War I, World War II, and the Korean War—buried at the never-officially-named Tomb of the Unknowns. (The Vietnam veteran who had been buried there was identified in 1998, and his body was returned to his family in St. Louis.) President

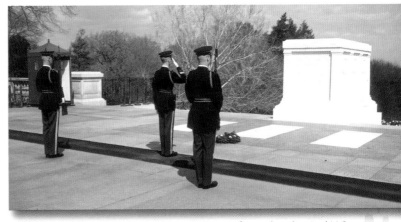

Tomb Guard sentinels, who are volunteers from the elite 3rd U.S. Infantry, keep watch over the Tomb of the Unknowns 24 hours a day, 365 days a year.

John F. Kennedy is buried in Arlington, and his grave is marked by the Eternal Flame, a specially designed flame that never goes out.

U.S. Holocaust Memorial Museum

The mission of the U.S. Holocaust Memorial Museum in Washington, D.C., is to **ENSURE THAT THE HORRORS OF THE HOLOCAUST ARE NEVER FORGOTTEN.** The museum is devoted to documenting, studying, and interpreting the history of the Holocaust, and it is also a memorial to the millions of Holocaust victims. Beyond educating the public about the tyranny of Nazi Germany against Europe's Jews, Romanis, and members of other minority groups, the museum **serves to remind visitors that their responsibilities as citizens of a democracy are never to be taken lightly.**

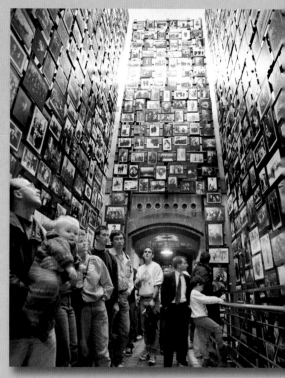

On the National Mall, the Holocaust Memorial Museum was chartered by Congress in 1980. Its exhibitions focus on artifacts, art, and other evidence of the Holocaust and the death and destruction it wrought. Every spring, a solemn and reflective ceremony is held on the grounds on Holocaust Remembrance Day.

The Tower of Faces contains more than 1,300 photos of Jewish life in the Lithuanian town of Ejszyszki taken between 1890 and 1941.

National Air and Space Museum

SHOWCASING THE ICONS OF SPACE AND AVIATION—Apollo modules, a Mercury space capsule, lunar landing probes, the Wright Brothers' 1903 Flyer, and full-size missiles—**the most-visited museum in the world exhibits the real deal instead of models.** At this Washington, D.C., attraction you can touch a piece of real moon rock, activate a supersonic wind tunnel, and see an actual spy satellite.

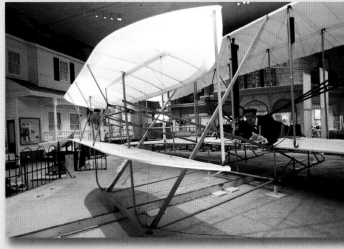

It looks like Orville Wright is bringing it in for a landing. A section of the 1903 Wright Flyer, the world's first airplane, is on display at Smithsonian's National Air and Space Museum. The exhibit also features a letter that Wilbur Wright wrote to the Smithsonian Institution requesting publications on aviation.

There's a space station you can actually walk through (where wax astronauts sleep upright strapped to cots) and many multimedia areas that ratchet up the experience, especially for kids. One sure favorite is the At the Controls-Flight Simulator Zone, which allows visitors to climb aboard a MaxFlight FS2000 simulator and pilot through a twisting 360-degree barrel roll or pull back on the joystick to complete an upside-down loop during their incredible five-minute adventure.

International Spy Museum

You and your children can learn firsthand how a spy operates at **the only museum in the United States dedicated to the world of espionage.** Upon your arrival at Washington, D.C.'s International Spy Museum, you'll adopt a "cover" and receive a new identity. You'll need to remember this information to see how well you perform as a spy, particularly when border guards throughout the museum interrogate you.

The whole family will pick up other cloak-and-dagger skills, including:

- How spies disguise themselves with fake hair and face-altering makeup
- How secret codes are made and broken
- How concealment devices are invented

ALSO ON DISPLAY ARE CLASSIC HIDDEN SPY CRAFT TOOLS such as buttonhole cameras, lapel knives, lipstick pistols, and hollowed-out coins concealing microdots.

National Museum of the American Indian

This **showplace of Native American cultures,** from the Arctic Circle to Tierra del Fuego, is a must-see in Washington, D.C. Upon arriving, many visitors head right to Lelawi Theater, which continually screens a short film that is projected on four Native American blankets and an adjacent dome. The film shows the lives of residents in Native American communities today.

Exhibits at the museum include painted hides from the Plains Indians, woodcarvings from North America's northwest coast, basketry from the southwestern United States, carved jade from the Maya, and gold from the Andean cultures. Performances feature storytellers, Bolivian dancers, Andean musicians, and informative talks by Native Americans. At the museum café, you can sample native specialties such as buffalo chili on fry bread, Peruvian mashed potato cakes, and smoked Northwest salmon.

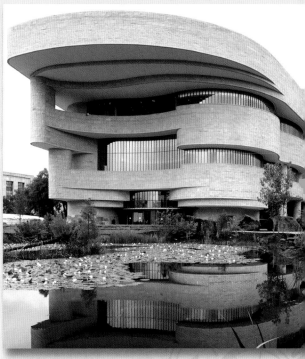

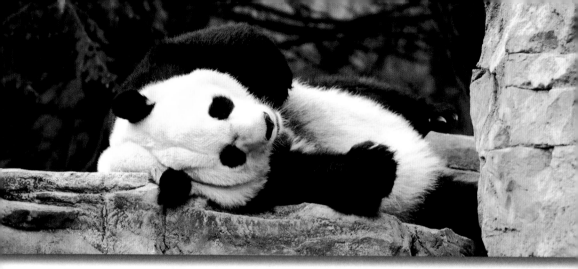

National Zoo

Start the day bright and early with a visit to the National Zoo. It opens early so visitors can view the animals when they are particularly lively. It's easy to see why the zoo's most popular residents are the adorable giant pandas from China, Mei Xiang, Tian Tian, and their offspring. **ALMOST ONE-QUARTER OF THE ZOO'S ANIMALS ARE ENDANGERED SPECIES,** including the pandas, Asian elephants, and western lowland gorillas.

The zoo's many highlights include the rare Sumatran tigers; the Reptile Discovery Center; and Amazonia, a re-creation of an Amazon rain forest. Visitors can observe the the cognitive abilities of the orangutans in the Think Tank exhibit. They can also see these active apes climb and swing overhead and travel to and from the Great Ape House on the "O Line," a series of towers and cables.

THE SOUTH

Monticello

Monticello, the Virginia home of American founder Thomas Jefferson, **is a Roman neoclassical masterpiece.** Jefferson moved onto the property in 1770, but the mansion was not completed until 1809, after Jefferson's second term as president. The house was the centerpiece of Jefferson's plantation, which totaled 5,000 acres at its peak. About 130 slaves worked the land, tended livestock, cooked, and cleaned there during Jefferson's life.

The domed building features east- and west-facing porticos that bookend an entrance hall and parlor. Jefferson, ever the tinkerer and innovator, made all sorts of improvements to Monticello to maximize space and light. **THE 43-ROOM MANSION HAS 13 SKYLIGHTS,** including one over Jefferson's bed.

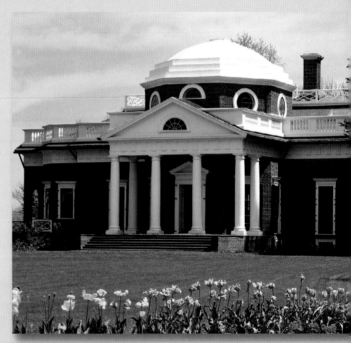

The west side of Jefferson's Monticello may seem familiar—it was featured on the back of the U.S. nickel from 1938 to 2003.

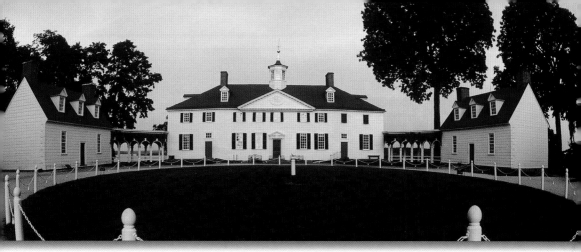

Washington and his family lived in the "Mansion House Farm" section of Mount Vernon.

Mount Vernon Estate and Gardens

Mount Vernon was home to George Washington, the first president of the United States. The land in eastern Virginia was given to John Washington, George's great-grandfather, in 1674, and it remained in the family for seven generations.

George spent five years at Mount Vernon as a child and later lived there as an adult with his wife, Martha. **THE PLANTATION GREW TO 8,000 ACRES WHILE WASHINGTON SERVED AS COMMANDER IN CHIEF DURING THE REVOLUTIONARY WAR.** Although Washington was best known as a military and political leader, he also left a strong architectural legacy: He designed and built many of the structures at Mount Vernon, including the famed mansion with its distinctive two-story portico. The estate is now 500 acres, 50 of which are open to the public.

Colonial Williamsburg

Williamsburg, Jamestown, and Yorktown make up Virginia's Historic Triangle. Known as Colonial Williamsburg, **THE AREA IS THE WORLD'S LARGEST, AND POSSIBLY GREATEST, LIVING-HISTORY MUSEUM.** Nowhere else do people take more care to create, re-create, and maintain a semblance of pre-Revolutionary life in the

The Yorktown Victory Center gives visitors a look at life on a 1780s Virginia farm.

United States. Actors wear period clothing and interact with each other and the visiting public to **simulate life in Williamsburg during the 17th century.**

Jamestown was the first capital of Virginia, but it lay in a low marsh area that compromised defenses against both hostile native people and malaria-carrying mosquitoes. The army moved some soldiers to nearby Middle Plantation, five miles away on a high point between the James and York rivers. In 1693, King William III and Queen Mary II granted a charter to the College of William and Mary, the colonies' second university (Harvard was the first). In 1699, the settlement was re-named Williamsburg after the king and was declared the new colonial capital. Williams-

burg remained the capital until 1780, when Governor Thomas Jefferson moved the capital to Richmond.

Fast-forward to the 20th century. Williamsburg's neglected center, the old capital, was fast decaying until a local pastor persuaded John D.

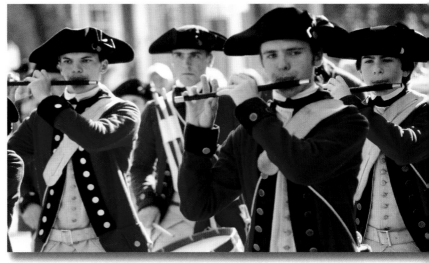

Today the Colonial Williamsburg Fifes and Drums are boys and girls ages 10 to 18 who carry on the tradition of military music.

Rockefeller Jr. to take an interest. Rockefeller quietly bought property and privately financed a plan for the city's restoration. The result is **TODAY'S 301-ACRE COLONIAL VILLAGE, WHERE 88 ORIGINAL BUILDINGS WERE RESTORED OR REPAIRED AND NEARLY 500 BUILDINGS AND OUTBUILDINGS WERE RECONSTRUCTED.** Colonial Williamsburg is a living museum, meaning while tourists visit museums, they are also invited to immerse themselves in another century and its homes, handicrafts, clothing, stores, taverns, gardens, and jails, as well as its people.

Shenandoah Valley

For years, the Blue Ridge Mountains seemed an insurmountable obstacle to the westward expansion of the United States. Many pioneers stopped cold in their tracks, but a spectacular sight greeted those who made it to the top of the ridge—the lovely Shenandoah Valley in Virginia. This **green paradise of endless forests**

The lush Shenandoah Valley stretches from Harpers Ferry, West Virginia, to Roanoke and Salem, Virginia.

and meadows cut by winding rivers and streams was so inviting that the valley seemed to hold all the promise of the West.

Skyline Drive runs along the crest of the Blue Ridge, providing 75 overlooks and magnificent vistas of forests, mountains, and the valley. Visit the valley in the spring or fall to see the fabulous blossoming flowers or autumn leaf displays. **MORE THAN 500 MILES OF TRAILS WIND THROUGH THE VALLEY,** including part of the Appalachian Trail. There are also numerous waterfalls—a dozen of them drop more than 40 feet.

Steven F. Udvar-Hazy Center

The Steven F. Udvar-Hazy Center, **AN EXTENSION OF THE SMITHSONIAN NATIONAL AIR AND SPACE MUSEUM,** was built to display the thousands of aviation and space-travel artifacts that won't fit into the popular Washington, D.C., museum. The Chantilly, Virginia, facility showcases famous aircraft, spacecraft, rockets, and satellites and a wide assortment of other space-exploration memorabilia.

A cavernous hangar that is more than three football fields in length and ten stories high, the center houses:

- the *Enola Gay*, the plane that dropped the atom bomb on Hiroshima
- a Concorde that once traveled in and out of adjacent Dulles Airport

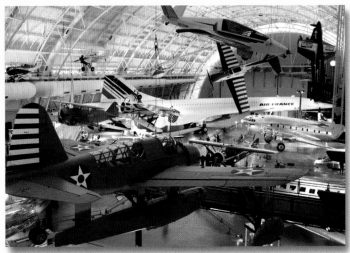

- the world's fastest jet
- the space shuttle *Enterprise*
- the *Gemini VII* space capsule

Interactive exhibits include a simulation of a shuttle flight, and special activities for families are offered throughout the year.

Monongahela National Forest

The Monongahela National Forest in West Virginia is **ONE OF THE LARGEST TRACTS OF PROTECTED EASTERN WOODLANDS.** This makes it a mecca for outdoorspeople of all stripes—anglers, hikers, mountain bikers, and paddlers. The forest's extensive network of backcountry trails will get you around **a landscape dotted with highland bogs and dense thickets of blueberries.**

Black bears, foxes, beavers, woodchucks, opossums, and mink are among the mammals found in Monongahela. There are also dozens of types of fish in the streams, more than 200 feathered species in the skies and the treetops, and 75 types of trees rooted in the forest's fertile soil.

Harpers Ferry National Historical Park

The town of Harpers Ferry, West Virginia, at the confluence of the Shenandoah and Potomac rivers, is **BEST KNOWN FOR ABOLITIONIST JOHN BROWN'S RAID ON AN ARSENAL IN 1859.** He believed that with the weapons stored there, the slaves could fight for their own freedom. When the Civil War ended, Harpers Ferry became a focal point during Reconstruction. The town made many early attempts at integrating former slaves into society. This included the 1867 establishment of Storer College, one of the first integrated schools in the United States.

Now designated Harpers Ferry National Historical Park, the town and surrounding areas in Virginia and Maryland create **a popular way station for hikers traveling the Appalachian Trail.** The town offers historical re-creations, but visitors also come to fish, raft, or hike and explore.

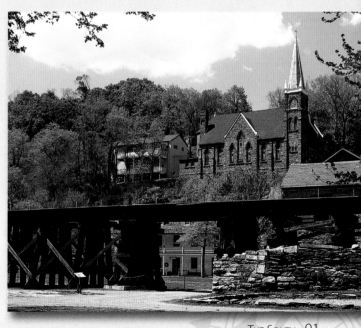

The small but historically important town of Harpers Ferry, West Virginia, has a population of a little more than 300.

Mammoth Cave

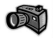

Mammoth Cave, **THE WORLD'S LARGEST NETWORK OF CAVERNS,** is hidden below the forested hills of southern Kentucky. There are **MORE THAN 367 MILES OF UNDERGROUND PASSAGES ON FIVE DIFFERENT LEVELS**—and that's just what's been mapped thus far. New caves and passageways are still being discovered.

The underground wonderland of spectacular Mammoth Cave is made up of limestone, which dissolves when water seeps through the ground. As the water works its way downward, the limestone erodes, forming the honeycomb of underground passageways, amphitheaters, and rooms that make up Mammoth

Cave, as well as its **dazzling array of stalagmites, stalactites, and columns.** A special tour just for children, called the Trog Tour, explores the connections between the cave and the sunlit world above. Wearing hard hats and headlamps, children walk and crawl through various passageways as they learn how the cave was formed and what lives in it.

National Civil Rights Museum

This Memphis, Tennessee, museum **pays tribute to the many people involved in the struggle for civil rights in the United States.** Built around the Lorraine Motel, where Dr. Martin Luther King Jr. was assassinated in 1968, the museum **CHRONICLES THE HISTORY OF CIVIL RIGHTS ACTIVITIES FROM THE BEGINNINGS OF SLAVERY THROUGH THE END OF THE 20TH CENTURY.**

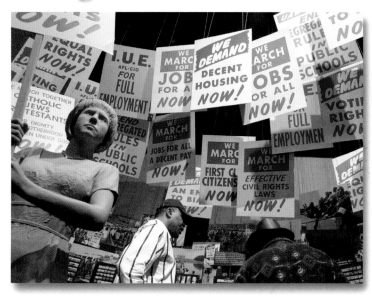

Exhibits focus on such events as the Civil War, the Supreme Court decision to desegregate schools, the lunch counter sit-ins, the Montgomery Bus Boycott, and the March on Washington. Multimedia presentations and full-scale exhibits bring the civil rights movement to life. Exhibits include a public bus similar to the one ridden by Rosa Parks when she refused to move to the back seats, the burned shell of a freedom-ride Greyhound bus, and the actual motel room where Dr. King stayed before he was slain.

Beale Street

Beale Street, in Memphis, Tennessee, is **truly a multisensory experience.** Pots of gumbo and red beans and rice simmer at every corner, but the smells and tastes of Beale Street are just side dishes. The main course is the music played at the neon-and-brick clubs. **BLUES, SOUL, AND ROCK 'N' ROLL CLAIM THE PERFECTLY IMPERFECT CITY OF MEMPHIS AS THEIR BIRTHPLACE.** And all three get people dancing on Beale Street every night.

In the early 20th century, Beale Street was one of the busiest markets in the South, with European immigrants selling goods to a largely African American clientele. In the 1980s, Beale Street was redeveloped into **an open-air, pedestrian-only center for music and nightlife.** The old market-place now hosts musicians, dancers, and sellers every night of the week.

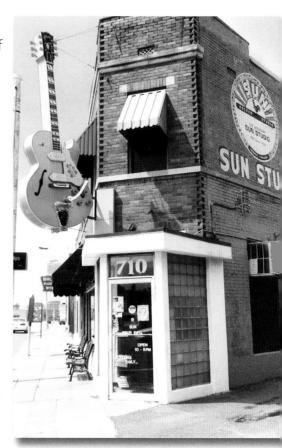

Memphis is home to Sun Records, the label that signed Elvis Presley to his first recording contract in 1954.

Grand Ole Opry

The Grand Ole Opry in Nashville, Tennessee, is **a cultural phenomenon.** At its heart, it's a radio program that showcases American country music. In fact, it's **THE LONGEST-RUNNING LIVE RADIO PROGRAM IN THE UNITED STATES.** But country music is just the starting point. The Opry is the centerpiece of Opryland, a comprehensive resort and convention center that offers everything from golf to shopping to, of course, country music.

It all began in 1925, when a brand-new Nashville radio station, WSM, hired a former Memphis newspaper reporter named George Hay to host a weekly program called the "WSM Barn Dance." In 1927, the show was renamed the "Grand Ole Opry," and its popularity snowballed. By 1932, WSM's 50,000-watt transmitter blasted the

program across the country and even to parts of Canada. Over the years, the Grand Ole Opry has become home to the "Who's Who" of American country music.

Graceland

Elvis Presley bought Graceland mansion in Memphis, Tennessee's Whitehaven neighborhood in 1957 when he was just 22 years old. He paid $102,500 for the property, **AN 18-ROOM MANSION ON NEARLY 14 ACRES OF COUNTRY ESTATE SURROUNDED BY TOWERING OAK TREES.**

The home's interior has been preserved as it was at the time of Elvis's death in 1977. Elvis's legendary taste included his so-called "Jungle Room," replete with

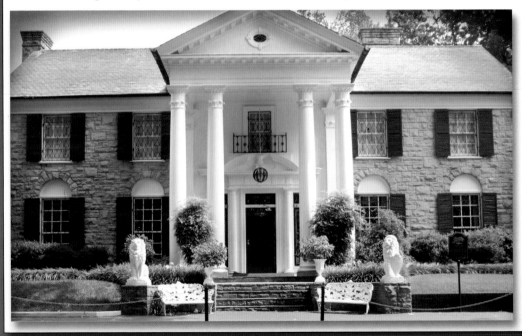

an in-wall waterfall and green shag carpeting on the floor and ceiling; his eclectic billiards parlor, plastered in yards of ornately patterned fabric; and his TV room, with a yellow, white, and blue color scheme and three television sets Presley watched simultaneously.

TEN OF THE MOST POPULAR ATTRACTIONS AT GRACELAND

- The music gates
- Hall of Gold (contains Elvis's gold records and other honors)
- Firearms collection
- Badge collection (given to Elvis by law-enforcement and security agencies from around the country)
- Elvis's record collection
- RCA display (more gold and platinum albums—111 in all)
- Meditation Garden (the final resting place of Elvis and his immediate family)
- Elvis's jet, the *Lisa Marie*
- The pink Cadillac Elvis bought for his mother
- The suit and wedding dress Elvis and Priscilla wore on their wedding day

Graceland is **NOW ON THE NATIONAL REGISTER OF HISTORIC PLACES, AND IT HAS BECOME A MAGNET FOR ELVIS FANS EVERYWHERE.** Fan clubs from as far away as Asia and Europe regularly send flowers and tributes to his grave. More than a quarter-century after his death, Elvis's house attracts upward of 750,000 fans a year—a testament to his lasting popularity.

Blue Ridge Parkway

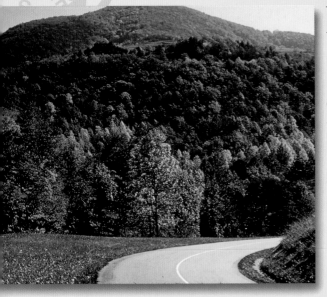

The Blue Ridge Parkway glides along the ridgetops of the southern Appalachian mountainside. The peaks are more than 6,000 feet above sea level, offering **REMARKABLE VIEWS OF THE VERDANT FIELDS AND COUNTRY TOWNS FAR BELOW.**

Construction crews began building the parkway in 1935 to link Shenandoah National Park in Virginia to the Great Smoky Mountains National Park in North Carolina and Tennessee. Construction was paused during World War II. By 1968, all that remained unfinished was a rugged stretch around North Carolina's Grandfather Mountain. But connecting the dots took nearly 20 more years and required building the Linn Cove Viaduct, a 1,200-foot suspended section of roadway that is considered an engineering marvel.

The Blue Ridge Parkway was officially dedicated in 1987, a full 52 years after construction began. It now offers **a portal into the history, culture, and natural wonder of southern Appalachia.**

Great Smoky Mountains National Park

Shrouded in thick forest along the border of North Carolina and Tennessee, the Great Smoky Mountains are **the United States' highest range east of South Dakota's Black Hills.** They are also **ONE OF THE OLDEST MOUNTAIN RANGES ON THE PLANET.** The park's highest point is the 6,643-foot peak of Clingman's Dome—on clear days, you can see as far as 100 miles from the top.

The Smokies' vast forest is one of the oldest on the continent. The park often feels like a vestige of an ancient era when trees ruled the planet. Today, more than 100 species of trees and 1,300 varieties of flowering plants grow in the park. The respiration of all this plant life produces the gauzy haze that gives the mountains their "smoky" name.

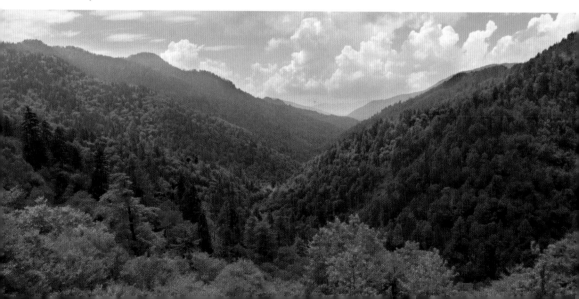

Cape Hatteras

Cape Hatteras is **A LARGELY UNTAMED STRING OF BARRIER ISLANDS ABOUT 70 MILES LONG.** The dunes, marshes, and woodlands that mark the thin strand of land between North Carolina's coastal sounds and the Atlantic Ocean are a diverse ecosystem defined by the wind and the sea. Nearly 400 species of birds have been seen in the Cape Hatteras area.

Countless shipwrecks have earned Cape Hatteras a treacherous reputation and the nickname **"The Graveyard of the Atlantic."** The navigational dangers led to the construction of several lighthouses, including Cape Hatteras Lighthouse and Ocracoke Lighthouse (built in 1823, it's the oldest operating lighthouse in North Carolina).

Although crowds are few and far between, Cape Hatteras is a popular recreational destination. Try the waters on each side of the island—they are considered some of the best on the entire East Coast for surfing and fishing.

The 208-foot-tall Cape Hatteras Lighthouse is the tallest in the United States. Visitors may climb the 268 steps to its top for a commanding view of the shoreline.

Biltmore Estate

THE LARGEST HOME IN THE UNITED STATES IS THE CENTERPIECE OF AN IMMACULATE 8,000-ACRE ESTATE that includes lush gardens, active vineyards, and a luxury inn. Originally the country retreat of the Vanderbilt family, Biltmore has evolved into a swanky tourist attraction.

Biltmore mansion was the vision of George W. Vanderbilt. In the late 1880s, he purchased 125,000 acres in the Blue Ridge Mountains near Asheville, North Carolina, where he built the **250-room French Renaissance château** that includes:

- 65 fireplaces
- an indoor pool
- a bowling alley
- gardens designed by landscape architect Frederick Law Olmsted

The Walled Garden on the Biltmore Estate blooms with a progression of color from spring through summer.

Outer Banks

Today **A PARTICULARLY SERENE STRETCH OF SEA AND SAND,** North Carolina's Outer Banks **belie their treacherous past.** A group of English men, women, and children settled on Roanoke Island in the 1580s and then mysteriously disappeared. Among the pirates who hid their treasure around these islands in the 18th century was the infamous Blackbeard. He materialized in the area with a price on his head and was quickly captured and executed.

Families will enjoy the lively Roanoke Island Festival Park, which has a hands-on museum, free concerts and plays, and a replica of the ship that brought over the colonists who disappeared. But the history doesn't end there. **The Wright Brothers National Memorial marks the site of the world's first successful airplane flight.**

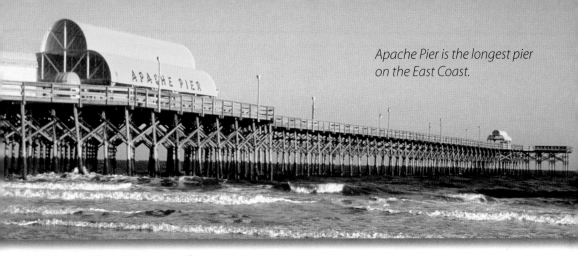

Apache Pier is the longest pier on the East Coast.

Myrtle Beach

South Carolina's Grand Strand, Myrtle Beach, has been a favorite sun-and-sand destination for more than a century. The beach is **named for the numerous wax myrtle trees growing along the shore.** The Seaside Inn, which opened in 1901, became the first of many increasingly sophisticated resorts that have made this **one of the top tourist areas on the East Coast.**

Myrtle Beach shares its name with the adjacent city. The beach itself bustles with all sorts of activity. Parasailers fly above the ocean, surfers hang ten on the tide, and divers explore the depths below. Pushcarts stocked with frozen lemonade and shops overflowing with T-shirts and bright beachwear are always close at hand. Myrtle Beach is known for its great family atmosphere, thanks to **A LIVELY BOARDWALK AND NUMEROUS WATERFRONT TOURIST ATTRACTIONS,** including an amusement park.

Hilton Head Island

Hilton Head Island is **one of the premier beach getaway destinations in the Southeast.** It was named for William Hilton, an English sea captain who explored the island in the 17th century. The foot-shape barrier island off the South Carolina coast is only 42 square miles, but that small space holds a semitropical paradise of white-sand beaches; salt marshes; lagoons; and lush forests of mossy oaks, palmettos, magnolia, and pine.

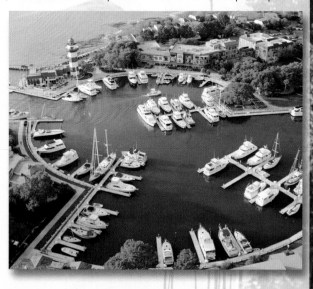

The island's pristine natural environment is balanced with the graceful aesthetics of **SOME OF THE FINEST RESORTS AND GOLF COURSES.** The combination is a magnet for visitors: Although the year-round population is just 31,000 people, Hilton Head Island sees more than 2.5 million tourists each year. They come not only for the lush scenery, posh resorts, and great golf but also for many deep breaths of fresh coastal air, abundant peace and quiet, and those beautiful sunsets that play out over the mainland on the western horizon.

Charleston

Charleston, South Carolina, is **A BEAUTIFULLY PRESERVED CITY FULL OF ANTEBELLUM MANSIONS, QUAINT COBBLESTONE ALLEYS, AND CAREFULLY PRESERVED HISTORIC BUILDINGS.** After the Civil War devastated the community, residents were so poor that they could not afford to rebuild, so the city simply adapted its old buildings, unknowingly protecting them as historical treasures for future generations to appreciate.

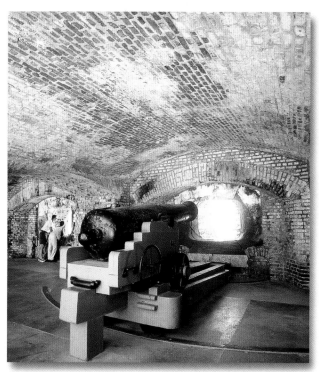

Magnolia Plantation is a great example of Charleston's preservation. You can tour the home and take the Nature Train tour to see the plantation's many animals, including alligators. You can also enjoy:

- the petting zoo
- the wildlife observation tower
- the garden maze

History buffs will enjoy a tour of **Fort Sumter National Monument** (left)**, where the first shots of the Civil War were fired.**

Martin Luther King Jr. National Historical Park

Martin Luther King Jr. was born in **A MODEST, COMFORTABLE HOME IN THE HEART OF ATLANTA'S "SWEET AUBURN" DISTRICT** (the city's prosperous African American downtown in segregated days). Visitors to the Martin Luther King Jr. National Historical Park in Atlanta are reminded that the great civil rights leader could have lived a quiet, cozy, middle-class life. Instead, King spent 1957 to 1968 fighting for civil rights for all Americans, risking his life to fight for his beliefs.

The historic **site evokes the memory of King's dreams.** The visitor center has a helpful video and exhibits aimed at young visitors. The King Center features exhibits about King; his wife, Coretta Scott King; and Mahatma Gandhi. **THE CENTER IS THE SITE OF KING AND HIS WIFE'S GRAVES.** He is entombed beside an eternal flame, but King's real eternal fire lives on in those who hear his message.

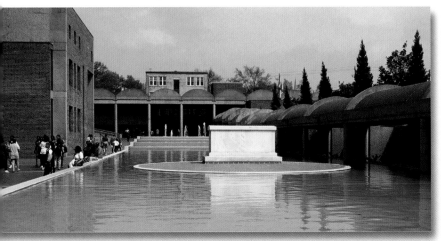

Savannah

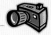

Savannah, Georgia's historic district is filled with elegant homes. Among these lovely mansions you'll find the home of Juliette Gordon Low, the founder of the Girl Scouts. The home has been converted into a museum and is a popular destination for Girl Scout troops from across the United States.

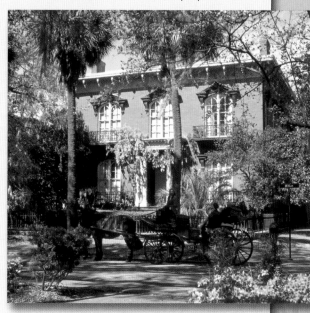

Another highlight is Old Fort Jackson, which was built in 1808 and helped protect the coast from British warships during the War of 1812. Visitors can tour the fort and, on certain days, watch battle reenactments and blacksmithing demonstrations. A popular stop is the fort's "privy" (bathroom)—the currents of the Savannah River provided its flushing action.

You can also tour Savannah by horse-drawn carriage. Guides will treat you to some background details about the city's notorious characters and occurrences. If your kids enjoy their history with a slightly spooky twist, they'll like the tours of the supposedly haunted areas of Savannah.

Stone Mountain

Stone Mountain, Georgia, is **THE WORLD'S LARGEST EXPOSED PIECE OF GRANITE— 7.5 BILLION CUBIC FEET OF ROCK.** This immense, bulging monolith is just a half-hour drive from Atlanta. But it's not just the size of the mountain that drives people to visit. Stone Mountain's **outstanding feature is the Confederate Memorial Carving.**

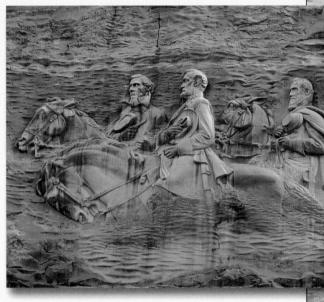

Three Southern heroes from the Civil War have been carved into the rock: Confederate President Jefferson Davis, General Robert E. Lee, and General Thomas J. "Stonewall" Jackson. The relief is massive, **SPANNING 90 BY 190 FEET,** and is surrounded by a carved surface that covers three acres.

Located just outside the park's west gate is Historic Stone Mountain Village. The village was established in 1839 and offers more than 50 specialty shops and restaurants. Visitors can browse through quaint antique stores and shop for art and jewelry created by local artisans.

Cumberland Island National Seashore

Visiting beautiful, mysterious Cumberland Island National Seashore takes a little effort, thanks to a policy that **permits a maximum of 300 visitors per day** and the fact that Cumberland Island has **ONLY ONE DEVELOPED CAMPSITE, SEA CAMP** (reservations can be made up to six months in advance). But a trip to the remote island is worth the hurdles.

The lucky few who make it have Cumberland Island seemingly to themselves. The island is **3 miles wide and is ringed by a beach almost 18 miles long.** It's covered by acres of marsh, tidal creeks, sand dunes, blinding white sand, and historic ruins and museums that compel admiration and amazement. And this doesn't even take into account the island wildlife. Georgia's southernmost barrier island is a sanctuary for gigantic loggerhead sea turtles. **HERDS OF WILD HORSES ROAM HERE,** too. It's said Spanish explorers left them behind in the 16th century.

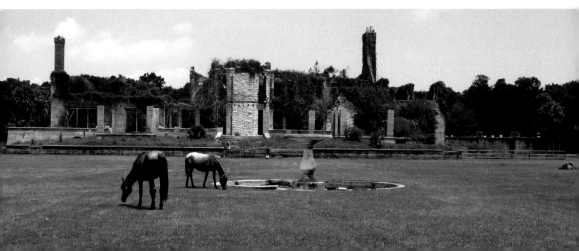

The Golden Isles

Georgia's great barrier islands shelter the Atlantic Intracoastal Waterway and guard the coastal shoreline. The beauties known as the Golden Isles—Sea Island, Jekyll Island, St. Simons Island, Little St. Simons Island, and Cumberland Island (see page 109)—are about 20 minutes from each other by boat or car, and each has a slightly different personality. All have stunning beaches, as well as marshes and creeks that are great fun to explore by canoe or kayak.

Sea Island is home to The Cloister, an acclaimed resort. Situated on five miles of sandy beach, the resort is a retreat for well-heeled guests. Even if you're not staying at the resort, it's fun to visit for a meal so you can experience its traditional Southern charm and cruise the mansions along the shore.

Jekyll Island is protected by offshore sandbars, so the surf is

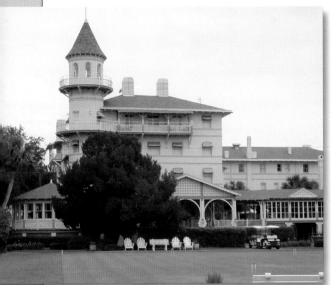

Jekyll Island was a popular destination for the country's rich and powerful and is now a favorite among families looking for a relaxing beach getaway. Jekyll Island Beach Club is a local landmark.

particularly calm. The island has 20 miles of paved bike paths that traverse salt marshes and beaches, past Spanish-moss-draped trees and palmettos, as well as the island's National Historic Landmark District. Its ten miles of beaches offer swimming, horseback riding, surf fishing, and kayaking. The island is a major site for sea turtle conservation.

St. Simons Island is the largest and most developed of the Golden Isles. It measures 45 square miles and boasts many beautiful old homes and estates. It's a terrific place to try surf casting, pier fishing, oystering, crabbing, or shrimping. St. Simons is home to one of the nation's oldest continually working lighthouses open to visitors. You can also explore the island on its numerous biking trails.

Little St. Simons Island is privately owned and is accessible only by boat or plane. It's virtually undeveloped, but its seven-mile stretch of beach is perfect for swimming, shelling, fishing, hiking, and bicycling.

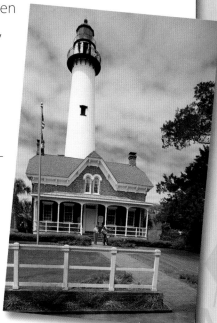

The lighthouse on St. Simons Island still guides boats into its harbor. The island also offers great fishing and inviting beaches.

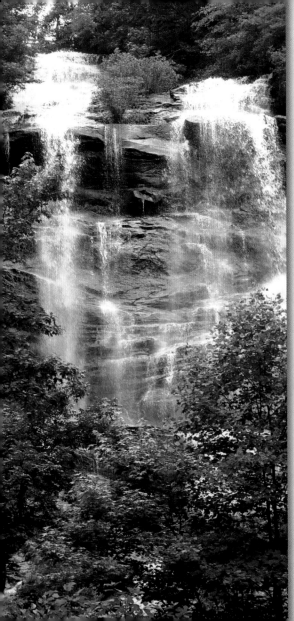

Amicalola Falls

A hiker's paradise unfolds at Amicalola Falls State Park in northern Georgia as 12 miles of trails weave through the picturesque Appalachian Mountains and lead to the Amicalola Watershed and Amicalola Falls.

AT 729 FEET, THIS IS THE TALLEST WATERFALL EAST OF THE MISSISSIPPI RIVER. Its name means "Tumbling Waters" in Cherokee. Visitors can stay at the 57-room modern lodge near the falls or at the remote Len Foote Hike Inn, accessible by a five-mile hike along the Hike Inn Trail. The secluded inn's 20 rooms are arranged around a two-story lobby. The rustic inn provides many gorgeous panoramas of oak and hickory forests with mountain laurel and rhododendron. It also is an access point for winding mountainside trails where you can catch a glimpse of warblers, vireos, white-tailed deer, rabbits, raccoons, and bears.

Georgia Aquarium

The Georgia Aquarium in Atlanta is big—really big. **THE WORLD'S LARGEST AQUARIUM HOLDS EIGHT MILLION GALLONS OF WATER, AND MORE AQUATIC LIFE LIVES THERE THAN AT ANY OTHER AQUARIUM.** One tank alone holds six million gallons of water; it has to because it's home to whale sharks, the largest fish species on Earth.

The rest of the aquarium features **100,000 animals in 60 separate habitats,** as well as several major viewing galleries, each arranged around a theme.

The Cold Water Quest exhibit cold water animals, including otters, penguins, and beluga whale. The Ocean Voyager section includes saltwater animals including whale sharks and rays, while Pier 225 puts the spotlight on sea lions. And the River Scout Gallery features not only alligators but fish found in the rivers of Africa, South America, Asia, and the state of Georgia.

World of Coca-Cola

Coca-Cola was invented in Atlanta, Georgia, in 1886, and it quickly became a favorite beverage across the world. The Coca-Cola Company's showcase museum, the World of Coca-Cola in the beverage's hometown, is a tribute to the brand. If you are one of countless hard-core Coke collectors, the place is a must-see.

The **MUSEUM TRACES COKE FROM ITS EARLY DAYS TO THE DRINK'S TRIUMPH AS A GLOBAL BEVERAGE.** Vistitors can go to the "Vault of the Secret Formula," where they can create their own flavor mixes, see a short film in the Coca-Cola Theater, see historical artifacts, and try more than 100 beverages produced by the company.

Ringling Estate

John Ringling, of Ringling Bros. and Barnum & Bailey Circus fame, had a passion for art, collecting works while touring Europe. In 1924, he and his wife, Mable, began building their **Italian Renaissance–style mansion in Sarasota Bay, Florida.** The building was called Cà d'Zan, meaning "House of John" in Venetian dialect. The man-

sion is a work of art. The building is capped by a 60-foot tower that was illuminated when the Ringlings were home. An impressive 8,000-square-foot marble terrace offers awe-inspiring views of Sarasota Bay.

In 1927, the Ringlings began building the **John and Mable Ringling Museum of Art** (now also known as the State Art Museum of Florida). Their art treasures include more than

The elegant Cà d'Zan is 200 feet from one end to the other and has 32 rooms and 15 baths.

10,000 paintings, sculptures, drawings, prints, photographs, and decorative arts. The museum HOLDS THE LARGEST PRIVATE COLLECTION OF PAINTINGS AND DRAWINGS BY PETER PAUL RUBENS, as well as masterworks by Lucas Cranach the Elder, Nicolas Poussin, Frans Hals, and Anthony Van Dyck.

Everglades National Park

Everglades National Park at the southern tip of Florida is home to so many exotic animals, you'll think you're on a Hollywood set. Scarcely more than a 90-minute drive from Miami, the park is inhabited by gorgeous fish, turtles, otters, lizards, and birds. There are plenty of alligators and crocodiles lurking in the freshwater and saltwater swamps. And if you are *very* lucky, you might even spot a rare Florida panther.

The park, which **COVERS 1.5 MILLION ACRES AND IS THE THIRD-LARGEST NATIONAL PARK IN THE CONTINENTAL UNITED STATES,** has five entrances. Most adventurers start at the

Ernest F. Coe Visitor Center near the main entrance on the eastern edge of the park. The Royal Palm Center is about four miles west of there. The Flamingo Visitor Center, 38 miles southwest from the main entrance, takes travelers deep into the park for hiking and canoeing; some areas are bike- and wheelchair-accessible, too.

The territory near the center of the park is said to be the preferred place for watching crocs, and **Eco Pond, one mile past the Flamingo Visitor Center, is prime gator habitat. (THE EVERGLADES IS THE ONLY PLACE ON EARTH NATURALLY OCCUPIED BY BOTH CROCODILES AND ALLIGATORS.)** In the park's northwest corner, The Gulf Coast Visitor Center lies across the water from the 10,000 Islands, a haven for fishing in the scenic backwaters. And the Shark Valley Visitor Center, on the Tamiami Trail (Highway 41) on the park's northern border, is an outpost on Florida's "River of Grass."

Novelist Marjory Stoneman Douglas founded Friends of the Everglades in 1969. "There are no other Everglades in the world," she wrote. "They are, they have always been, one of the unique regions of the earth; remote, never wholly known. Nothing anywhere else is like them"—not that visitors to this precious preserve need to be reminded.

Walt Disney World

If you have kids, chances are good at some point they'll ask you about visiting the biggest Disney complex in the world: Walt Disney World in Orlando, Florida. Four major theme parks make up Disney World, but there are also other attractions and two evening entertainment districts that deserve a visit.

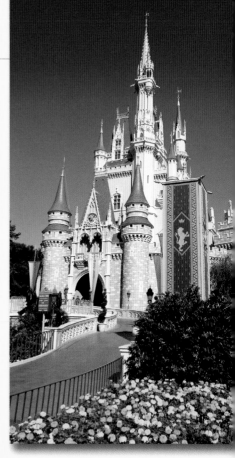

The Magic Kingdom, with its **CINDERELLA CASTLE CENTERPIECE AND COSTUMED CHARACTERS,** including Mickey, Minnie, Donald, and other Disney favorites, is the best known and possibly best loved of all the Disney World parks. Parents can take their children on such rides as the Mad Tea Party, Space Mountain, and the Jungle Cruise, as well as The Haunted Mansion and the Magic Carpets of Aladdin.

At **Disney's Hollywood Studios,** guests can tour the MGM back lot and see sets from favorite TV shows or visit the animation studios to observe the artists who work on Disney's animated features. Adrenaline junkies can hop onto the Rock 'n' Roller Coaster. There are also many excellent live stage shows featuring Disney

Right: *Epcot Center is filled with dazzling shows and amazing experiences. This family favorite celebrates the wonders of the world.* Below right: *Do you dare descend in the haunted elevator? The Twilight Zone Tower of Terror at Hollywood Studios will send you plunging in a special effects-filled thrill ride.*

characters, including the family favorite *Beauty and the Beast.*

Part zoo, part theme park, **Disney's Animal Kingdom** is **a blend of nature and adventure packaged with imaginative touches.** Like the Magic Kingdom, Animal Kingdom has different themed lands, each representing a different part of the world. In this park you'll find more than 1,000 creatures from all corners of the world living in re-created habitats.

Epcot Center SHOWCASES WORLD CULTURE AND TECHNOLOGY WITH A UNIQUE MIX OF ATTRACTIONS AND EDUCATIONAL EXHIBITS. It consists of two areas, World Showcase and Future World. Eleven countries are celebrated in the festive World Showcase; each country offers performances, traditional food, craft shops, and exhibits that spotlight its culture. Future World has cutting-edge interactive exhibits and rides that take you to the outer limits of the human imagination.

Little Havana

THE HEART OF CUBAN LIFE IN FLORIDA is the vibrant commercial strip in Miami's Little Havana **called Calle Ocho,** or Eighth Street. Calle Ocho is **THE EPICENTER OF AN ETHNIC EXPLOSION THAT INCLUDES IMMIGRANT COMMUNITIES FROM AROUND THE WORLD.** One of the many highlights is the authentic Cuban cuisine—restaurants serve up seafood paella, succulent marinated pork, and hearty beans and rice. Visitors can also sample the cuisines of Peru, Nicaragua, the Dominican Republic, and myriad other Latin lands. Tourists and locals alike dote on the neighborhood's trademark hand-rolled cigars, merengue and salsa music, and chess and dominoes games.

Cape Canaveral

Cape Canaveral is **A BARRIER ISLAND OFF THE EAST COAST OF FLORIDA** that's spacious enough to include the 58,000-acre Canaveral National Seashore, John F. Kennedy Space Center, and Cape Canaveral Air Force Station. Its 220 square miles are covered by marshes and many miles of shimmering beach.

Visitors are welcome at the Kennedy Space Center, whose **TOURS GIVE AN IN-DEPTH BEHIND-THE-SCENES LOOK AT NASA,** including visits to launch pads and rockets. Outer space may be the island's main attraction, but Cape Canaveral proves that Earth has its share of beauty and mystery, too. The space center borders the Merritt Island National Wildlife Refuge. There, manatees may graze underwater in the shadow of a launch pad, and endangered sea turtles swim to shore to lay their eggs in the silence of the night.

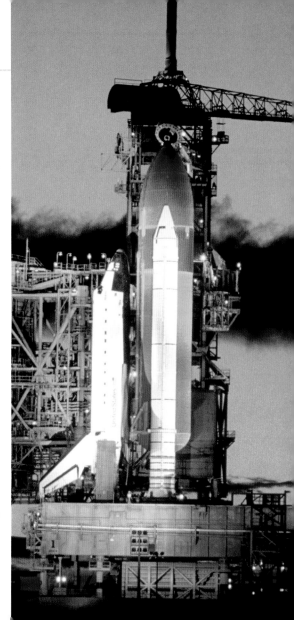

St. Augustine

Its beaches are legendary stretches of talcum-soft sand bordered by calm, blue water. But the real claim to fame of St. Augustine, Florida, is that it is **THE OLDEST PERMANENTLY INHABITED CITY IN THE UNITED STATES.** Founded in 1565, it's filled with reminders of its early Spanish history.

Wander through the narrow, picturesque streets of the town's carefully restored Spanish Quarter for a glimpse of how this community of Spanish soldiers, settlers, craftspeople, and families lived in the 18th century. You'll see narrow cobblestone streets, **the oldest wooden schoolhouse in the country,** and Ponce de Leon's Fountain of Youth. There are also a number of 17th- and 18th-century buildings that house ice-cream parlors and shops staffed by costumed interpreters who reenact life in the 18th century. A carriage tour is a great way to see the historic district, and drivers are always willing to share stories of the city's past.

The **St. Augustine Alligator Farm and Zoological Park, which has been operating since the late 1800s,** features crocodiles, caimans, and alligators of all sizes lolling around their enclosures. A boardwalk across a lagoon lets you observe birds, turtles, and alligators swimming in a natural setting. Other interesting reptiles, such as giant Galápagos tortoises, wander about, as well. Shows feature alligator wrestling, snake wrangling, and other crowd-pleasing feats.

This old wooden schoolhouse offers a view of a classroom from centuries ago. It is typical of the history-rich architecture you'll see in St. Augustine.

The St. Augustine Ripley's Believe It or Not! Museum was the first in the nation. It is located in Castle Warden, a historic Moorish Revival–style mansion built in 1887. The curiosities in it that kids like best are the ones that make most adults squeamish—the more gruesome the better—such as shrunken heads and other human oddities.

Castillo de San Marcos

Castillo de San Marcos, an authentic Spanish fort, and its 25 acres of old parade grounds are a must-see on any visit to St. Augustine, Florida. Construction of the fort began in 1672, and it was completed in 1695. The fort **BOASTS AN IMPRESSIVE MOAT, A DRAWBRIDGE, AND HUGE CANNONS ATOP WHICH KIDS CAN SIT.** Its walls are made of coquina, a limestone material composed of broken seashells and coral. Thanks to this durable substance, **the fort remained impenetrable, despite years of enemy fire and violent storms.** It once helped guard St. Augustine from pirate raids. Later, supporters of the American Revolution were locked away in its dank and creepy dungeons.

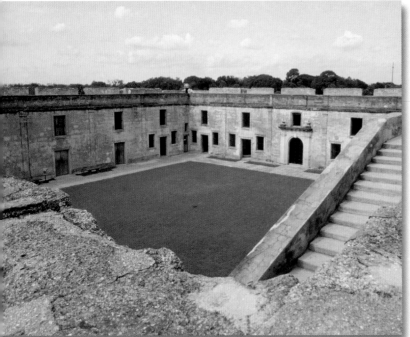

Castillo de San Marcos has served a number of nations in its history, but it was never taken by military force—control was passed by treaty.

Key West

Located at **THE SOUTHERNMOST TIP OF THE FLORIDA KEYS,** Key West has long been famous as **one of America's top destinations for fun-and-sun vacations** (that is, once hurricane season passes). Storms aside, Key West has few highs or lows—just steady sunshine, perfect for relaxing on the beach and soaking up some sun. A daily treat, Key West's Mallory Square hosts the Sunset Celebration each evening, with food vendors, fire-eaters, tightrope walkers, and arts and crafts exhibits.

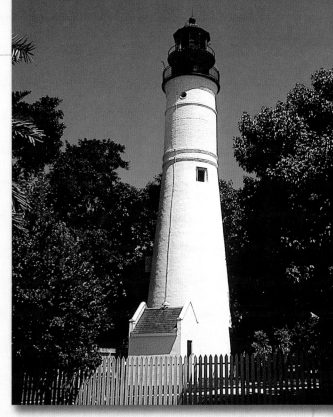

The historic Key West Lighthouse, built in 1847, offers spectacular views of the beach.

Interestingly, Key West, which has also been called "Margaritaville" and the "Conch Republic," didn't always have a reputation for laid-back living. **The name "Key West" is a corruption of *Cayo Hueso,* meaning "Island of Bones."** Early Spanish explorers bestowed this haunting name after landing and finding the beach littered with human remains.

Gulf Shores

The fine, white sand on the beaches of Gulf Shores on the Alabama Gulf Coast must have inspired the phrase "white sugar sand." There are 32 miles of white sand beaches, and the temperate water is warm enough to swim in eight months of the year. The towns of Gulf Shores and Orange Beach have plenty of accommodations lining the shore and are filled with family fun such as miniature golf, water parks, marinas, and ice-cream parlors.

Gulf State Park has 2.5 miles of uncrowded dunes dotted by sea oats, a tall grass. In spring and fall, this area is filled with migrating birds, especially around historic Fort Morgan, which is the first and last landfall for migrating songbirds. Every April and October, skilled bird banders arrive and stay for two weeks, gently catching and banding birds such as indigo buntings, warblers, and scarlet tanagers.

Gulf Islands National Seashore

From above, the Gulf Islands National Seashore looks like a sandy string of pearls off the coasts of Florida and Mississippi. Along the water are miles of snow-white beaches, bayous, saltwater marshes, maritime forests, barrier islands, and nature trails. **OF THE MORE THAN 135,000 ACRES OF NATIONAL SEASHORE, 80 PERCENT OF THE PARK IS UNDERWATER.**

The environment is diverse, but visitors to the seashore usually focus on the beach. **Miles and miles of white powdery sand extend into the sparkling water.** Especially intriguing are the barrier islands, notably the Horn Island and Petit Bois Island wilderness areas, each about ten miles out from the Mississippi coast. Camping is permitted anywhere on the islands, but check for closures first if you visit during hurricane season.

Hot Springs National Park

Hot Springs National Park protects 47 different hot springs and their watershed on Hot Springs Mountain, as well as the eight historic bathhouses in the town of Hot Springs, Arkansas. **FOR MORE THAN 200 YEARS, VACATIONERS HAVE COME TO THE WATERS IN BATHHOUSE ROW IN HOPES OF CURING ALL KINDS OF ILLS,** and tourists can still enjoy a soak in several bathhouses.

Take a walk along the Grand Promenade, a landscaped walkway behind Bathhouse Row, to get a glimpse of the protected springs. A number of hiking trails that wind through the Hot Springs Mountain area begin here, including Dead Chief Trail, which leads to an observation tower at the top of the

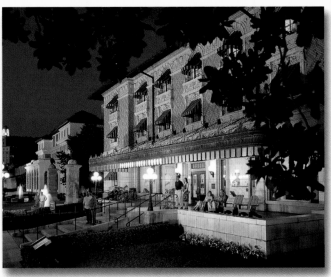

The architectural style and interior details of the Fordyce Bathhouse pay tribute to the "life-giving" waters of the hot springs that flow nearby.

mountain. If the 1.4-mile hike sounds too strenuous, take a trolley from town.

Blanchard Springs Caverns

Blanchard Springs Caverns in north-central Arkansas is the jewel of the Ozarks. This three-level cave system has almost every kind of cave formation: from soda straws to bacon formations to rimstone cave pools. The most famous formation in these caverns is the 70-foot-high joined stalagmite-stalactite called the Giant Column.

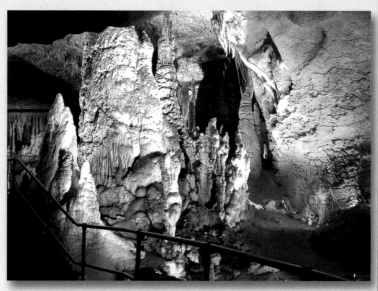

Visitors can choose from three scenic trails through Blanchard Springs Caverns. The Dripstone Trail is a one-hour trail around the upper level that is stroller- and wheelchair-accessible. The Discovery Trail is a longer section that winds through the middle level. If you're looking for a challenge, the four-hour Wild Cave Tour is an introduction to spelunking requiring athleticism, endurance, and equipment available by reservation only.

Mardi Gras World

While the spectacular floats and the sequined-and-feathered costumes of Mardi Gras would appeal to just about any child, most parents find the parade and the associated debauchery a bit too racy for the kids. So, to get into the Mardi Gras spirit year-round, visit Mardi Gras World, **WHERE 80 PERCENT OF THE FLOATS THAT TRAVEL DOWN THE NEW ORLEANS, LOUISIANA, STREETS DURING CARNIVAL SEASON ARE DESIGNED AND BUILT.**

It's an actual working studio, where artists sketch, sculpt, and paint the colorful figures and floats for the next year's parades. You'll tour enormous warehouses filled with floats and **LEARN ABOUT THE TRADITIONS SURROUNDING MARDI GRAS PARADES, BALLS, AND MUSIC.** You'll also get the inside scoop on float designing and building. There's a chest full of bejeweled costumes for children to try on, and king cake, a tasty Mardi Gras tradition, is served at the end of the tour.

Plantation Alley

Louisiana's Great River Road is also known as Plantation Alley. There, 30 antebellum mansions and 10 other ancient properties sit regally on bluffs overlooking the Mississippi River. All are open for tours or have been converted into hotels or bed-and-breakfast inns. Along the Great River Road, they provide a dignified procession of antebellum architecture surrounded by sugarcane fields and pecan groves.

Take in the atmosphere on your way to see the plantations. Start in Baton Rouge, and drive south. Instead of taking I-10 straight to New Orleans, travel along the Mississippi River toward Plaquemine, White Castle, and Donaldsonville. Visits to the gracious mansions of the old South still mean magnolia-perfumed passages through formal gardens and expansive homes that have terrific river views.

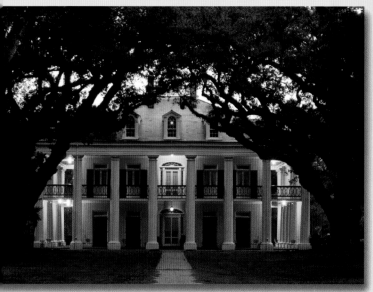

Celina Roman called her home Bon Sejour ("pleasant sojourn"). But travelers on the Mississippi called it "Oak Alley," impressed by the mighty trees, and the name has stuck to this day.

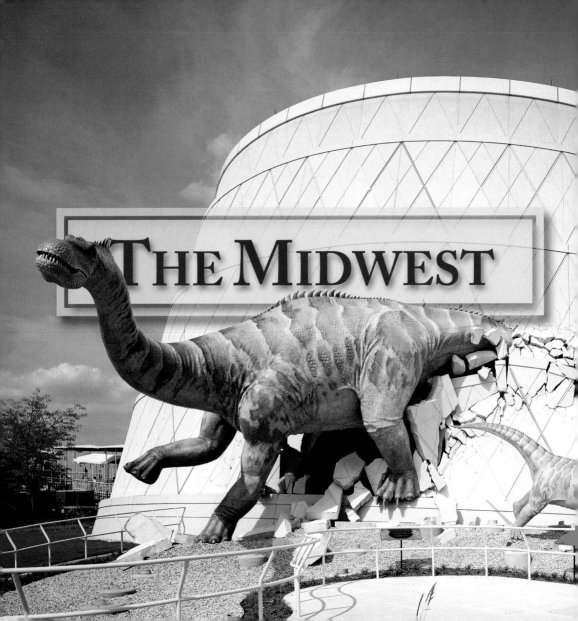

THE MIDWEST

Rock and Roll Hall of Fame and Museum

Rock 'n' roll lives on today, more than a half-century after its birth. One reason is Cleveland's Rock and Roll Hall of Fame and Museum. Designed by architect I. M. Pei, **the building expresses the raw power of rock music.** The

geometric and cantilevered forms are often compared to a turntable. The striking building and its 162-foot tower anchor Cleveland's North Coast Harbor.

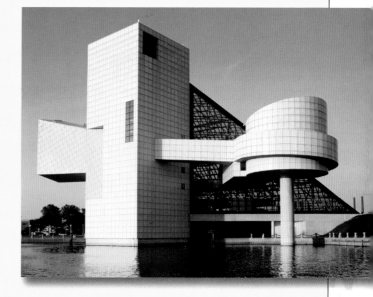

The hall began operation in 1986 with the ceremonial induction of its first class of rock stars: Chuck Berry, Elvis Presley, Little Richard, Sam Cooke, the Everly Brothers, and Buddy Holly, among others. **It holds a collection of rock memorabilia and rarities and features groundbreaking exhibitions.** Celebrity sightings are frequent, so put on your blue suede shoes and rock, rock, rock!

Cedar Point Amusement Park

Cedar Point is a 364-acre peninsula in Sandusky, Ohio, that first became popular in 1870 as a bathing beach. Today, it is home to the **WORLD'S LARGEST COLLECTION OF RIDES AND ROLLER COASTERS, AND MANY CONSIDER IT ONE OF THE BEST AMUSEMENT PARKS ON THE PLANET.** Critics rave about it, roller-coaster enthusiasts love it, and families enjoy its full range of theme park entertainment.

Besides its menu of heart-pounding coasters (one of which hits 120 miles per hour!) and various other amusement park rides, Cedar Point boasts:

- a water park
- resort hotels
- a luxury RV campground
- an entertainment complex
- live shows
- kids' areas, rides, and shows

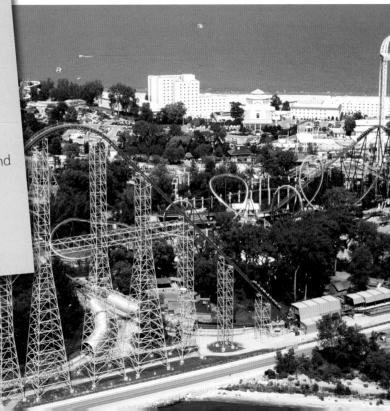

Cuyahoga Valley National Park

Cuyahoga Valley National Park, which lies between Akron and Cleveland in Ohio, may be the park service's most urban-friendly environment. The park **preserves 33,000 acres along the Cuyahoga River, called "crooked river" by the Mohawk Indians.** The forests, plains, streams, and ravines here contain an astonishing array of fauna and flora, not to mention a variety of recreational opportunities.

The park has almost no roads, but you can explore plenty of bike and hiking paths. **A perennial favorite is the 20-mile Towpath Trail.** Don't miss the cultural exhibits and events, such as historic displays and outdoor concerts.

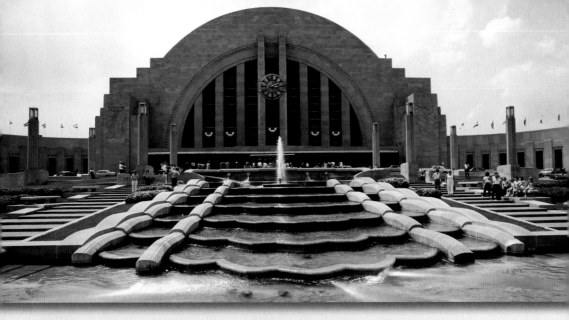

The Cincinnati Museum Center

The Cincinnati Museum Center **AT UNION TERMINAL IS AN ART DECO MASTERWORK.** Union Terminal opened during the depths of the Great Depression; this gem debuted in 1933. The building was an architectural icon from the beginning, but after train travel dwindled, the terminal was declared a National Historic Landmark in 1977 and stood empty for more than a decade. The beautiful terminal today is home to five major Cincinnati cultural organizations: the Cincinnati History Museum, the Duke Energy Children's Museum, the Museum of Natural History & Science, the Robert D. Lindner Family OMNIMAX Theater, and the Cincinnati History Library and Archives. Because of ongoing renovations beginning 2016, check for closures before you visit.

The National Underground Railroad Freedom Center

Cincinnati was once a major hub of Underground Railroad activity due to its location on the Ohio River. In the 1800s, the city offered refuge to thousands fleeing slavery in the South. The National Underground Railroad Freedom Center **showcases the importance and relevance of human struggles for freedom** in the United States and around the world, in the past and the present.

Everyday Freedom Heroes is just one of the exhibits you'll find at the Freedom Center, which opened its doors in 2004. The center has three buildings that symbolize the cornerstones of freedom: courage, cooperation, and perseverance.

Local educators helped design many of the exhibits to parallel the curricula of area schools. **THE EXHIBITS ARE CHILD-FRIENDLY AND USE STORYTELLING, ROLE-PLAYING, AND HANDS-ON ACTIVITIES TO ENGAGE YOUNG VISITORS.** A wide range of educational programs take place most weekends, including concerts, lectures, and workshops.

Serpent Mound

Serpent Mound, **A WINDING MOUND OF EARTH A QUARTER-MILE LONG AND THREE FEET HIGH,** remains a mystery despite all the science that has been thrown at it. There are many Native American mounds in North America, but Serpent Mound State Memorial, near Peebles, Ohio, is **the largest prehistoric animal effigy, or image, in the world.**

Serpent Mound uncoils in seven curved stages along a bluff over Rush Creek and is completed by an oval that appears to represent the head and mouth of the serpent. Some believe that the serpent's head points toward the summer solstice. Park archaeologists say the builders carefully planned the serpent's form, outlined it with stones, and then covered it with baskets of earth.

Pictured Rocks National Lakeshore

Pictured Rocks National Lakeshore spans 42 miles of Lake Superior shoreline, covering **more than 73,000 acres of Michigan's Upper Peninsula.** It is a preserve of **SPECTACULAR SCENERY AND CASCADING SAND DUNES.** The most photographed area is the five miles of "perched" dunes and sparse jack pine forests of the Grand Sable Dunes.

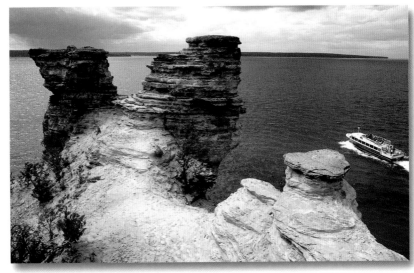

Despite the remote location, almost 400,000 visitors each year seek out Pictured Rocks for hunting, fishing, hiking, and boating in summer and spring. In fall and winter, snowshoeing, snowmobiling, ice fishing, and cross-country skiing are popular. You can hike to astonishing waterfalls, including Spray Falls, Alger Falls, Wagner Falls, Chapel Falls, and Laughing Whitefish Falls, which has a dramatic 100-foot drop.

Isle Royale National Park

Isle Royale, which was carved and compressed by glaciers, is **the largest island on Lake Superior.** It exists in splendid isolation—you can only get to the island by boat, seaplane, or ferry. Together with numerous smaller islands it makes up Isle Royale National Park, located off of Michigan's Upper Peninsula. Only about 20,000 people visit this remote, tranquil setting each year.

THERE ARE NO ROADS ON THE ISLAND, BUT YOU CAN CHOOSE ROUTES FROM AMONG THE 165 MILES OF HIKING TRAILS. The most striking hike is Greenstone Ridge, a trail more than 40 miles long along a basalt flow that was formed by lava and tinted green by copper. Diving for shipwrecks is another favorite activity—there are more than ten major wrecks below the surface of the lake.

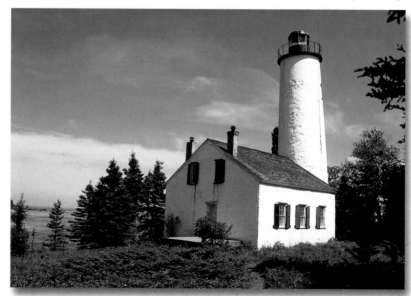

The Rock Harbor Lighthouse at the northeast end of Isle Royale was built in 1855.

Mackinac Bridge

The mighty Mackinac Bridge straddles the Straits of Mackinac between Lake Michigan and Lake Huron to connect Michigan's upper and lower peninsulas. Pronounced *MA keh nah*, Mackinac is short for Michilimackinac, which was an Indian territory on what is now Mackinac Island. Measured the conventional way, between towers, Mackinac Bridge is the world's ninth-longest suspension bridge. Measured by impact, it ranks right up there with the Golden Gate Bridge. No wonder Michiganders call it "Mighty Mac."

MIGHTY MAC MEASUREMENTS

Total length of bridge	26,372 feet
Length of suspended section	8,614 feet
Length of main span between main towers	3,800 feet
Height of main tower above water	552 feet
Total length of wire in main cables	42,000 miles
Total concrete in bridge	466,300 cubic yards
Total weight of bridge	1,024,500 tons

Henry Ford Museum and Greenfield Village

The eclectic Henry Ford Museum in Dearborn, Michigan, was founded in 1929 by the Ford family **PRIMARILY AS A PLACE TO HOUSE INVENTOR HENRY FORD'S IMMENSE PERSONAL COLLECTION OF AMERICANA.** It also serves to honor America's technological ingenuity and innovative thinking. Instead of focusing on a single time period or location, the museum spans 350 years of American history.

Both the museum and neighboring Greenfield Village reflect the quirks of their eccentric founder, who collected whatever tickled his fancy. The collection is so diverse that it's wise to study the visitor's guide and pick out some of the museum's unique treasures for a closer look.

As you might imagine, automobiles are well represented here with dozens of cars of various shapes and sizes, as well as an exhibit that explains how the car influenced everyday life in the 20th century. You'll also find on display old racecars, the ill-fated Edsel that was named after Henry Ford's son, and a 1953 Stout Scarab that was billed as a living room on wheels. Historical highlights include:

- The Birmingham bus on which Rosa Parks refused to give up her seat
- The presidential limousine that carried John F. Kennedy when he was assassinated
- Inventor Thomas Edison's last breath, which was captured in a test tube

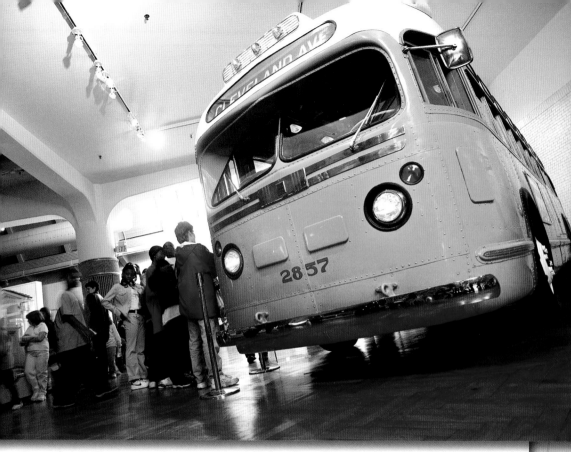

Greenfield Village contains more than 80 historic structures, including the bike shop where the Wright brothers designed and built their first airplane. Visitors can also tour the room where Noah Webster wrote the first American dictionary. Ford's admiration of Edison is especially apparent here, as he relocated or re-created many of the buildings in which Edison lived and worked.

Children's Museum of Indianapolis

THIS WORLD-CLASS COLLECTION OF HANDS-ON FUN MAKES UP THE LARGEST CHILDREN'S MUSEUM IN THE WORLD. Its exhibits continue to amaze and entertain local children, as well as families who make the trek to the city just to visit this renowned attraction.

The astonishing **Fireworks of Glass,** a blown-glass exhibit in the five-story atrium, is **the largest permanent sculpture that artist Dale Chihuly has ever created.** The 43-foot-tall glass tower rises above what appears to be a floating glass ceiling. A number of innovative hands-on activities are offered to promote an appreciation of the work that went into the sculpture. Children can create

The amazing Fireworks of Glass, *sculptor Dale Chihuly's innovative creation, is made up of 3,200 individually blown pieces of brilliantly colored glass.*

their own sculptures using colorful plastic shapes or view a film at the museum's planetarium that demonstrates the sights and sounds of glassblowing.

The popular **Dinosphere** exhibit IMMERSES CHILDREN IN THE CRETACEOUS PERIOD of more than 65 million years ago and lets them examine actual fossils and fossilized bones. Kids can learn about the preparation of fossils in the Paleo Prep Lab, where they can watch real paleontologists at work.

The **Playscape Preschool Gallery**

is DESIGNED SPECIFICALLY FOR KIDS FIVE AND YOUNGER. Little ones can splash around at the water table and play in the sand dome, and they can plant flowers in the garden while a friendly scarecrow looks on. Story-telling sessions are also part of the fun. And everyone enjoys the Carousel Wishes and Dreams Gallery, where families can ride a real carousel under a starry sky, explore the inside of a giant kaleidoscope, and navigate a mirror maze.

The largest artifact in the Children's Museum is also a fun ride. The 1900s-era carousel, located in the Carousel Wishes and Dreams Gallery, is one of the few surviving wooden carousels left in the United States. It was originally part of an Indianapolis amusement park.

Conner Prairie

At Conner Prairie in Fishers, Indiana, you can travel back in time to the 1800s to experience firsthand how everyday life has changed during the past two centuries. Known especially for its **ENTERTAINING, YET AUTHENTIC, PRESENTATION OF THE PAST,** this living-history museum has different areas replete with costumed interpreters and hands-on experiences that bring the past to life.

Prairietown is a restored and re-created 1836 Indiana frontier village. At the 1816 Lenape Indian Camp, you can enter a Native American wigwam, learn to

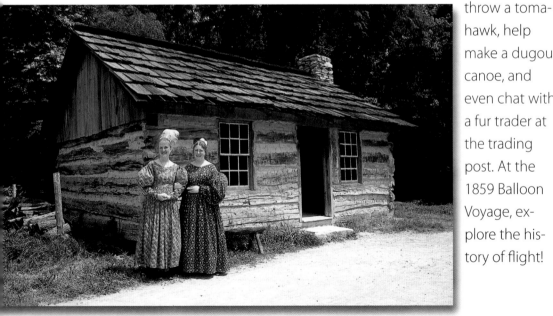

throw a tomahawk, help make a dugout canoe, and even chat with a fur trader at the trading post. At the 1859 Balloon Voyage, explore the history of flight!

The Magnificent Mile

Chicago's Magnificent Mile **stretches along North Michigan Avenue between Oak Street and the Chicago River.** The 100-story John Hancock Center may be the most prominent building on this stretch, but don't overlook the other architectural gems. **THE TRIBUNE TOWER, WITH ITS DECORATIVE BUTTRESSES AND GOTHIC DESIGN, WAS ONCE CALLED "THE MOST BEAUTIFUL AND EYE-CATCHING BUILDING IN THE WORLD."** Park Tower, a 67-story skyscraper, preserves the facade of the landmark 1917 Perkins, Fellows, and Hamilton Studio. And there's the distinctive Old Water Tower. It was built in 1869 and was one of the few buildings to survive the Great Chicago Fire of 1871. Today it stands near Water Tower Place, a high-rise shopping mall with more than 100 specialty shops.

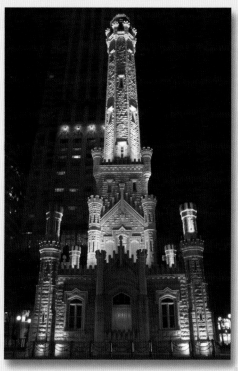

The Old Water Tower was one of the only buildings to survive the Great Chicago Fire.

Which brings us to the truly magnificent part of the Magnificent Mile: Bloomingdale's, Louis Vuitton, Chanel, Gucci, Lalique, Ralph Lauren, Neiman Marcus, Giorgio Armani, and Hugo Boss. Be sure to bring your credit card when you visit.

Millennium Park

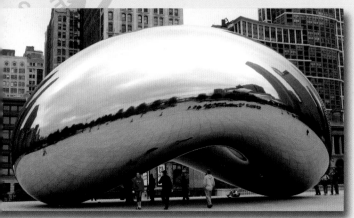

What was once an eyesore of decaying railroad tracks and parking lots near Chicago's lakefront is now **A STUNNING 24.5-ACRE URBAN JEWEL** called Millennium Park. Among its major attractions are two extraordinary pieces of public art that have captivated visitors. One is **a highly reflective 110-ton polished steel sculpture officially named *Cloud Gate* but affectionately called "The Bean."** Visitors can wander under and around it to see the park and cityscape reflected in its curves. The other, **the Crown Fountain, is a reflecting pool flanked by two 50-foot towers onto which close-up images of Chicagoans are projected.** The lips on the faces purse, and water sprays from them, making the ever-changing faces resemble giant gargoyles. A large outdoor ice-skating rink is open throughout the winter months.

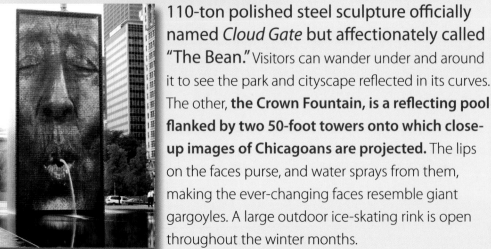

Wrigley Field

The Chicago Cubs and their fans prize their quaint home ballpark, Wrigley Field. Wrigley was built in 1914 for $250,000 and featured baseball's first permanent

concession stand. It's the **second-oldest major league park,** next to Fenway Park in Boston. And in 1988, it became the last MLB venue to host night games when lights were finally added to the park.

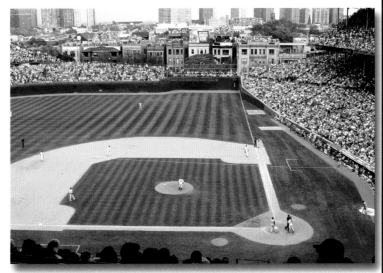

THE "FRIENDLY CONFINES" OF WRIGLEY ARE KNOWN FOR THEIR ECCENTRICITIES. Fickle winds can change the outcome of the game: Watch for home runs when the breeze blows toward Lake Michigan. And hard-hit balls always have a chance of getting stuck in the ivy-covered outfield walls. Wrigley's capacity is relatively small—a mere 41,160—but additional fans can pay to see the game from rooftop facilities across Sheffield and Waveland avenues.

The Art Institute of Chicago

The Art Institute of Chicago **boasts more than 300,000 works,** including treasured paintings, such as Edward Hopper's "Nighthawks," Grant Wood's "American Gothic," and Georges Seurat's "A Sunday on La Grand Jatte." **IT IS ONE OF THE MOST ASTOUNDING ART MUSEUMS IN THE WORLD,** with an impressive permanent collection and featured exhibits throughout the year. The striking Italian-Renaissance architecture gives the building a distinctive look among the skyscrapers of downtown Chicago.

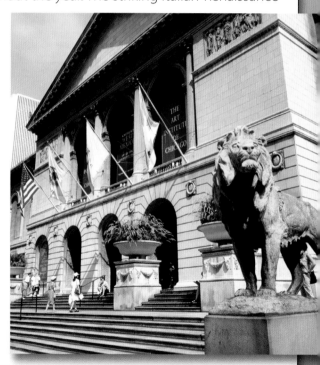

The Art Institute's collections of early Italian, Dutch, Flemish, and Spanish works include paintings by El Greco, Hals, Rembrandt, and Goya. Its comprehensive Impressionist collection features **one of the largest collections of Monet's works.** The museum is also renowned for its arms and armor; Chinese art; prints and drawings; and decorative arts, such as porcelains, textiles, and glass.

Museum of Science and Industry

This innovative Chicago museum is **ONE OF THE BEST IN THE COUNTRY AND FEATURES A WIDE VARIETY OF THOROUGHLY ENGAGING EXHIBITS FOR FAMILY MEMBERS OF EVERY AGE.** You can climb through the cramped confines of a real World War II German U-boat to get a feel for life undersea, descend into a coal mine like a real miner, and operate a series of 12 toy-assembling robots that can produce 300 gravitron toys per hour.

Peek into the world of miniatures at The Great Train Story, which features 34 model trains racing along an elaborate cross-country set that starts at Seattle Harbor and ends in Chicago. The astonishing Fairy Castle, designed by Colleen Moore, is a wonderland of miniature treasures from around the world. And speaking of little

things, the Chick Hatchery is another favorite. Every day, visitors witness chicks carefully pecking their way out of their shells.

It was once the terror of the Atlantic Ocean during World War II. This authentic U-505 German submarine was captured off the coast of Africa in 1944, and it is now on exhibit at the Museum of Science and Industry.

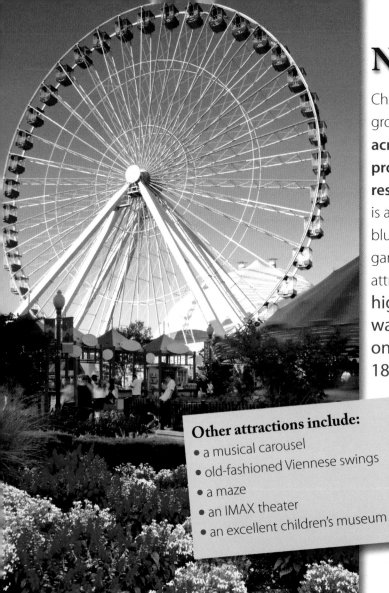

Navy Pier

Chicago's lakefront playground is **a fabulous 50-acre complex of parks, promenades, shops, and restaurants.** Much of it really is a pier overhanging the blue waters of Lake Michigan. Navy Pier's most visible attraction is a **150-foot-high Ferris wheel that was modeled after the one built for Chicago's 1893 World Columbian Exposition.** It's a great way to get a bird's-eye view of the area and the city's spectacular skyline.

Other attractions include:
- a musical carousel
- old-fashioned Viennese swings
- a maze
- an IMAX theater
- an excellent children's museum

Captain Frederick Pabst Mansion

The front of the Pabst Mansion in Milwaukee is a looming gate reminiscent of a Renaissance fort. The heavy, square architecture was patterned after the 16th-century palaces and fortresses in Flanders, Belgium. Today, Pabst Mansion is called **"the Finest Flemish Renaissance Revival Mansion in America."**

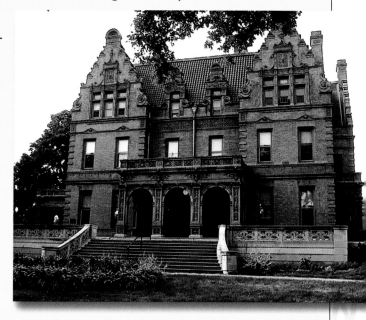

This magnificent home was the 1892 creation of the prolific Frederick Pabst, whose many titles included sea captain, beer baron, real estate mogul, philanthropist, and patron of the arts. Not only does the architecture harken back to the Renaissance but the custom furniture and art do, too. **IN ITS TIME, THE HOUSE WAS A HIGH-TECH MARVEL FEATURING ELECTRICITY, PLUMBING FOR 9 BATHROOMS, AND 16 THERMOSTATS.** The foyer and massive wood-carved Grand Stair Hall are breathtaking.

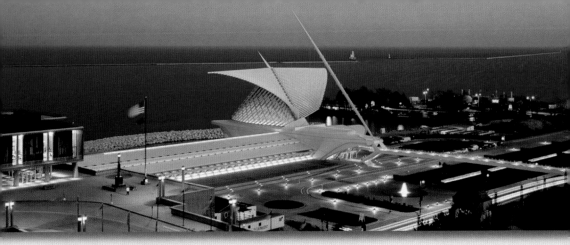

Milwaukee Art Museum

When we think of Milwaukee, beer, bratwurst, and Brewers baseball come to mind.
But beyond the bars and ballpark walls lies an increasingly sophisticated city with
AN AMAZING, WORLD-CLASS ART MUSEUM.

In 1957, the Milwaukee Art Center opened its Eero Saarinen Building, named after
the architect who designed it. The building itself is a work of art. It has a float-
ing cruciform shape with four large wings that cantilever in space. In 2001, the
Quadracci Pavilion, designed by Santiago Calatrava, was added to the building.
The prominent pavilion **has attracted worldwide attention for its light, lacy
facade that curves like a sail,** despite being built from 20,000 cubic yards of
concrete. The museum hosts a masterful collection of more than 20,000 pieces,
from ancient artifacts to modern masterpieces. Works by Degas, Homer, Monet,
O'Keeffe, Picasso, Rodin, Toulouse-Latrec, and Warhol are just some of its treasures.

Wisconsin Dells

Nearly two-dozen water parks lure families to the Dells in south-central Wisconsin year-round: It's **considered to be the water park capital of the world.** Many of them are themed—pirates, King Arthur, the lost world of Atlantis—and each one tries to outdo its neighbor with more lavish rides, bigger splash-and-play pools, and longer and faster waterslides.

The Dells was **a popular family vacation spot** long before the first water park opened its gates. Visitors initially came to take boat tours through the **UNUSUAL SANDSTONE CLIFFS ALONG THE WISCONSIN RIVER.** In the mid-1950s, "Ducks"—World War II water/land vehicles once used for beach invasions—were introduced to the Dells and used for tours. A flashy water-ski show also debuted. Both the Duck tours and the water show are still popular today, but the water parks have become the area's biggest draw.

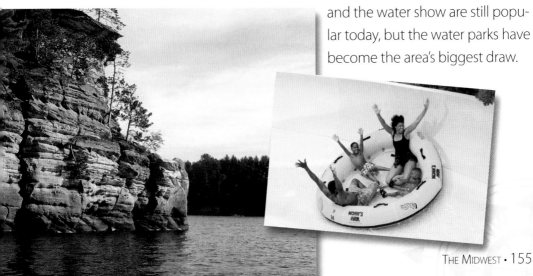

Apostle Islands National Lakeshore

The 21 islands of Apostle Islands National Lakeshore dot the coast of northern Wisconsin just off Bayfield Peninsula. The popular Madeline Island is the largest of the group and the only one that permits commercial growth. **Nesting bald eagles at Bay State Park** are this island's main attraction.

Winter brings cross-country skiers and ice fishers to the islands. During warmer weather, visitors enjoy hiking, picnicking, scuba diving, swimming, hunting, fishing, excursion cruises, kayaking, camping, and sailing. Once past Madeline Island, take in the beauty of the sandscapes, sea caves, and waterfalls of the Lake Superior lakeshore. There are woods of hemlock; white pine; and northern hardwood and pristine old-growth forests on Devils, Raspberry, Outer, and Sand islands. Deer and beavers are common on the islands, as are black bears, mink, muskrat, otters, red foxes, and snowshoe hares.

Taliesin

Taliesin is regarded as **A PRIME EXAMPLE OF FRANK LLOYD WRIGHT'S ORGANIC ARCHITECTURE.** The house is located in Spring Green, Wisconsin, an hour's drive from Madison. Wright built the house in the valley settled by his Welsh ancestors and named it after the Welsh bard Taliesin. Wright's technique of building the house from native limestone made it look organic, as though the house was part of the hill on which it was built. In 1976, Taliesin was recognized as a National Historic Landmark.

Today, **tours of Taliesin begin at the Frank Lloyd Wright Visitor Center, which is a part of the only Wright-designed freestanding restaurant.** On the tour, you'll see many structures Wright built on the 600-acre estate: the Romeo and Juliet Windmill Tower, Hillside Home School, Tan-y-deri, and Midway Barns.

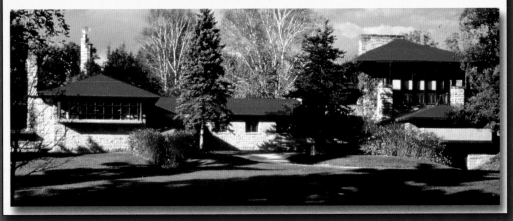

Door County

The long, finger-shaped peninsula that separates the main body of Lake Michigan from the city of Green Bay, Wisconsin, is called Door County. It is **KNOWN FOR ITS QUIET BEACHES, PICTURESQUE TOWNS, HISTORIC LIGHTHOUSES, AND SCENIC FARMS.** Scandinavians settled here in the 1850s, and their influence is evident in the delicious food specialties offered throughout the region, such as Icelandic pancakes with lingonberry syrup and skorpa, a sweetly spiced Swedish toast.

Fish boils are a tradition you won't want to miss: They date back to when Door County was populated by settlers and lumberjacks. Today's fish boils consist of fresh whitefish steaks cooked with onions and potatoes in a huge pot over an open fire. **The dramatic flare-up, or "overboil," is a sure sign that dinner is ready.**

The Boundary Waters Canoe Area Wilderness

The Boundary Waters Canoe Area Wilderness is **the busiest wilderness area in the United States.** More than 200,000 people visit the Boundary Waters each year. The vast size (more than one million acres) of the preserve and its beautiful terrain are a draw for tourists.

The Boundary Waters **stretch along almost 150 miles of the Canadian border in northeastern Minnesota.** The region is a mass of marshes, lakes, and bogs on terrain once raked by glaciers at the edge of the Canadian Shield. Waterfalls plunge off cliffs, and you can catch a glimpse of native wildlife, such as otters, deer, moose, beavers, ducks, loons, osprey, and bald eagles. The wilderness is perfect for canoeing (with 1,200 miles of canoe routes), fishing, and camping.

Voyageurs National Park

At Voyageurs National Park, it helps to know your way around canoes and other watercraft. Voyageurs is **THE ONLY NATIONAL PARK IN THE UNITED STATES THAT HAS NO ROADS; THE PARK IS ACCESSIBLE ONLY BY WATERWAY.** And that's perfectly okay for the quarter-million visitors who explore the park's nearly 220,000 acres each year.

Voyageurs extends along the southern edge of the great Canadian Shield, also called the Laurentian Plateau, an enormous stretch of North America that includes most of Canada and parts of Minnesota, Wisconsin, Michigan, and northern New York. Voyageurs lies in Minnesota, close to International Falls. Fifty-five miles of the park run along the U.S.-Canadian border. **The northern parts of the park are tundra; farther south are immense forests of pine and hardwoods, swamps, bogs, lakes, and beaver dams.** Four lakes, Kabetogama, Namakan, Rainy, and Sand Point, cover almost 40 percent of Voyageurs.

Rock formations rise in Voyageurs near the edge of the Canadian Shield. These ancient formations of exposed Precambrian rock were scoured by glaciers, which scraped the rocks into rugged shapes. A thin layer of topsoil that is sufficient for tree growth now covers some areas, including the park's North Woods. But the most treasured wooded site in Voyageurs is the 75,000-acre Kabetogama Penin-sula, a vast forest interspersed with hills, swamps, and small lakes. You can travel to Kabetogama Peninsula and the other islands or shoreline of the park by watercraft in warm weather or by skis, snowshoes, or snowmobile in winter.

Sculpture Garden and Walker Art Center

It's hard to believe, but **a hotbed of contemporary art in the United States** is a garden in downtown Minneapolis. The Minneapolis Sculpture Garden, along with the Walker Art Center, contains fine examples of modern art.

Especially in warm weather, a lunch hour in the garden can mean eating egg salad on rye beside ***Spoonbridge and Cherry,*** **which is a sculpture-bridge of a humongous spoon holding a gigantic cherry.** Then take a leisurely stroll over to James Turrell's "Sky Pesher." The installation is approached through an underground

tunnel that leads visitors to a room with a 16-square-foot opening at the top of its curved white ceiling. "Sky Pesher" uses lighting to create an illusion that's said to "bring the sky down."

Amana Colonies

The Amana Colonies made up **A HISTORIC UTOPIAN SOCIETY IN THE GENTLY ROLLING HILLS OF IOWA'S RIVER VALLEY.** Established shortly before the Civil War by German immigrants of the Community of True Inspiration sect, the colonies today are on the National Park Service National Register of Historic Places.

Blankets and fabric have been produced at the Amana Woolen Mill since 1857, despite structure damage caused by fires, floods, and high winds.

The Amana communities encompass 20,000 acres and 31 historic places. They were **one of the world's longest active communal societies, lasting from 1855 to 1932.** Hundreds of buildings were once part of the communities, and almost 500 have survived. Probably the best place for visitors to start, however, is the Museum of Amana History, which helps explain what the communities' religionists called "the Great Change" away from shared life. The Amana Church remains pivotal in the communities: Residents still attend services and live their lives infused by their faith.

Bridges of Madison County

Madison County, Iowa, used to be a typical Midwestern farm area. Less than an hour south of Des Moines, the county was notable as the birthplace of John Wayne, for the home of the 18-acre Madison County Historical Society building, and for its rustic covered bridges. Then Robert James Waller wrote the best-selling novel, *The Bridges of Madison County*.

The Holliwell Bridge is one of the five original bridges still standing in Madison County.

Madison County's covered bridges became such a tourist draw that **THE COUNTY LOOKED INTO BUILDING REPRODUCTIONS OF LOST COVERED BRIDGES.**

Madison County at one time tallied 19 picturesque covered bridges; today **just five of the original bridges survive, and all are on the National Register of Historic Places.** Although Waller's book tells a romantic tale, the bridges' origins were quite practical: The Madison County Board of Supervisors ordered that they be covered to preserve their large flooring timbers, which were more expensive than the lumber used to cover the bridges' sides and roofs.

Branson

Branson, Missouri, was a quiet town until the Presley family (no relation to Elvis) began performing at Branson's Underground Theatre (now called Presley's Jubilee Theatre) in 1963. Soon other music acts crowded the venues along Highway 76. A building boom followed, and the Branson Strip was born.

The town has **A POPULATION OF JUST 11,000, BUT IT GREETS SEVEN MILLION VISITORS EACH YEAR.** Branson's theaters offer acts from country favorites Mel Tillis and the Gatlin Brothers to the Acrobats of China and Russian comic Yakov Smirnov; in all, there are 46 music theaters and more seats than there are on Broadway in New York.

SILVER DOLLAR CITY

Most families visiting Branson spend at least one day at Silver Dollar City, an amusement park based on 1880s Ozark Mountain life. The park offers traditional Ozark food, music, and crafts along with water rides, thrill rides, roller coasters, and rides for younger kids.

The Gateway Arch

The soaring Gateway Arch in St. Louis is the **TALLEST MONUMENT IN THE NATION.** This graceful 630-foot-high stainless-steel structure commemorates the city's history and the thousands of pioneers who stopped here to rest and replenish their provisions before continuing west. Visitors can take a tram up the Arch to an observation room for views of the city, the Mississippi River, southern Illinois, and the vast plains stretching out into the distance. The Museum of Westward Expansion is located at the base of the monument and features exhibits about the exploration of the West and noteworthy people who formed its history, including Lewis and Clark, the Plains Indians, and the Buffalo Soldiers.

The Magic House

This three-story Victorian house in St. Louis is packed with hands-on learning disguised as fun. *U.S. Family Travel Guide* and *FamilyFun* magazines have ranked The Magic House, St. Louis Children's Museum as one of the top family destinations in the country. Most of the more than 100 exhibits here encourage children to touch, poke, push, pull, or play.

Among other educational diversions, kids can:

- Glide down a three-story slide
- Record their own music
- Become news anchors on the KIDS-TV news station
- Lift themselves off the ground with pulley power
- Change their shadows into a multitude of colors
- Tap out messages in Morse code

Very impressive! First Impressions, *an exhibit at The Magic House, is one of the largest movable art sculptures in the United States. It stands eight feet tall and is made up of 75,000 plastic rods.*

Kaleidoscope

Hallmark Cards, Inc., created an art studio for children right next door to its visitors center in Kansas City, Missouri. Called Kaleidoscope, it's **AN 8,000-SQUARE-FOOT SPACE DIVIDED INTO VARIOUS COLORFUL THEME AREAS WITH ALL KINDS OF ART SUPPLIES AND CREATIVE MATERIALS.**

Children need only bring their imaginations and willingness to create. Ribbons, papers, melted crayons, cutout shapes, and **all kinds of other craft materials are provided.** In one part of the room, children color a plain piece of cardboard that is then cut into a puzzle by a special device while they watch. Another area is decorated in an outer-space motif. It is lit by black light so the ink of the fluorescent markers glows as children color. Every day brings new projects and supplies (castoffs from the Hallmark studios).

Dodge City

THE LAWLESS, GUN-SLINGING REPUTATION OF THIS KANSAS FRONTIER TOWN WAS WELL DESERVED. Beginning in the 1860s, Dodge City drew all sorts of people who traveled along the Santa Fe Trail (and later the Atchison, Topeka, and Santa Fe Railroad). **Gambling and prostitution ran rampant, and the term "red light district" was coined here** after the train masters who would take their red caboose lanterns out with them. With no law in town, disagreements often led to sudden death.

Today Dodge City celebrates its past. Re-creations of Front Street, the Long Branch Saloon, and Boot Hill Cemetery are a reminder of the Old West and its colorful history (the buildings represent Dodge City in 1876). There are also tours of Fort Dodge and the Mueller-Schmidt House Museum (built in 1881, it's the oldest house in Dodge City).

Carhenge

In the small town of Alliance, Nebraska, is the unusual sculpture known as Carhenge. Carhenge is a **REPLICA OF STONEHENGE IN TERMS OF SIZE AND ORIENTATION,** but the story of its origin is a bit different.

As creator Jim Reinders explained, it was just "something to do at our family reunion." Reinders wasn't kidding: **Carhenge was built during a reunion at the family farm in 1987.** Reinders and 35 of his relatives grabbed their backhoes, found a forklift, and worked seven 8-hour days to position the 38 cars, which were painted battleship gray in accordance with Stonehenge's appearance. People were immediately drawn to Carhenge, despite its location four hours from Cheyenne, Wyoming. An estimated 40,000 to 80,000 folks visit each year.

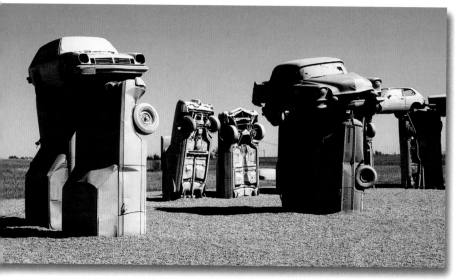

Henry Doorly Zoo

Workers at Omaha, Nebraska's award-winning zoo like to say **THE ANIMALS ROAM FREE AND ITS VISITORS ARE CAPTIVE.** This claim is partially true. In Hubbard Gorilla Valley, a 520-foot-long window-lined tunnel allows visitors to travel into the middle of the three-acre gorilla habitat to observe these majestic creatures. The zoo's orangutans can study their visitors from two 65-foot-high banyan trees. In turn, visitors can view the orangutans from a 70-foot-high platform that is accessible by elevator.

The authentically re-created Lied Jungle exhibit features lush vegetation and fascinating animals that are native to the jungles of three continents. The habitat has waterfalls, cliffs, caves, medicinal plants, giant trees, and about 90 different animal species. The zoo's Desert Dome has viewing areas at two levels: The desert exhibit is in the dome, while Kingdoms of the Night, the world's largest exhibit of nocturnal animals and their habitats, is located beneath the desert level.

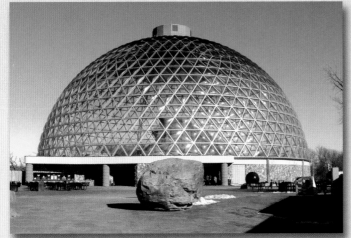

Beneath the Desert Dome at Henry Doorly Zoo you'll find Kingdoms of the Night. The exhibit covers 42,000 square feet and is home to 75 animals.

Chimney Rock and Scotts Bluff National Monument

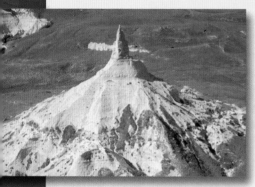

Chimney Rock rises to **A SPIRE ALMOST 325 FEET ABOVE THE NORTH PLATTE RIVER VALLEY** in Nebraska. It can be seen from miles away, so it was the ideal landmark for pioneers traveling the Mormon, California, and Oregon trails. Today, Chimney Rock is a National Historic Site that still marks the place where the plains give way to the Rocky Mountains.

About 45 minutes from Chimney Rock is **Scotts Bluff National Monument,** another important three-trail landmark. The monument is striking for its key features—Scotts Bluff and South Bluff and their dramatic cliffs. The monument also boasts barren badlands between Scotts Bluff and the North Platte River, providing a **SMORGASBORD OF LANDSCAPES IN ITS 3,000 ACRES.** A museum on the national monument grounds houses exhibits about the area's history.

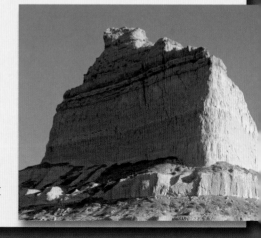

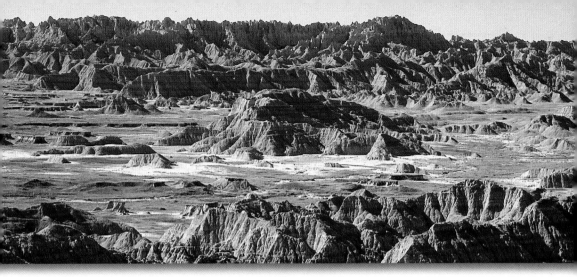

Badlands National Park

Badlands National Park in southwestern South Dakota (about 80 miles east of Rapid City) is 244,000 acres of buttes, pinnacles, and spires. It is **THE LARGEST MIXED GRASS PRAIRIE IN THE UNITED STATES AND RESEMBLES MILES AND MILES OF ETHEREAL MOONSCAPE.**

Strange shapes carved into soft sedimentary rock and volcanic ash dot the landscape of the park. Because the land is so dry, wind and water cause rapid erosion (an average of one inch per year) of the sprawling rock formations. The result is a **rugged terrain unlike any other in the United States.**

Badlands is divided into two separate sections of four units. The most visited unit is the Cedar Pass Area, near Interior, South Dakota. Try to visit the Badlands Wilderness Area Sage Creek Unit, a primitive camping area, as well.

Mount Rushmore

This presidential face-off of monumental proportions is a jaw-dropping feat of art and engineering. Blasted and chiseled out of granite, Mount Rushmore features four presidents: George Washington, Thomas Jefferson, Theodore Roosevelt, and Abraham Lincoln. **THE FACES ON THE 5,725-FOOT-TALL LANDMARK ARE 60 FEET HIGH** and tower over a majestic forest of pine, spruce, birch, and aspen trees in South Dakota's Black Hills.

The herculean effort began in 1927, with sculptor Gutzon Borglum and a team of dedicated South Dakota workers. They **blasted and crafted this shrine to democracy over a 14-year period.** (Borglum's son, Lincoln, finished directing the project after his father died in March 1941.) Borglum chose this particular mountain for his work because of the smooth, homogenous, and durable granite (it erodes just an inch every 10,000 years). He favored the mountain because it dominated the surrounding landscape. He also liked that Mount Rushmore faced southeast, so sunlight would illuminate his masterpiece as much as possible.

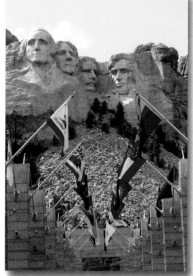

The Avenue of Flags displays the 56 flags of the states and territories of the United States.

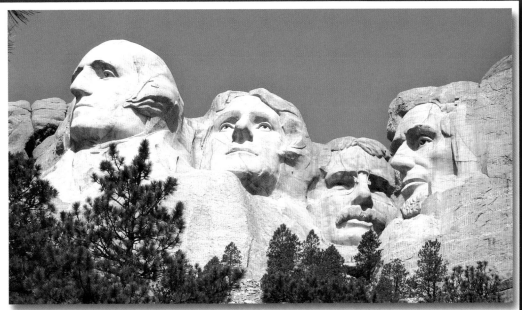

Before you begin walking the half-mile Presidential Trail to get a closer view of the faces, visit **The Lincoln Borglum Museum** to listen to INTERVIEWS WITH MOUNT RUSHMORE'S WORKERS, VIEW HISTORIC FOOTAGE OF THE CARVING PROCESS, AND LEARN MORE ABOUT THE MONUMENT'S SCULPTOR. There is even an exhibit where you can become a worker on Mount Rushmore, "detonating" dynamite charges on the mountain. You can take a ranger-guided walk along the Presidential Trail or travel at your own pace. The Sculptor's Studio features an interesting display of the tools used to carve the mountain. The studio also offers ranger-led discussions about the sculpture's history.

Crazy Horse Memorial

Both the Crazy Horse Memorial's story and its sheer size are amazing. The memorial's completed face of Crazy Horse—87 feet, 6 inches high—is taller than the entire Mount Rushmore monument. When the statue is completed, it will be taller than the Washington Monument and larger than the Sphinx in Egypt.

The memorial's story began in 1939. A group of Lakota Sioux chiefs, insulted by Mount Rushmore, asked sculptor Koczak Ziolkowski to create Crazy Horse. The artist studied Crazy Horse for years and began the mammoth project near Rapid City, South Dakota, in 1946, first sculpting a marble Crazy Horse, scaled 1-to-300 to the final product. Ziolkowski died in 1982, but his family has carried on his vision, finishing Crazy Horse's face in 1998. The sculpture has been privately financed and will be completed…someday.

The Mammoth Site

This treasure trove of fossils in Hot Springs, South Dakota, was discovered in 1974 when excavation for a housing development unearthed the remains of a mammoth. Since then, budding paleontologists and their parents have visited the site to get **HANDS-ON EXPERIENCE IN AN ACTUAL DIG.**

To date, the fossilized skeletons of **more than 50 mammoths have been identified,** along with the remains of a giant short-faced bear, a camel, a llama, a prairie dog, a wolf, fish, and numerous invertebrates. Walkways throughout the excavation afford visitors close-up views of the skulls, ribs, tusks, femurs, and even nearly complete skeletons visible in the mass grave that resulted when these prehistoric animals fell into a sinkhole.

A simulated excavation for junior paleontologists is held daily during the summer months. Children learn excavation techniques and dig up replicas that are buried in a special area next to the actual sinkhole.

Theodore Roosevelt National Park

Part of the expansive North Dakota badlands, Theodore Roosevelt National Park commemorates the conservation policies of the 26th U.S. president. The park **covers more than 70,000 acres, of which 30,000 are wilderness.** It's divided into three units: The South Unit (the most-visited area), Elkhorn Ranch (Theodore Roosevelt's ranch), and the North Unit (70 miles north of the South Unit near the headwaters of the Little Missouri River).

If you hike or ride horseback through the park, **YOU CAN SPEND DAYS OUT OF SIGHT OF CIVILIZATION.** Take a leisurely drive, and stop at the overlooks to view the ragged landscape or tour the restored cow town of Medora. Or, hike the half-mile Wind Canyon Trail to see a remarkable view of the strangely beautiful badlands and the Little Missouri River.

International Peace Garden

Spanning the invisible line where North Dakota becomes Manitoba is the 2,339-acre International Peace Garden. Officials from the United States and Canada dedicated the garden in 1932 after selecting an idyllic spot, cradled in the gentle green wrinkles of the Turtle Mountains between a sea of wheat to the south and woodland to the north. The garden **CONSISTS OF MORE THAN 150,000 FLOWERS, PLANTED ANNUALLY AND SHAPED INTO A DRAMATICALLY BEAUTIFUL LANDSCAPE AMONG TREES AND FOUNTAINS.** Most displays change from year to year, but the traditional arrangements in the shape of the Canadian and United States flags are permanent features.

The monuments to peace include girders from the World Trade Center and seven "Peace Poles"—gifts from Japan inscribed with "May Peace Prevail" in 28 languages. At the garden's center, there is a chapel whose limestone walls are engraved with words of peace. A Carillon Bell Tower chimes periodically.

THE SOUTHWEST

Big Bend National Park

Nicknamed "the last American frontier," Big Bend National Park is in the middle of nowhere—and that's a good thing. It is named for the turn of the Rio Grande along the park's southern boundary in southwest Texas. Surrounded by beautiful, gnarled desert, the heart of Big Bend is the Chisos Mountain Range. Some peaks in the Chisos soar to nearly 8,000 feet in elevation. Cloaked in green forest, the lush mountains are a sharp contrast to the arid surroundings.

Winding through Big Bend, the Rio Grande has carved three of the continent's most striking canyons—Boquillas, Mariscal, and Santa Elena. Rafters are drawn to the waterway, and hikers climb trails that wind through the mountains, with the desert acting as a gateway to the north.

The Alamo and Riverwalk

Texas's most visited site (more than 2.5 million visitors annually), the Alamo, is more modest than its reputation might suggest. But the architecture of this historic mission church, now surrounded by modern downtown San Antonio, is hard to forget.

Spanish missionaries established the Mission San Antonio de Valero in the vicinity of the Alamo in 1718 and worked to convert the local people to Catholicism. **They began building the Alamo in 1724** after a hurricane decimated the original site. The Spanish secularized the mission in 1793. However, it was abandoned before the legendary battle of 1836 broke out.

The missionaries' onetime living quarters, the Long Barrack, have been turned into a museum that recounts Texas's turbulent past, emphasizing the memorable two-week Battle of the Alamo. THE CHURCH AND THE LONG BARRACK ARE THE ONLY TWO STRUCTURES FROM 1836 THAT ARE STILL STANDING. Also onsite are the serene Alamo Gardens, which provide a good spot to rest and reflect.

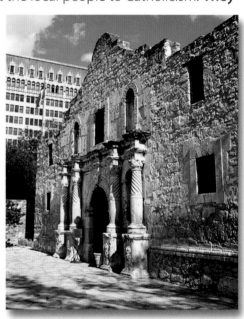

The Alamo remains an icon and a reminder of Texas's struggle for independence.

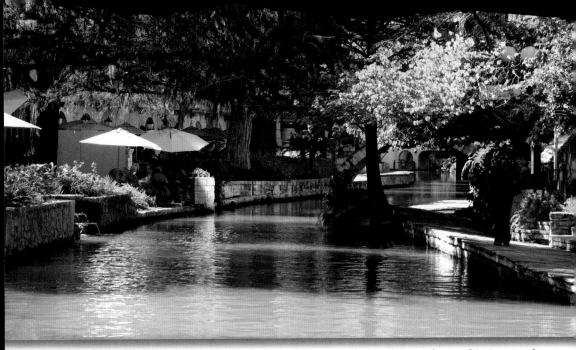

San Antonio's lively downtown area is known for its Riverwalk, a tree-lined, flower-filled oasis of cool walkways, shops, and cafés located along the river.

The popular **RIVERWALK, ALSO KNOWN AS PASEO DEL RIO, FORMS A VIBRANT CIRCLE AROUND DOWNTOWN SAN ANTONIO ALONG THE SAN ANTONIO RIVER.** After the 1968 HemisFair exposition in San Antonio, commercial development along the Riverwalk boomed, and hotels, galleries, restaurants, and boutiques now crowd the river's banks. The river bustles with activity, too; there are holiday boat parades, and river taxis are available every day of the week. Visitors can also take narrated tours along the river, which last about 35 to 40 minutes and are available daily.

Space Center Houston

Located in the Johnson Space Center complex, Space Center Houston was designed by Walt Disney Imagineering with both entertainment and education in mind. It's **A PERFECT PLACE FOR SPACE BUFFS TO GET A CLOSE-UP LOOK AT THE COUNTRY'S SPACE PROGRAM,** and younger children will enjoy its expansive play areas.

- The **NASA Tram Tour** allows visitors a behind-the-scenes look at the Johnson Space Center.

- **Starship Gallery** reveals the evolution of crewed space flight in the United States with authentic artifacts from different space missions.

- The **Lunar Samples Vault** lets visitors view actual lunar rocks.

- **Above and Beyond** is a hands-on exhibit that includes simulations and interactive galleries. Kids can even design their own jet!

For the true space aficionado, check out the Level 9 tour of Space Center Houston. Only 12 people per day are admitted on the escorted tour, which takes you right into NASA's control center and onto the observation decks of the neutral buoyancy lab. The tours are available for those 14 and older.

Austin

Austin stands out from most Texan metropolises. With more than 650,000 people, this is no small town (although it's certainly much smaller than Dallas and Houston). Austin has a Bohemian aura, due in part to the University of Texas campus. And politics prevail here: Austin is **TEXAS'S CAPITAL CITY, AND ITS CAPITOL BUILDING IS THE LARGEST IN THE COUNTRY.**

The aroma of barbecue and Tex-Mex cuisine hangs in the air, and nightclub-lined Sixth Street is one of the best spots for live music in the entire world. Then there are the **1.5 million Mexican free-tailed bats that hang from the downtown Ann W. Richards Congress Avenue Bridge,** which spans the Colorado River. Crowds gather from March through November to watch them emerge en masse at sunset.

Guadalupe Mountains National Park

At the tip of the Trans-Pecos region (the far west Texas panhandle) and just southwest of New Mexico's Carlsbad Caverns, the Guadalupe Mountains loom over the surroundings like mighty centurions. The **ROCKY CLIFFS DEVELOPED LONG AGO WHEN TODAY'S DESERT WAS AN ANCIENT OCEAN.** The now-lofty mountains were once a reef. As the water receded, it left fossil records of Cambrian sea life on today's craggy peaks.

The modern park contains both **Guadalupe Peak,** which at 8,749 feet above sea level is **THE HIGHEST POINT IN TEXAS,** and McKittrick Canyon, believed by many to be the prettiest spot in the state. The former is a backpacker's dream: The summit offers sublime views of the surrounding desert. The latter is a vestige of the last ice age that explodes with color in the fall.

Big Thicket National Preserve

East Texas's Big Thicket National Preserve is **97,000 acres of biological crossroads** in southeast Texas. This is where the sultry swamps of the South, the verdant forests of the East, and the seemingly endless savannah of the Great Plains meet and mingle. Meadows are scarce, as the flora thrives in the rich soil and wet climate.

The unique environment translates into a habitat for all sorts of wildlife. In Big Thicket's **DIVERSE BIOSPHERE, DESERT ROADRUNNERS LIVE ALONGSIDE SWAMP CRITTERS,** such as alligators and frogs. And they coexist near deer, mountain lions, and 300 species of nesting and migratory birds. This is the only place on the planet where many of these species live side by side.

Padre Island National Seashore

The pristine beaches, wind-sculpted dunes, and saltwater marshes of Padre Island National Seashore stretch for 80 miles along the Gulf of Mexico off of south Texas. It's **THE LONGEST SPAN OF UNDEVELOPED BEACH IN THE UNITED STATES AND THE LONGEST UNDEVELOPED BARRIER ISLAND IN THE WORLD.** A major migratory bird flyway is found here, making this area **one of the prime bird-watching regions on the planet.**

Padre Island also is **a fishing enthusiast's paradise.** It offers speckled trout, black drum, redfish, and flounder. The saltwater lagoon between the island and the mainland is a perfect place to learn to windsurf—it's only three to five feet deep with a soft, sandy bottom. Pack a picnic, and watch one of the world-class windsurfing competitions held throughout the year.

Lake Amistad

Lake Amistad is an oasis in the Texas badlands. This confluence of the Rio Grande, Devils, and Pecos rivers on the United States-Mexico border has been alive with human activity for millennia. **People have trafficked the limestone canyons of the Lower Pecos region for more than 10,000 years.** In their travels, these people left behind one of the world's most spectacular collections of rock art. The artifacts are scattered throughout nearly 250 known sites that

An overlook reveals the dazzling Pecos River below.

include some of North America's largest multi hued rock paintings, some of which are 4,000 years old.

In 1969, the rivers were dammed here, creating Lake Amistad. The 67,000-acre reservoir extends up the Rio Grande for 74 miles, Devils River for 24 miles, and the Pecos River for

The Pecos Bridge spans the Pecos River near where it feeds into Lake Amistad.

14 miles. From its 850 miles of shoreline, many people are enticed by the reservoir's **STRIKING BLUE WATER, WHICH IS EXTRAORDINARILY CLEAR DUE TO THE LACK OF LOOSE SOIL.** Visitors can traverse the lake on watercraft of all kinds. Many people enjoy swimming, scuba diving, and fishing for behemoth catfish and bass.

Atop the six-mile Amistad Dam is a bridge that connects the United States to Mexico. Its center is marked by a pair of eagle statues, one on each side of the official border.

Oklahoma City National Memorial

At this peaceful plaza in downtown Oklahoma City, **the east gate is inscribed with the time 9:01, the west gate with 9:03. The first time represents the moment innocence was lost; the second one the time healing began.** On the morning of April 19, 1995, a terrorist's bomb took the lives of 168 people at the Alfred P. Murrah Federal Building in this southwestern city.

The stark gates frame **168 FOREVER-EMPTY CHAIRS, REPRESENTING THE LIVES LOST THAT TRAGIC MORNING.** The chairs surround a single American elm, the Survivor Tree. The site is a stirring, visceral reminder of the damage done by violence and the resilience of the human spirit.

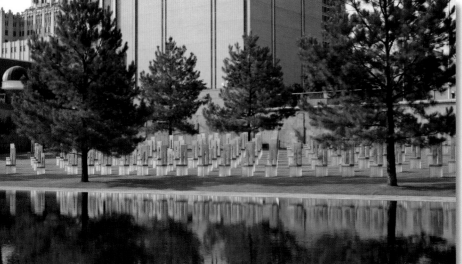

Designers Hans and Torrey Butzer created the concept for the memorial chairs honoring the 168 people who were killed.

National Cowboy & Western Heritage Museum

The National Cowboy & Western Heritage Museum in Oklahoma City has a pretty broad mission statement: "To preserve and interpret the heritage of the American West for the enrichment of the public." But that all-encompassing spirit has led to the development of a world-class, 200,000-square-foot complex showcasing one of the United States' top collections of Western art, with works by such legends as Charles Russell and Albert Bierstadt. "Canyon Princess" is one of the famous sculptures on display at the museum. The 16,000-pound white marble cougar by sculptor Gerald Balciar guards the entrance to the Gaylord Exhibition Wing.

The museum also features:
- A re-created early-1900s cattle town
- A research center
- Galleries dedicated to firearms, Western performers, cowboys, and rodeos

The sculpture "The End of the Trail" by James Earle Fraser has become a symbol of the American West.

Roswell

On **July 4, 1947,** many residents of the sleepy agricultural town of Roswell, New Mexico, reported seeing **AN UNIDENTIFIED FLYING OBJECT STREAKING ACROSS THE NIGHT SKY.** Other locals reported a loud explosion. The next week, the local newspaper, the *Roswell Daily Record,* reported that the authorities at Roswell Army Air Field had found the remains of a flying saucer that crash-landed in the vicinity. The story was based on the only military or federal disclosure of a possible UFO in history. The facts, however, quickly shifted: Officials recanted the initial account within days and said it was a weather-balloon experiment gone awry.

So, **did the government cover up a UFO crash and take the wreckage to the now-infamous Area 51,** or was the object really a weather balloon? Visitors flock to Roswell's **International UFO Museum and Research Center** to judge for themselves.

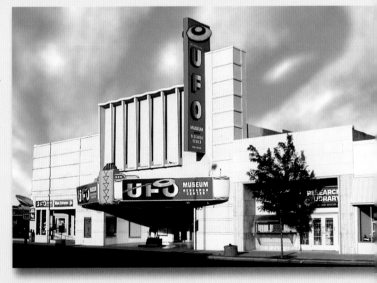

Taos Pueblo

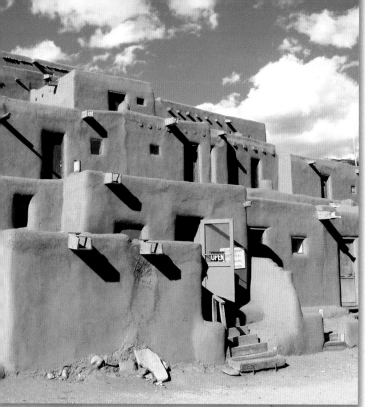

The Taos Pueblo in northern New Mexico is **THE OLDEST CONTINUOUSLY OCCUPIED STRUCTURE ON THE CONTINENT.** Dating back to A.D. 1000, its adobe walls today house about 150 Taos Native Americans who maintain the ancient traditions of their ancestors. The Pueblo is not a historical artifact or a re-creation; it is **an actual town that offers a fascinating introduction to Native American life.**

Taos Pueblo is made from adobe—a mix of sun-dried earth and straw.

The Pueblo's distinctive style has influenced much of the region's architecture. **IT CONSISTS OF TWO LONG, MULTISTORY ADOBE STRUCTURES, ONE ON EACH SIDE OF A FRESHWATER CREEK.** Explore on your own, or take an escorted tour that recounts the Pueblo's history, which includes occupation by Spanish conquistadors in 1540 and by Franciscan friars in the 1590s.

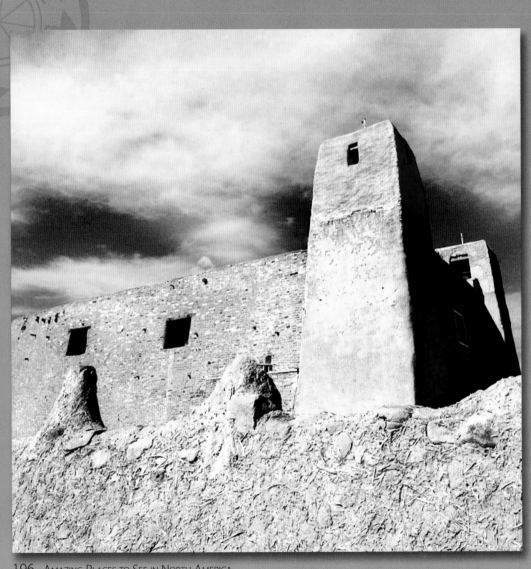

New Mexico Missions

In 1598, Spanish conquistador Don Juan de Oñate crossed the Rio Grande near the city limits of modern-day El Paso, Texas. De Oñate led his party north past Franciscan missionaries along the Rio Grande's banks to its intersection with the Chama River. Here he established the San Gabriel Mission, New Mexico's second Spanish capital, in 1600—a full seven years before the English settled in Jamestown, Virginia.

This first Spanish mission in modern-day New Mexico set the stage for many more to come. **MANY OF THE STATE'S 17th-CENTURY CHURCHES ARE STILL STANDING AND ACTIVE TO THIS DAY.** In 1610, the Spanish capital moved to Santa Fe, where San Miguel Mission, now considered the oldest operational church in the United States, was established. Another nicely preserved church from this early era is the Mission of San José at Laguna Pueblo (1699), 45 miles west of Albuquerque. About 25 miles to the southwest is the **Mission of San Esteban del Rey at Acoma Pueblo, perched majestically on a 367-foot sandstone mesa since 1626.** To the southeast are the ruins of four more 17th-century missions that were abandoned before 1700 and now comprise Salinas Pueblo Missions National Monument.

ACOMA PUEBLO

Nicknamed "Sky City" for its lofty locale atop a sandstone mesa that rises 367 feet above the surrounding desert, Acoma Pueblo is one of the oldest continuously inhabited cities in the United States: It was established before A.D. 900.

Carlsbad Caverns

Nature's artistic streak takes a fanciful turn in this famous and **ENORMOUS CAVE SYS-TEM CREATED BY WATER DRIPPING THROUGH AN ANCIENT REEF MADE OF POROUS LIMESTONE.** More than 30 miles of the main cavern have been explored, and the three miles of caves that are open to visitors are among the largest and most magnificent underground formations in the world.

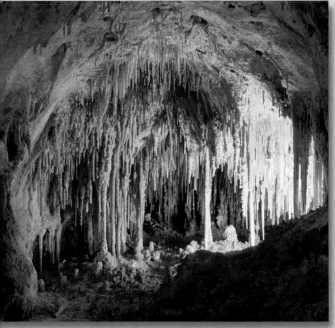

Tiny stalactites called soda straws form Dolls Theater, part of the Big Room in Carlsbad Cavern.

The vast **Big Room** has a **CEILING THAT ARCHES 255 FEET ABOVE THE FLOOR, AND IT CONTAINS A SIX-STORY STALAGMITE AND THE SO-CALLED BOTTOMLESS PIT, WHICH IS MORE THAN 700 FEET DEEP.** In the summer months, bats that inhabit parts of the caverns are an additional attraction. Each evening at sunset the creatures swarm out of the cave to feed on insects in the surrounding area of southeastern New Mexico. The event is best observed at the Bat Flight Amphitheater at the cavern entrance.

Santa Fe

Santa Fe, New Mexico, is **the second-oldest city in the United States.** It's a place where the merging of three cultures—Anglo, Hispanic, and Native American—can be seen in its vibrant art, architecture, and food.

The center of the town is the Plaza, which once marked the official end of the Old Santa Fe Trail. It is now lined with shade trees, famous landmarks, and museums, including the Palace of the Governors. Native American artisans display their wares on beautiful blankets in front of the Palace: You'll see silver-and-turquoise jewelry, pottery, leatherwork, and hand-woven blankets for sale. But Santa Fe is about much more than the Plaza. The city is **FILLED WITH EXQUISITE ART GALLERIES, FASHION-ABLE SHOPS, AND SOPHISTICATED RESTAURANTS.**

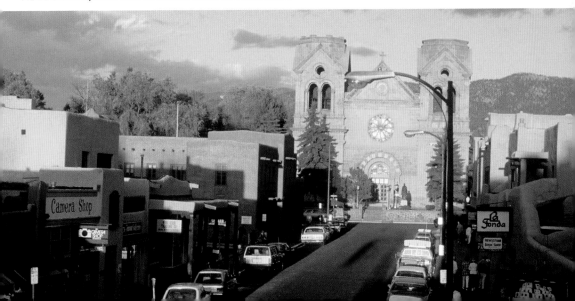

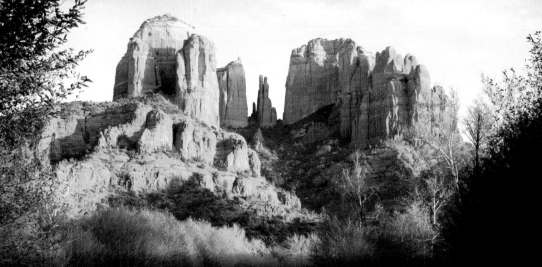

Sedona

At the base of the Mogollon Rim and its lofty formations of vibrant red sandstone lies Sedona, Arizona. Although Sedona is only 110 miles north of Phoenix, it seems to be a world away. This small town has only a few more than 10,000 residents, but its BRILLIANT SCENERY AND LIVELY CULTURE attract more than four million tourists each year.

Atop the Mogollon Rim, many of the wondrous sandstone formations that tower over Sedona are named after objects they appear to mimic, such as Cathedral Rock, Coffeepot Rock, and even Snoopy Rock, named for the beloved beagle from the comic strip *Peanuts*. Boutiques and art galleries are common along the town's cobblestone roads, and visitors enjoy intimate restaurants, friendly local cafés, and quaint bed-and-breakfasts.

Petrified Forest National Park

Some 225 million years ago, the arid desert of north-central Arizona was a lush tropical forest dominated by towering conifers. This era ended when catastrophic floods devastated the area, uprooting tree after tree. Over millions and millions of years, layers of silt, mud, and volcanic ash covered the spent trees and slowed the process of decay. Silica from the ash gradually penetrated the wood and turned to quartz. Minerals streaked the former wood with every color of the rainbow, resulting in wet-looking "logs" that spanned the color spectrum.

To protect the petrified wood in its natural environment, President Theodore Roosevelt created Petrified Forest National Monument in 1906; it became a national park in 1962. Beyond the magnificent petrified wood, the park also contains one of the best fossil records from the Late Triassic period, including aquatic phytosaurs; armored aetosaurs; sharp-toothed rauisuchians; and crocodylomorphs, the ancestors of crocodiles.

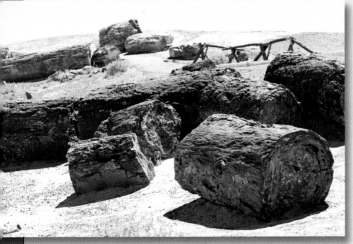

The Grand Canyon

Millions of years of erosion caused by wind and the Colorado River have carved and sculpted Arizona's Grand Canyon, truly one of the world's most dramatic natural wonders. At 227 miles long and 18 miles across at its widest point, **THIS BREATHTAKING ABYSS PLUNGES MORE THAN A MILE FROM RIM TO RIVER BOTTOM AT ITS DEEPEST POINT.**

The North and South rims are 215 miles apart by car, so if your time is limited, it's best to visit just one. The **South Rim** area attracts roughly 90 percent of the park's

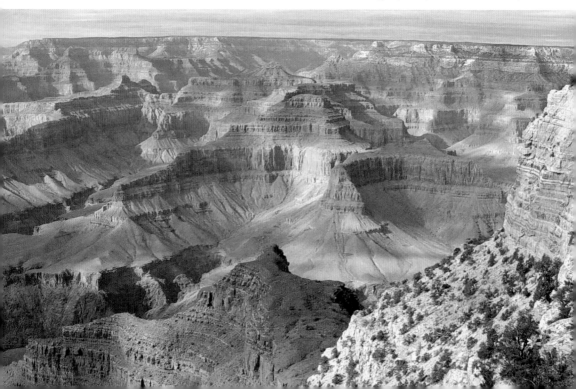

visitors, largely because the **VIEWS ARE THOUGHT TO BE BETTER AND IT HAS THE MAJORITY OF THE PARK'S ACCOMMODATIONS AND RESTAURANTS.** Stroll along the paved South Rim Trail, or exercise your legs on the steep switchbacks of Bright Angel Trail to get a real view of the landscape.

Visitors seeking tranquility should head to the less-visited North Rim. It has lodge accommodations, hiking trails, camping, and somewhat limited services. The rim is usually buried in snow during winter, but in summer, it's the **FIRST CHOICE OF SERIOUS HIKERS AND OUTDOORSY PEOPLE HOPING TO GET AWAY FROM THE CROWDS.** And if you're looking for an even more extreme view of the Grand Canyon, check out the Grand Canyon Skywalk at Grand Canyon West. The Skywalk is a horseshoe-shape, glass-bottom walkway that extends over the edge of the canyon and gives visitors the opportunity to look 4,000 feet straight down.

At the South Rim, you'll find:
- Grand Canyon Village, where you can rent horses and shop.
- Several small museums that highlight Native American culture and local flora and fauna.
- An IMAX theater that offers a virtual tour of the Grand Canyon that is packed with information about the park.

Sabino Canyon

The **HIKING TRAIL** leading up Sabino Canyon on the outskirts of Tucson, Arizona, is **AMONG THE MOST BEAUTIFUL IN THE UNITED STATES.** The steep red walls, dotted with saguaro cacti, mesquite trees, and ocotillo plants, plummet to the canyon floor, where a paved trail beckons hikers and bikers. There is also a tram to deliver passengers to the top without breaking a sweat.

Due to rainy seasons in summer and winter, Sabino Canyon is **surprisingly green for a desert,** providing habitat for roadrunners, deer, rattlesnakes, mountain lions, and the collared peccaries known as javelinas. Seasonal storms replenish Sabino Creek, which runs down the canyon, and a number of pools that lie along the creek bed.

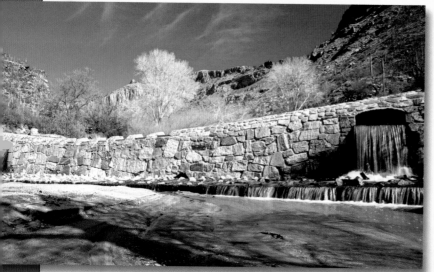

The 3.8-mile paved path through the canyon crosses nine stone bridges over Sabino Creek.

Window Rock

Window Rock, Arizona, is **BOTH A COMMUNITY AND A GEOLOGICAL MASTERSTROKE.** It is the capital of the Navajo Nation, the largest Native American government in the United States, and home to about 3,000 people. It is also a natural landmark— the city has taken its name from the wondrous pothole arch. **Over millions of years, sunlight, wind, water, and chemical exfoliation formed the distinctive window.** These elements slowly peeled away layer after layer of red sandstone, leaving a nearly perfect circular hole in its place.

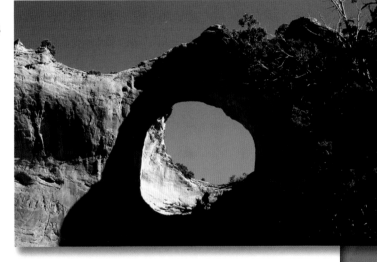

The formation is known as *Tségháhoodzání*, which in Navajo means "perforated rock." Window Rock has long been **a sacred place in the Water Way Ceremony,** or *Tóhee*. The 200-foot formation has traditionally been one of four sources for the water Navajo medicine men use in the ceremony performed to ask the gods for rain.

Great Basin National Park

Amidst the lonely desert that unfolds between the Rockies and the Sierras, a rugged landscape rises into the beautiful blue sky of eastern Nevada. **FORESTED MOUNTAINS TOWER A MILE ABOVE THE FLATLANDS BELOW.** Great Basin, which was cut by glaciers during the Pleistocene ice age, has been a national park since 1986 and is defined by the Snake Range, which has 13 peaks that rise more than 11,000 feet high and nearly 100 valleys snaking among the soaring summits. Alpine lakes cascade into rollicking streams and rivers, and the bristlecone pine forest opens into lush meadows dotted with wildflowers. A labyrinth of limestone caverns winds underground.

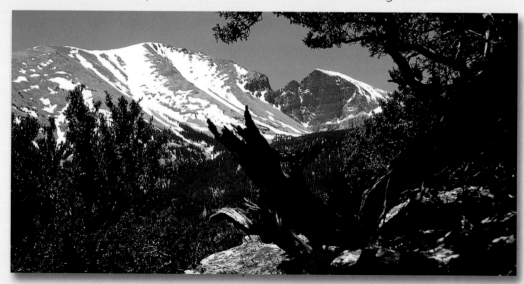

Nevada's second-tallest mountain, Wheeler Peak, reaches an elevation of 13,063 feet in Great Basin.

Pyramid Lake

Named for the distinctive 400-foot rock near its eastern shore, Pyramid Lake is a striking contrast to its rugged, arid surroundings in northwestern Nevada. The lake is **ONE OF THE LARGEST DESERT LAKES IN THE WORLD AND IS FAMOUS FOR ITS TUFA ROCK FORMATIONS.** Its surface vacillates from turquoise to dark blue. Across the lake, views of the mountains, streaked with gray and pink, are unforgettable.

Located on the Paiute Indian Reservation, Pyramid Lake's **warm, shallow waters are a magnet for anglers and swimmers.** The world-record cutthroat trout— a 41-pound whopper—was pulled from these electric blue waters in 1925.

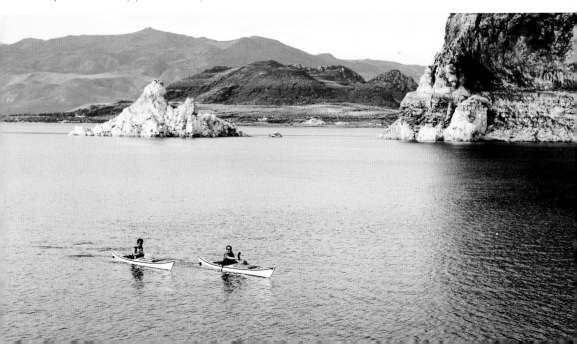

Las Vegas Strip

The Las Vegas Strip ORIGINATED IN **1938,** SEVEN YEARS AFTER GAMBLING WAS LEGALIZED IN NEVADA. Bucking the trend of the downtown casino, an entrepreneur opened a gambling hall four miles south of Las Vegas's city center on U.S. Highway 91.

In 1941, the Hotel El Rancho Vegas resort opened at the corner of San Francisco Avenue and U.S. 91. The hotel offered its guests an unprecedented slate of facilities and activities, including restaurants, live entertainment, shops, a travel agency, horseback riding, and, of course, a swimming pool. Gambling, nonetheless, remained the top draw.

This neon sign at the south end of the Strip greets travelers who arrive via Las Vegas Boulevard.

Today, Hotel El Rancho Vegas's legacy is unmistakable. **The Strip (Las Vegas Boulevard) dwarfs the downtown area** when the cityscape first comes into view. The ornate palaces of South Las Vegas Boulevard and their endless ribbons of neon make it one of the few stretches of road that's more scenic at night.

Amazingly, **16 OF THE 20 LARGEST HOTELS IN THE WORLD ARE RIGHT THERE ON ONE FOUR-MILE SLICE OF REAL ESTATE** in the middle of the Nevada desert. A visitor could walk from one end of the Strip

Glamorous resort-casinos on the Vegas Strip bring the city to life each night with flashing lights and extravagant decor.

to the other in a couple of hours and see everything from replicas of the Eiffel Tower and the New York skyline to dazzling water fountains that dance to music. **Big-name performers take to the stages here nightly,** entertaining the vacationing masses with comedy, magic, music, and dance.

Nothing is permanent here; the Strip is one of the most dynamic environments on the planet. As the resorts try to capture more market share and more tourist dollars, they constantly expand their facilities and activities, rebuilding and reshaping to keep up with the times.

Hoover Dam

In the Black Canyon of the Colorado River, just 30 miles southeast of fabulous Las Vegas, Nevada, sits the engineering marvel known as Hoover Dam. The dam was **CONSTRUCTED BETWEEN 1931 AND 1935 AND CONSISTS OF 3.25 MILLION CUBIC YARDS OF CONCRETE, ENOUGH TO PAVE A ROAD FROM NEW YORK TO SAN FRANCISCO.** The dam widens the Colorado into the vast waters of Lake Mead, a year-round recreation destination that attracts millions of visitors each year for swimming, boating, waterskiing, and fishing.

About 20,000 laborers built the Hoover Dam, which was the largest dam in the world when it was completed. Although it's no longer the world's biggest, Hoover Dam stands to many as **a symbol of the United States' progress during the adversity of the Great Depression.** It is a National Historic Landmark and has been selected by the American Society of Civil Engineers as one of "America's Seven Modern Civil Engineering Wonders."

Quick Facts About the Hoover Dam

- Height—726.4 feet
- Weight—6.6 million tons
- Can store up to 9.2 trillion gallons of the Colorado River in its reservoir, Lake Mead. That's nearly two years of the average "flow" of the river.
- Has a power-generating capacity of 2.8 million kilowatts.
- Is part of a system that provides water to more than 25 million people in the southwest United States.

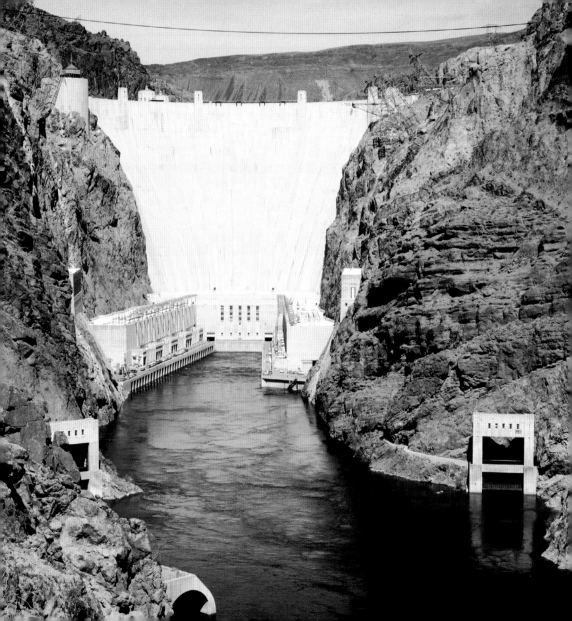

THE ROCKY MOUNTAINS

Pikes Peak

Lieutenant Zebulon Pike first spied this **14,110-FOOT MOUNTAIN ALONG COLORADO'S FRONT RANGE** in November 1806. But his attempt to scale the mountain that now bears his name was foiled by heavy snow, and Pike said the rocky pinnacle would never be reached. Never say never. In 1820, Major Stephen Long led a party that reached the top of Pikes Peak in two days.

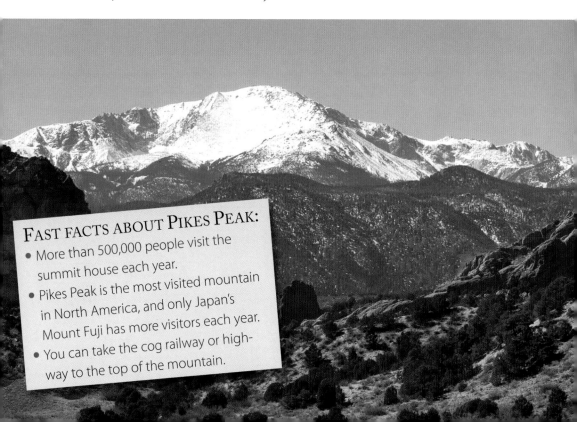

FAST FACTS ABOUT PIKES PEAK:
- More than 500,000 people visit the summit house each year.
- Pikes Peak is the most visited mountain in North America, and only Japan's Mount Fuji has more visitors each year.
- You can take the cog railway or highway to the top of the mountain.

Red Rocks Park and Amphitheatre

In Morrison, Colorado, Red Rocks Park and Amphitheatre is nestled in the stunning mountainside and natural red rocks. Its **ACOUSTICS ARE SUPERB, PERHAPS RIVALED ONLY BY THE BEAUTY OF ITS SPECTACULAR SURROUNDINGS.** The north and south sides of the amphitheatre are 300-foot geological masterstrokes named Creation Rock and Ship Rock, respectively. The seats stretch across the steep slope between the two.

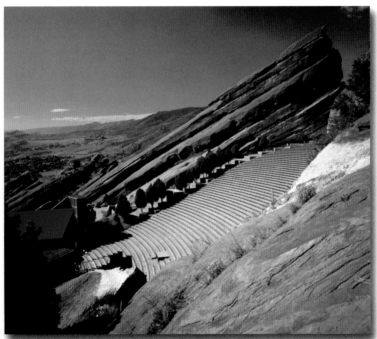

The giant Creation Rock and Ship Rock frame Red Rocks Amphitheatre.

Concert industry trade journal *Pollstar* named Red Rocks its **"Best Outdoor Venue" every year from 1989 to 1993 and its "Best Small Outdoor Venue" every year from 1995 to 1999.** It then dropped the amphitheatre from consideration—and renamed the small outdoor venue award after Red Rocks.

Telluride

Telluride is **ONE OF THE MOST ALLURING TOWNS IN THE WEST.** This picture-perfect boomtown on Colorado's Western Slope is nestled in a snug box canyon and is surrounded by forested peaks and idyllic waterfalls.

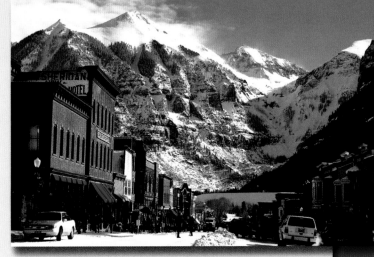

Tucked among the snow-capped Rockies, Telluride is a skier's paradise.

Telluride's beginning years in the late 1800s were marked by ambition. The silver veins in the surrounding mountains proved exceptionally rich. But Telluride's mining economy faltered after World War I, beginning a long, slow period of decline. But in 1972, the Telluride Ski Resort was born, and the population of miners gave way to Bohemians. The town's destiny—which at one point appeared to be total abandonment—suddenly changed. **The entire town has been a National Landmark Historic District since 1964,** and this status has kept its lovely character intact.

Rocky Mountain National Park

Perched atop the Continental Divide, Colorado's Rocky Mountain National Park is archetypal high country, offering a **jaw-dropping panorama of daunting summits and alpine tundra** in the mountains of north-central Colorado. There are 60 peaks in the park that reach 12,000 feet above sea level. The highest, Longs Peak, scrapes the sky at 14,259 feet.

Based on these lofty numbers, it should come as no surprise that the park has the highest average elevation of any U.S. national park, including those in Alaska. A good amount of Rocky Mountain National Park is above the area's 11,500-foot timberline. A stretch of **Trail Ridge Road, the highest continuous road in the United States, climbs above the timberline to a height of 12,183 feet.** But the meadows below are starkly different from the harsh landscape of the mountaintops, especially after the wildflowers push through the ground in spring.

More than three million people visit the park each year. The drive along Trail Ridge Road from Estes Park on the east side to Grand Lake, the park's western gateway, reveals picturesque scenes. The park's **BOUNTIFUL BACKCOUNTRY IS A WORLD-CLASS DESTINATION FOR CLIMBING, FISHING, HIKING, AND CROSS-COUNTRY SKIING.**

Estes Park features an abundance of family activities. A number of horseback-riding stables offer trail rides, and a small lake comes complete with boating and fishing. Other activities include bicycling and cultural events. Estes Park

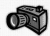

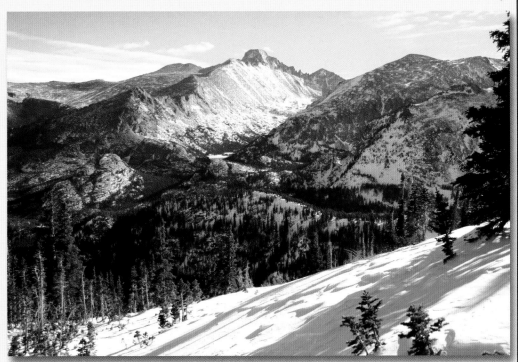

Longs Peak stands tallest in Rocky Mountain National Park. Hikers can take the Keyhole Route to ascend almost 5,000 feet.

offers a number of family-friendly accommodations for those who don't want to camp out. One of the best is the Stanley Hotel, which was the inspiration for Stephen King's *The Shining*.

Mesa Verde National Park

About 700 years ago, people now called **THE ANASAZI LIVED IN COMMUNITIES CLINGING TO THE CLIFFSIDES** of the American Southwest. The name Anasazi originally meant "enemy ancestors" in Navajo but has come to mean "ancient people" or "ancient ones." These ancient people belonged to about 20 tribes, such as the Hopi and the Zuni, and were the ancestors of today's Pueblo Indians. They left a remarkable legacy in what is now Mesa Verde (Spanish for "green table") National Park, which comprises **more than 4,000 archaeological sites, including 600 cliff dwellings,** in southwest Colorado.

Visitors can see a handful of the most spectacular of these uncanny ruins on tours led by park rangers, and trails to mesa tops are open to hikers. Some tourists balk at the regimentation of the guided tours, but regulation is the price today's travelers pay for the damage done by visitors before them. Still, Mesa Verde is spellbinding. An anonymous architect said it held "timeless forms and abiding mystery." Others, such as author Evan S. Connell, have written about the captivating shadows, sunlight, and transcendental aura of the ancient civilization.

The Mesa Verde cliff dwellings were abandoned about 700 years ago. The area's Ute Indians refused to go near the Two-Story Cliff House, believing it was sacred and occupied by spirits of the dead. They were reluctant even to show the ruins to their white friends.

Despite modern amenities, visitors should make no mistake that the park is part of the rugged American West. Hiking at an altitude of 8,400 feet with little humidity is a great way to enjoy Mesa Verde—just be sure to include lots of water, sunblock, and your best hiking boots.

The nicely shaded cliff dwellings in Mesa Verde National Park were home to the Anasazi people, who abandoned them about 700 years ago.

Glenwood Hot Springs Pool

Open all year, no matter what the weather, the king-size swimming pool in Glenwood Springs, Colorado, is more than three city blocks long. Located about 40 miles northwest of Aspen, **it's the world's largest hot mineral pool and is naturally heated to a comfortable 90 to 93 degrees Fahrenheit year-round.**

Kids love cascading down the pool's two giant waterslides and playing in the warm, relaxing water. There are lanes for lap swimmers, diving boards, and a special

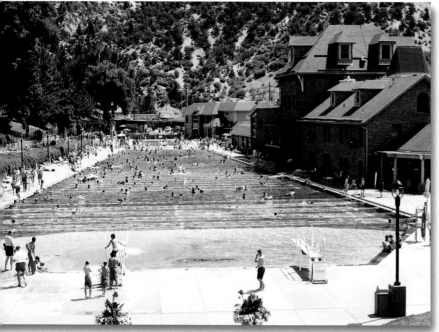

shallow pool for younger children. Tired from a day of hiking and sightseeing? You can relax in the smaller therapy pool that is heated to 104 degrees Fahrenheit. Pop a quarter into the "bubble chairs" for a special massage.

Great Sand Dunes National Park and Preserve

Stretching across 8,000 square miles at an average elevation of 7,500 feet, southwestern Colorado's vast San Luis Valley is the world's largest alpine valley. It's full of mysteries and surprises, from UFO lore to alligator and potato farms.

But the most incredible surprise here may be the Great Sand Dunes, which have been continuously sculpted by wind, water, and time. In the shadow of the Sangre de Cristo ("Blood of Christ") Mountains, these are **the tallest dunes in North America, reaching as high as 750 feet.** The scale is striking: The dunes contain nearly five billion cubic meters of sand. The best way to get a feel for this ever-changing landscape is to lace up your hiking boots and work your way up to the summit of High Dune—the view from the top gazing across the sandy dunes is sublime.

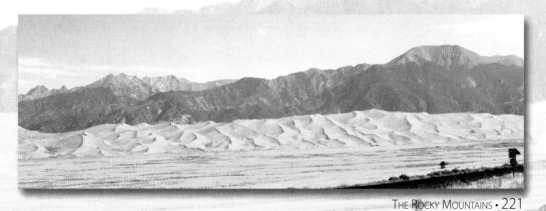

The Great Stupa of Dharmakaya, Shambhala Mountain Center

Cradled in the pine-clad mountains near Red Feather Lakes, Colorado, the Great Stupa of Dharmakaya is the largest stupa (monument to a great Buddhist teacher) in the Western Hemisphere. It is also the largest and most elaborate example of Buddhist sacred architecture in North America.

The monument was built in honor of Chögyam Trungpa Rinpoche (1939–1987), the founder of the Shambhala movement and one of the key figures who helped introduce Tibetan Buddhism to the United States. Construction on the Great Stupa of Dharmakaya began in 1988, and the monument was consecrated in 2001. The 108-foot-high masterpiece is a mesmerizing work of ornate art, laden with meaningful symbolism. Engineers built it with reinforced concrete so it will last a millennium.

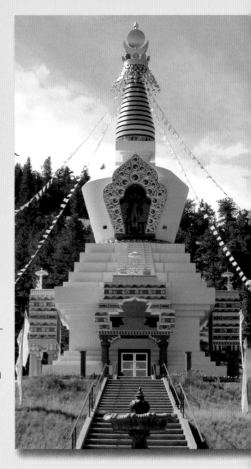

Grand Teton National Park

The beauty of the Teton Range in northwestern Wyoming is rapturous. It's difficult to take a picture in Grand Teton National Park without capturing these awe-inspiring peaks.

Grand Teton National Park is situated in Jackson Hole, the famed valley bounded by Yellowstone to the north and the Tetons to the west. Grand Teton, Mount Owen, and Teewinot are collectively known as the Cathedral Group, and the view of these mountains from the northeast is astounding.

What you may not know about the Tetons:

- The granite atop the Tetons is more than three billion years old, making it some of the oldest rock on the continent.
- The mountains themselves are among the youngest in the Rockies; they formed about ten million years ago.
- The summit of Grand Teton is 13,770 feet above sea level.

Yellowstone National Park

Yellowstone National Park in Wyoming, Montana, and Idaho was **THE WORLD'S FIRST NATIONAL PARK.** At 2.2 million acres, it is one of North America's largest areas of protected wilderness. These distinctions have preserved Yellowstone's wild nature and made it a model for other parks.

One striking aspect of Yellowstone is the volcanic plumbing below Earth's surface that powers geothermal features, including dramatic geysers such as Old Faithful, steaming fumaroles (holes in volcanic regions that issue vapors and hot gasses), bubbling hot pools, and belching mud pots. Yellowstone is **one of only two intact geyser basins on the planet.** (The other, on the Kamchatka Peninsula in Russia, is much less accessible.)

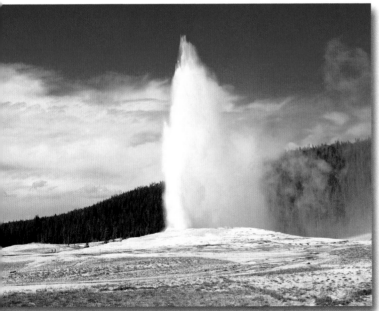

It took an earthquake to knock Old Faithful off its schedule. The geyser erupted every 76 minutes until a 1998 earthquake rocked the area. Eruptions now occur every 80 minutes.

Yellowstone's wildlife is every bit as astounding as its thermal features. **The Lamar Valley,** in the park's northeastern corner, **is known as "The Serengeti of North America."** There are more large mammals here—such as deer, moose, elk, bison, bears, and wolves—than in any other ecosystem on the continent. This diverse menagerie is on display during the spring as animals graze, scavenge, and hunt.

Yellowstone's wealth doesn't begin and end with the geysers and the animals. The park is a trove of aquatic wonders, especially **Yellowstone Lake (the largest high-altitude lake in the continental United States,** at 7,733 feet above sea level) and the spectacular geothermal theatrics on its shores at West Thumb. There's also the Grand Canyon of the Yellowstone River, a geological masterwork punctuated by two dramatic waterfalls, 109-foot Upper Falls and 308-foot Lower Falls.

The lakeside thermal features at West Thumb are among the many spectacular sights in the park.

Devils Tower National Monument

The origins of the igneous spire known as Devils Tower date back 60 million years, when columns of molten magma cooled a full mile-and-a-half below Earth's crust. After eons of erosion, the soft sedimentary layers that once covered the spire

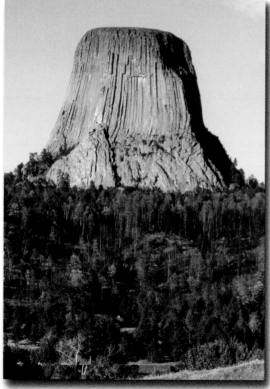

disappeared, and the tower now **REACHES 867 FEET FROM ITS BASE INTO THE SKY** in northeast Wyoming.

Wildlife is abundant in the area. More than 100 species of birds circle in the sky; chipmunks scurry on the tower; and the forested base is alive with rabbits, deer, and porcupines. Above, the sky holds the promise of unidentified flying objects: **Like the Lakota and the Cheyenne, sci-fi fans have long held Devils Tower sacred,** thanks to its star turn as the setting for the climactic scene of Steven Spielberg's *Close Encounters of the Third Kind.*

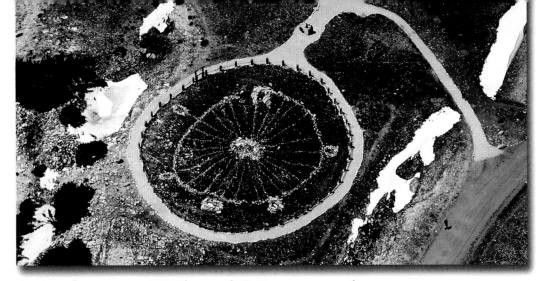

Medicine Wheel National Historic Landmark

Wyoming's Medicine Wheel is located in a remote area of the Bighorn National Forest at an elevation of 9,642 feet. It is **one of the oldest active religious sites on the planet:** For 7,000 years, this spot on Medicine Mountain has been sacred.

Medicine Wheel is part of a larger system of interrelated religious areas, altars, sweat lodge sites, and other ceremonial venues, and it is still in use. The lasting artifact at the site is the actual Medicine Wheel, which is **75 FEET IN DIAMETER AND COMPOSED OF 28 "SPOKES" OF ROCKS INTERSECTING IN A CENTRAL ROCKY CAIRN.** Originally built several hundred years ago, it is now a National Historic Landmark enclosed by a simple fence of rope. It is considered one of the best-preserved sites of its kind.

Arches National Park

Arches National Park in eastern Utah defies the imagination. Sandstone has eroded and been whittled into **an astonishing landscape of color, shape, and texture.** Arches National Park is home to the densest concentration of these rocky masterworks on the entire planet—there are more than 2,000 in all.

The size of the park's arches ranges from three feet in diameter to the massive 306-foot Landscape Arch (the world's longest arch). This arch is one of eight along the two-mile-long Devils Garden Trail. The park's best-known attraction is Delicate

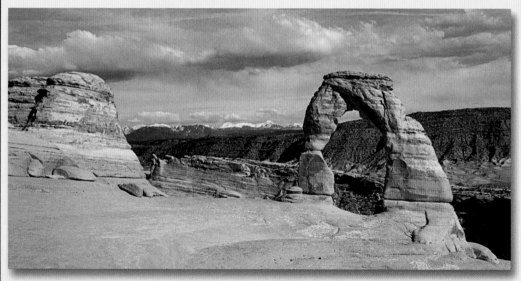

Delicate Arch is a natural masterpiece of sculpted red sandstone.

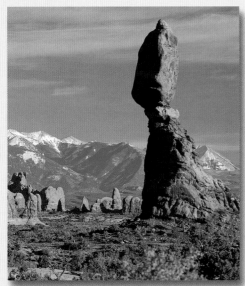

Beyond the park's namesake arches is a diverse array of stunning geology, including Balanced Rock in the Windows area.

Arch, which creates an amazing visual against a panorama of infinite sandstone.

Although these dramatic sandstone portals are the stars of the park, Arches is **home to a rich and unusual ecosystem.** It sits atop the Colorado Plateau, a high desert region that unfolds from western Colorado into Utah, New Mexico, and Arizona. Other geological wonders are found throughout the park, including balanced rocks; spires; slick-looking domes; and "Park Avenue," a series of bright red fins that loom over the vivid desert like Manhattan skyscrapers.

Arches National Park also has **NUMEROUS PETROGLYPHS AND TOOL-MAKING SITES,** signs of a long and storied human history. Nomadic hunter-gatherers began frequenting the vicinity of the modern park at the end of the last ice age, about 10,000 years ago.

The Great Salt Lake

Utah's Great Salt Lake is **THE LARGEST LAKE IN THE UNITED STATES WEST OF THE MISSISSIPPI RIVER.** It covers about 1,700 square miles in the shadows of the grand Wasatch Range. The lake is **a remnant of a prehistoric inland sea called Lake Bonneville** that was once ten times bigger than the Great Salt Lake.

Visitors enjoy boating and swimming in its **WATERS, WHICH ARE SALTIER THAN THE OCEANS,** and sunbathing on white sand beaches. There are also trails for hiking and mountain biking on Antelope Island, a Utah State Park, as well as other stretches of shoreline. A luminescent sunset over the Great Salt Lake—clouds and sky streaked with vivid hues of orange and red—is unforgettable.

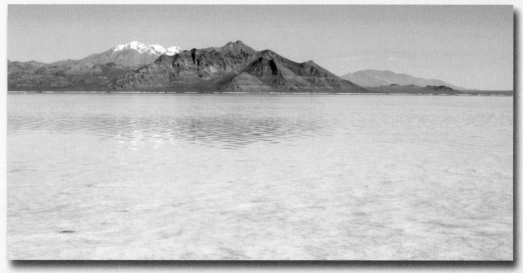

Temple Square

Temple Square in Salt Lake City is the most visited site in Utah. The striking Salt Lake Temple is at its center. This architectural wonder is a living legacy to 40 years of hard work and perseverance.

Work on the Salt Lake Temple began in 1853, six years after Brigham Young led thousands of Mormons to the Great Salt Lake to escape persecution in Nauvoo, Illinois. During the next four decades, workers painstakingly carved granite blocks to create the temple. What kind of construction feat was this? Consider:

- The granite came from Little Cotton-wood Canyon, about 20 miles away.
- Each block weighed a ton or more, and many were transported by ox-drawn wagon.
- Master stonecutters then fit the blocks perfectly into place—without the aid of mortar.

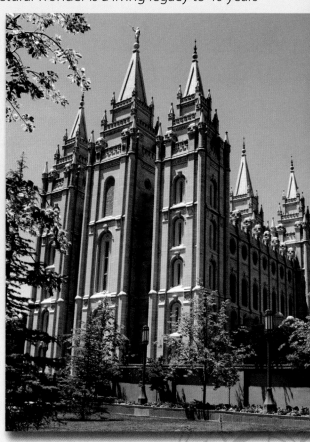

Zion National Park

The **sheer, vibrantly colored cliff and canyon landscape** of Zion stretches across 229 square miles in southwestern Utah. The nine distinct layers of rock found in the park are accented by traces of iron, creating an array of reds, pinks, whites, and yellows, as well as flashes of black, green, and purple.

More than 200 million years ago, the land here was a sea basin, but tectonic forces thrust the land up, and rivers and wind carved the winding canyons.

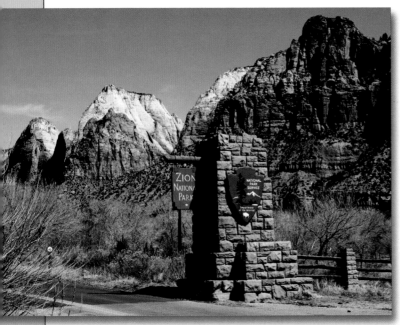

FOSSILS OF SEASHELLS, FISH, TREES, SNAILS, AND BONES HAVE BEEN FOUND EMBEDDED IN THE ROCKS. There are plenty of live animals here, too, including mountain lions and ring-tailed cats. And along the north fork of the Virgin River is a spectacular gorge where the walls of the canyon rise 2,000 to 3,000 feet.

Canyonlands National Park

The wide-open wilderness of sandstone canyons in southeast Utah's Canyonlands National Park is the remarkable product of millions of years of rushing water. The **COLORADO AND THE GREEN RIVERS HAVE SHAPED THIS LANDSCAPE OF PRECIPITOUS CHASMS AND VIVIDLY PAINTED MESAS, PINNACLES, AND BUTTES.**

The rivers meet and merge at **the amazing Confluence in the heart of Canyonlands, dividing the park into four distinct sections.** In the north is the Island in the Sky, a mesa that rises more than 1,000 feet above the rivers. East of the Confluence is the Needles, a landscape of grassy valleys dominated by banded pinnacles.

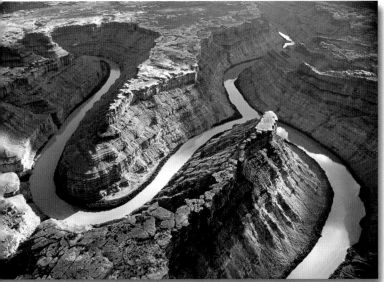

The isolated western area of the park is The Maze, so named for its labyrinth of canyons. The final section, Horseshoe Canyon, is known for its rock art and spring wildflowers.

The Y-shape Confluence of the Colorado and Green rivers is the heart of Canyonlands National Park.

Bryce Canyon National Park

Bryce Canyon is **a spectacular display of geological formations** in southern Utah. It is the sculpted side of the Paunsaugunt Plateau that is a fantasyland covered by thousands of red and orange hoodoos (rock columns). These sandstone towers were left behind when layers of the surrounding rock eroded.

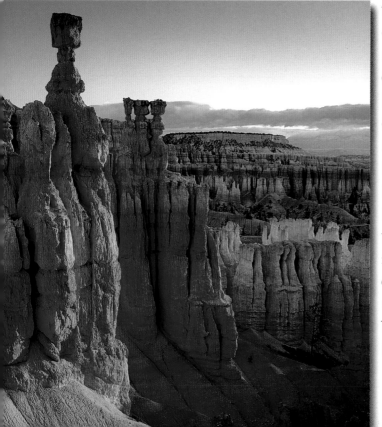

THE SEEDS FOR BRYCE CANYON'S DENSE FOREST OF HOODOOS WERE PLANTED 60 MILLION YEARS AGO, when inland seas and lakes covered the area. Over eons, sediment collected on the lake's floor and congealed into rock. Later, movements in the Earth's crust pushed the Paunsaugunt Plateau skyward, leaving its eastern edge exposed to the ravages of wind and water. The resulting multihued hoodoos are incredible.

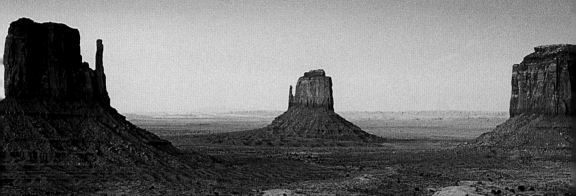

Monument Valley

Mythic-looking monoliths of red sandstone loom over the sandy desert floor of Monument Valley in Utah and Arizona. This Navajo Nation Tribal Park offers some of the most enduring images in the West.

The formations in Monument Valley (known as *Tsé Bii'Ndzisgaii* in Navajo, or "Valley of the Rocks") were pushed through Earth's surface by geological upheaval and then carved by wind and rivers. Among the most recognizable are the 300-foot-tall, precariously narrow Totem Pole; the arch known as Ear of the Wind; and the East Mitten and West Mitten buttes.

Glacier National Park

The perfect geometry scoring the sides of the canyons, valleys, cirques, and mountains of Montana's Glacier National Park is the majestic work of nearly extinct glaciers. During the past 60 million years, these glaciers have melted, contracted, receded, and shaped vast areas of rock and earth in northern Montana.

This is still a land of water, wind, and ice, with a long, determined winter. **Six hundred and fifty-three lakes and 1,000 miles of rivers and streams are shoehorned into roughly 1,600 square miles** (about the size of Delaware). The trail system covering the rugged terrain is a hiker's paradise.

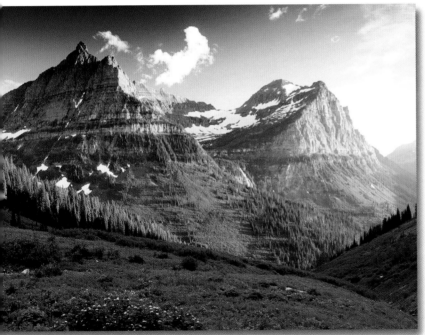

Glacier National Park, named for the rivers of ice that sculpted its dramatic alpine landscape, is the national park many people say they would most like to revisit.

Viewed from the plains east of Glacier National Park, the Rocky Mountains are stunning. They abruptly **rise from 4,000 feet in elevation to more than 10,000 atop the highest peaks,** and then just as precipitously drop off to about 3,000 feet at Lake McDonald in the park's southwestern quarter. To the north, Glacier connects with Waterton National Park in Alberta, Canada, and the two make up International Peace Park, a World Heritage Site.

FLATHEAD LAKE

Flathead Lake (above), which lies just southwest of Glacier National Park, is the largest natural freshwater lake west of the Mississippi River. It is 28 miles long and 15 miles across at its widest point. It is also 370 feet deep at its deepest point, which has helped fuel legends of a prehistoric sea creature lurking in its depths. Sightings of a whalelike beast have been reported for more than a century.

The glaciers here are receding quickly. With global temperatures on the rise, the number of ice shelves has dwindled from historical highs by 50 percent in recent years, and climatologists say the glaciers might be gone in the next century.

Museum of the Rockies

Long before grizzlies and bighorn sheep roamed the Rockies, Montana's claim to fame was wildlife of a different kind—dinosaurs. **About 60 million years ago, the region was tropical.** Local dinosaurs included the *tyrannosaurus rex*, *apatosaurus*, and *triceratops*, all of which thrived until a shift in climate wiped them out.

This rich prehistory is told at Bozeman's Museum of the Rockies, **HOME TO THE LARGEST COLLECTION OF AMERICAN DINOSAUR BONES IN THE WORLD,** nearly all of which were discovered in Montana. Some displays showcase casts, and others hold real fossils, including the largest dinosaur skull in the world (a nine-foot *torosaurus* noggin) and a *T. rex* femur that amazingly revealed soft tissues that had been preserved inside for 68 million years. The exhibits here dig into dinosaur biology and behavior, as well as the science and research that goes into fossil recovery and paleontology.

Lewis and Clark National Historic Trail Interpretive Center

The Lewis and Clark National Historic Trail Interpretive Center in Great Falls, Montana, is **THE LARGEST MUSEUM DEDICATED TO THE LEWIS AND CLARK EXPEDITION** and provides a wealth of information and exhibits about their famous journey. Children can:

- Crawl inside a miniature Native American lodge.
- Pull a rope as if they're portaging waterfalls.
- Attend a day camp along the river, where they can learn how to decorate clothing with beads, set up a wedge tent, and prepare the kind of campfire meal the explorers might have eaten.

The life-size display of Lewis and Clark's portage around the falls of the Missouri River shows how members of the expedition painstakingly hauled canoes and supplies around waterfalls that were between 70 and 80 feet high.

Craters of the Moon National Monument and Preserve

Called by an early visitor **the strangest 75 square miles on the North American continent,** Craters of the Moon National Monument and Preserve in south-central Idaho is **A REMARKABLE VOLCANIC LANDSCAPE POCKMARKED WITH CINDER CONES, LAVA TUBES, DEEP FISSURES, AND LAVA FIELDS.** Rather than one large volcano cone, there are many small craters and fissures through which lava flowed at one time. In some places, the molten lava encased standing trees and then hardened. Eventually, the wood rotted, resulting in bizarre tree-shape lava molds. The landscape is so strange and lunarlike that American astronauts have actually trained at the site.

Hells Canyon of the Snake River

A huge lake once covered the area now bisected by the Oregon-Idaho state line. The rocky bulge of the Owyhee Mountains kept the Snake and Columbia rivers separate until giving way roughly a million years ago. Then the Snake rapidly cut its way through as much as ten miles of igneous rock to join with the Columbia, chiseling out the chasm now known as Hells Canyon of the Snake River.

Today, Hells Canyon is **one of the continent's most dramatic landscapes.** The adjacent mountain ridges rise an average of more than a mile above the

canyon floor, towering over the whitewater below. The pinnacle of He Devil Mountain is almost 8,000 feet higher than the river, making for the deepest gorge in the United States.

THE PACIFIC

Disneyland

Walt Disney envisioned **A PLACE WHERE PARENTS COULD RECAPTURE CHILDHOOD MEMORIES AND ENJOY A MAGICAL WORLD OF FANTASY WITH THEIR CHILDREN.** Disneyland in Anaheim, California, brought this vision to life. Many of its early rides and attractions are still in place and are as popular as ever, attesting to the power and longevity of Disney's imagination.

An adjacent park, **Disney's California Adventure, features rides and attractions including several based on *Cars*.** Mickey's Fun Wheel, on Paradise Pier, is an eccentric wheel, a non-conventional Ferris Wheel. Downtown Disney, located in the middle of the resort complex, is a shopping and dining hub of activity that will keep all ages entertained.

Something old, something new, and everything to delight the family can be found at Disneyland. An old favorite, the Mad Tea Party ride, has been taking families for a spin since the park opened in 1955.

Redwood National and State Parks

Near remote stretches of northwest California's oceanfront, the water, soil, and sun blend perfectly for redwood growth. The results are the astounding redwood forests. More than 100,000 acres of soul-stirring forest are protected under the auspices of Redwood National and State Parks—**THE LAST SPOT IN NORTH AMERICA WHERE THE TREES THRIVE IN SIZE AND NUMBER.**

Imagine this: The tallest redwood in the parks is more than twice as tall as the Statue of Liberty. The parks' tallest trees, located in the aptly named Tall Trees

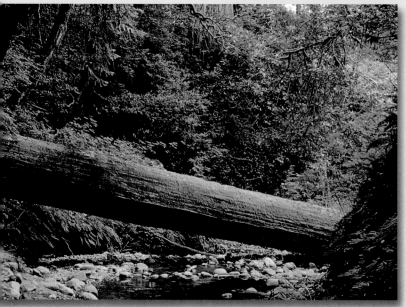

Grove, measure about **360 feet from base to treetop, heights that have taken them more than 600 years to attain.**

The cycles of tree growth and rot supply nutrients to a host of plants and fungi, and the lush greenery makes a great habitat for small creatures,

such as voles and banana slugs, and large animals, including a sizable elk herd.

TALL TREE TALES

The coast redwood, *Sequoia sempervirens*, is the tallest known plant species in the world. Fossil records have shown that this type of redwood thrived during the Jurassic era 160 million years ago, and it has changed little since then.

- The oldest specimen of coast redwood was logged in 1933—it was 2,200 years old.
- Coast redwoods can reach heights of more than 360 feet, which is as tall as a 35-story skyscraper.
- The diameter at the base of a redwood can be as much as 22 feet.
- These redwoods can weigh up to 1.6 million pounds.
- The bark can be up to 12 inches thick.

Sequoia and Kings Canyon National Parks

General Sherman is the leader among trees. This huge sequoia tops off at 275 feet—as tall as a 26-story building. It is Sequoia's most famous resident and is **one of the largest living organisms in the world**—its diameter is a gargantuan 36 feet. Thousands of General Sherman's relatives fill the pristine forests of these two spectacular national parks, which are in central California, east of Fresno.

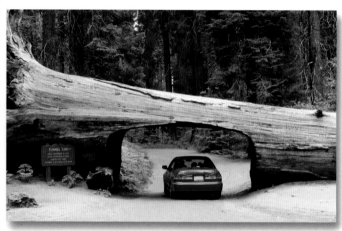

The drive-through in Sequoia National Park is open 24 hours! Before this sequoia fell in 1937, it stood 275 feet high. Rather than attempt its removal, the park service carved a tunnel through it that measures 17 feet wide and 8 feet high.

The best place to see these breathtaking giants is suitably named the **GIANT FOREST, HOME TO FOUR OF THE FIVE TALLEST TREES IN THE PARK.** Visitors also enjoy the park's diverse landscape, which includes deep canyons, granite cliffs, wildflower-filled meadows, a wild river, and a 1,200-foot waterfall.

Point Reyes National Seashore

The peaceful, pastoral Point Reyes Peninsula is a world apart from San Francisco, just 22 miles to the south. From its eastern boundary, Inverness Ridge, to the Pacific Ocean, the peninsula is **A LAND OF WINDSWEPT BEACHES, GRASSLANDS, AND FOREST. IT'S THE WINDIEST SPOT ON THE WEST COAST.**

The entire Point Reyes Peninsula is in perpetual motion—**it's moving northwest at approximately two inches a year.** The peninsula lies on the Pacific Plate along the San Andreas Fault. Along the fault, pressure builds up gradually when the plates shift, and the fault eventually gives way—in other words, an earthquake occurs. The biggest earthquake was in 1906, when the entire peninsula shot 20 feet northwest in an instant.

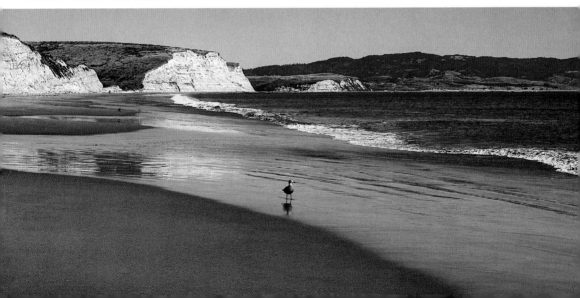

Napa Valley Vineyards

Napa Valley is only five miles across at its widest point and 30 miles long, but its reputation stretches around the world. About 50 miles north of San Francisco, **the valley is home to roughly 100,000 people, five incorporated cities, and at**

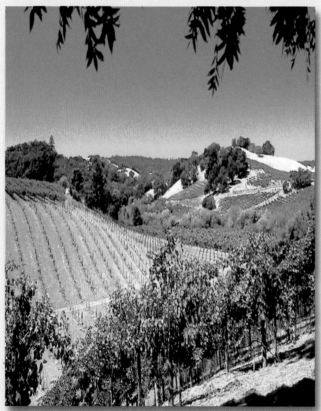

least 300 wineries. The long-standing success of the local wine industry is a result of the climate and soil, which are ideal for growing grapes. The soil is especially diverse: HALF OF THE VARIETIES OF SOIL ON THE PLANET ARE FOUND WITHIN THE CONFINES OF NAPA VALLEY.

The valley was carved by the Napa River, which flows directly into the San Francisco Bay and attracts anglers and paddlers. But most visitors come for the fresh air, the good food, and, of course, the great wine.

Chinatown

San Francisco's Chinatown is **THE LARGEST CHINATOWN ON THE CONTINENT,** and it explodes with color every day of the year. Chinatown is **one of the Bay Area's most visited tourist hotspots,** with plenty of eateries, bars, and shops. But it also serves as an authentic neighborhood where people live, work, and play.

If you're in San Francisco around the beginning of the year, you might be lucky enough to see **the Chinese New Year Parade (a San Francisco tradition since just after the 1849 Gold Rush).** This is now **the biggest illuminated nighttime parade in North America.** In fact, it's the largest event of its kind on any continent except Asia.

Golden Gate Bridge

San Francisco's Golden Gate Bridge does for the West Coast what the Statue of Liberty and the Manhattan skyline do for the East: **It welcomes newcomers while proclaiming the golden, youthful promise of the New World.**

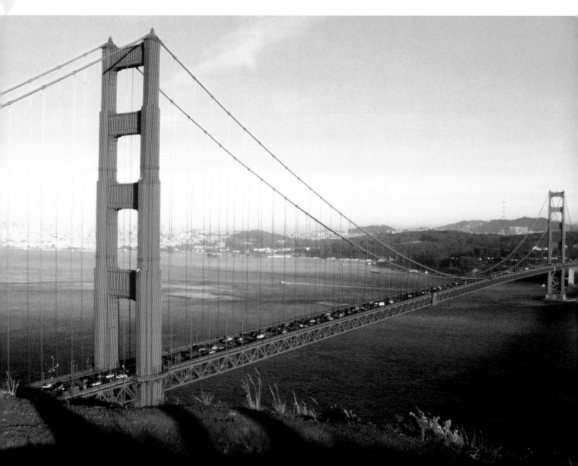

The bridge was named not for its color (it's actually orange vermilion) but because **it spans the Golden Gate Strait,** named by explorer John C. Fremont. Some opponents argued that only steel gray or carbon black paint could protect the bridge; the U.S. Navy wanted it painted yellow with black stripes. The bridge's architect, Irving Morrow, insisted paint could be invented to protect and burnish the bridge's graceful, sinewy architecture and increase its visibility in fog while blending with its natural surroundings. He was right: The bridge didn't require an overall repainting for 27 years.

The Golden Gate Bridge saved San Francisco from its isolation on a peninsula. The bridge—which, **at 4,200 feet from tower to tower, reigned as the world's longest suspension bridge for 27 years**—heralded an era in which suspension bridges defined modernism. The bridge forged the way to a generation of graceful, buoyant Art Deco architecture in the midst of the Great Depression.

The beautiful bridge is also the **centerpiece of the Golden Gate National Recreation Area.** Golden Gate is the most popular destination in the national parks system, with more than 14 million visitors each year. The 74,000-acre expanse contains such destinations as China Beach, Muir Beach, Fort Mason, and Alcatraz Island. It also includes the Presidio of San Francisco, which was established by the Spanish in 1776 and has become the oldest continuously operating U.S. military base.

Alcatraz Island

Kids will love their visit to **the country's most noted lockup,** where audio tours discuss some of the various escape attempts that have become a part of the island's history. Even though Alcatraz is only about one mile off San Francisco's shore, **MOST WOULD-BE ESCAPEES WERE SWEPT OUT TO SEA BY THE TREACHEROUS CURRENTS OF THE SAN FRANCISCO BAY OR DIED OF EXPOSURE IN THE ICY PACIFIC OCEAN.**

The boat trip to Alcatraz Island is just part of the entertainment. You'll find tour boats docked between Fisherman's Wharf and Pier 39. This area offers a hodgepodge of tourist delights, and youngsters will love browsing the souvenir shops and watching the street performers while you wait for your boat. You'll be treated to **breathtaking views of the San Francisco skyline and the Golden Gate Bridge** as you travel across the bay to Alcatraz.

Winchester Mystery House

In 1884, **Sarah Winchester,** heiress to the Winchester Rifle Company, visited a fortune-teller after the death of her husband and their baby daughter. The medium told her that her fate was tied to her house: **CONTINUOUS BUILDING WOULD APPEASE THE EVIL SPIRITS AND HELP HER ATTAIN ETERNAL LIFE.** Winchester took the premonition very seriously. **She continued building her San José, California, mansion for the ensuing 38 years,** spending the bulk of her multimillion-dollar inheritance in the process.

When the hammering finally stopped after Winchester's death in 1922, there were:

- 160 rooms
- 40 staircases, some of which (along with many doors) lead nowhere
- 52 skylights
- Many design elements that Winchester believed would ward off the evil spirits, including stained glass that seems inspired by a disturbing spiderweb
- Zero blueprints, although Winchester did sketch plans for rooms on paper and sometimes tablecloths

Yosemite Valley

The unmistakable panorama of Yosemite Valley in central California reveals **A DAZZLING WONDERLAND OF GRANITE SCULPTED OVER EONS BY ICE, WIND, AND WATER.** Waterfalls cascade down the granite cliffs, the most famous of which is Yosemite Falls, at 2,425 feet the tallest waterfall in North America—the equivalent of 13 Niagaras.

Yosemite Valley is bookended by two famous geologic masterworks. These hulking, distinct formations are known worldwide: **Half Dome** rises 4,800 feet above the eastern end of the valley, while the 3,600-foot **El Capitán** (Spanish for "the captain") stands sentry at the western entrance, **fronted by one of the sheerest cliffs in the world.** As any visitor to Yosemite quickly learns, it's difficult to take a photograph in Yosemite Valley without framing this handsome pair. The peaks and meadows of today's landscape in Yosemite Valley are the work of glaciers. The slow-moving sheets of ice carved this masterpiece over the course of three million years, expanding and contracting and tearing granite asunder.

The 2,425-foot ribbon of water known as Yosemite Falls is just one of many superlative sites visitors gawk at from the valley floor.

The transcendent scenery, sheer beauty, and untamed nature of Yosemite Valley draw a crowd. With **more than three million visitors each year,** the summer traffic can get quite thick. At times, the valley's population exceeds 20,000, making it the center of activity for the entire Sierra Nevada region. Crowds form at the developed areas, the hotels, and the various eateries throughout the valley, but there's still plenty of room to roam.

The landmark granite formation Half Dome was once considered impossible to climb.

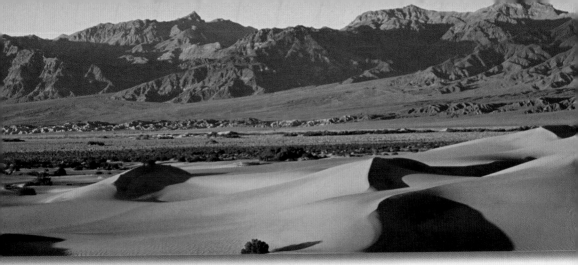

Death Valley National Park

A brutally beautiful land of extremes, Death Valley, which is near the California-Nevada border, northwest of Las Vegas, holds the record for the highest temperature ever recorded in the Western Hemisphere—134 degrees Fahrenheit. Average annual rainfall here is less than two inches, which makes Death Valley the driest spot on the continent. It also contains the lowest point in the western hemisphere—near Badwater, where the surface is 282 feet below sea level. But the park ventures to other extremes, as well. Telescope Peak is 11,049 feet above sea level and gets plenty of snow in wintertime.

At 3.3 million acres, Death Valley is **THE LARGEST U.S. NATIONAL PARK OUTSIDE ALASKA.** The vast and varied landscape includes seemingly endless salt and alkaline flats, swaths of ever-shifting sand dunes, and colorful rock cliffs and ridges.

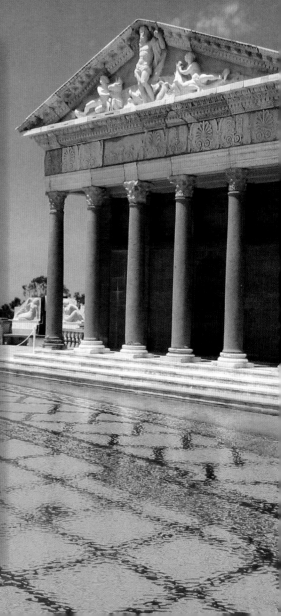

Hearst Castle

Over the course of nearly three decades, newspaper baron William Randolph Hearst built this luxurious and legendary home on the 250,000-acre San Simeon, California, ranch he inherited in 1919. An opulent example of Mediterranean Revival architecture, the estate's prime attraction is Casa Grande, the 60,645-square-foot main house. Its more than 100 rooms are the setting for Hearst's priceless collection of European art and antiques. The estate includes a trio of luxurious guest abodes and SOME OF THE MOST MAGNIFICENT SWIMMING POOLS IN ALL OF CALIFORNIA, INCLUDING THE STUNNING MARBLE NEPTUNE POOL.

Today, Hearst Castle is a tourist attraction (the Hearst Corporation donated it to the state in 1957). It remains a tribute to wealth and power beyond almost anybody's wildest dreams.

La Brea Tar Pits

Rancho La Brea is in the heart of urban Los Angeles, so it's hard to imagine that millions of years ago it was submerged in the ocean, teeming with sea life. When the Pacific Ocean receded about 100,000 years ago, sediments sheathed the area and fossil fuels formed below the surface.

About 40,000 years ago, oil began to seep through the labyrinth of fissures and permeable rock, creating what are now known as the La Brea Tar Pits. Back then, dire wolves, sabertooth tigers, mastodons, mammoths, and giant sloths roamed the area. The oily tar pits captured and trapped many animals one by one. These animals' unfortunate fate translates into an exceptional fossil record preserved in the pits. Archaeologists have unearthed an entire prehistoric ecosystem here, from plants and insects to camels and bison.

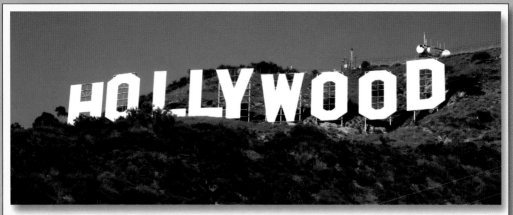

Hollywood

Hollywood is not just a place. In certain contexts, Hollywood is **shorthand for America's film industry.** In others, it's the destination for every aspiring actor, director, or screenwriter. It's also the setting for so many legends and rumors it's hard to keep them straight.

Regardless, Hollywood is amazing. The rolling Hollywood Hills, clad in a lush layer of greenery, cradle neighborhoods of all kinds and feature a **ONE-OF-A-KIND AMERICAN ICON, THE HOLLYWOOD SIGN.** Down below, on Hollywood Boulevard, the sidewalk sports 2,000 terrazzo-and-brass stars that immortalize giants of the entertainment industry. The street is a colorful spot for people-watching and is the address of **Grauman's Chinese Theatre, perhaps the most famous cinema in the world.**

San Diego Zoo

From the tiny shrew to the mighty elephant, the San Diego Zoo offers visitors some of the world's most exceptional animals. **As one of the finest zoos on the continent, it is home to more than 3,800 creatures representing 800 species.**

The **Lost Forest** allows you to visit a number of primates, including Bonobos, gorillas, orangutans, as well as hippos, okapis, and more. You'll even travel through a bog garden and see carnivorous plants along its pathways. Along the Tiger Trail, a simulated Asian rainforest contains mist-shrouded trails that wind down a canyon where tigers, tapirs, and other creatures wander among exotic trees and plants. In Panda Canyon, you can see some of the most popular animals, giant pandas, as well as red pandas.

Several play areas are located throughout the zoo: the Polar Play Area allows children to investigate a polar bear den, while they can dig for fossils at the Elephant Play Yard.

Nearby, the San Diego Zoo Safari Park offers visitors a chance to see many endangered species in open-range enclosures.

SeaWorld

Though there are a number of SeaWorld locations, the first opened in San Diego in 1964. Visitors can see a number of marine animals, including stingrays, cephalopods, turtles, penguins, and sharks—and the park's signature orca whales.

The park has a collection of rides that includes water coasters; raft rides; and the Wild Arctic experience, where guests find themselves on a stomach-twirling simulated helicopter ride to a remote Arctic research station. If you're up for it, check out the 280,000-gallon shark exhibit that features a 57-foot-long acrylic tunnel that allows you to walk right through a school of sharp-toothed predators.

Santa Catalina Island

Only 22 miles from Los Angeles, quiet Santa Catalina Island seems a world apart from the hustle and bustle of the big city across the water. It's **A LAID-BACK, TRAFFIC-FREE, CLEAN-AIR VACATION SPOT** that offers hiking, snorkeling, kayaking, and exploring.

Visitors take ferries from San Pedro, Long Beach, or Dana Point to get to one of Catalina's two principal towns: Avalon, with its famous old casino, or the more isolated Two Harbors. Both towns have **picturesque harbors where boats of all sizes and shapes are anchored.** Most of the island's beaches are somewhat rocky, but there's plenty to do besides lounge in the sand. Lover's Cove, a protected marine preserve, is a short walk from Avalon and is an excellent spot for snorkeling. The fish are plentiful and used to people, thanks to frequent feedings from passengers on the glass-bottom boats that tour the area.

Monterey Bay Aquarium

One of the finest aquariums in the United States—and quite possibly the world—the Monterey Bay Aquarium attracts almost two million visitors a year,

and it's easy to see why.

The aquarium is located in the converted former Hovden Cannery, which canned squid and sardines until the early 1970s on Monterey's legendary Cannery Row. The aquarium is **HOME TO MORE THAN 30,000 AQUATIC CREATURES, WITH EVERYTHING FROM JELLYFISH TO SHARKS.** The exhibits are fed by water that comes directly from Monterey Bay, which hosts one of the most diverse marine ecosystems on the planet. The mudflats, kelp forests, and nutrient-rich water support all sorts of sea life in the confines of the bay.

Exploratorium

You'll never hear the words "hands off" or "don't touch" at this San Francisco family favorite. On the contrary, this wonderful museum teaches children about the world and the way it works through the hands-on, touch-and-tinker experiences of more than 650 permanent exhibits, such as:

- **Shadow Box,** a darkened room with phosphorescent vinyl wallpaper that freezes your shadow on the wall when a strobe light flashes.
- **Tornado,** where a ten-foot-tall tornado alters its shape when you place your hands in it.

- **The Wave Organ,** a wave-activated acoustic sculpture located a short walk from the Exploratorium on a jetty in San Francisco Bay. The intensity and complexity of **THE MUSIC MADE BY THE WAVES IS DIRECTLY RELATED TO THE TIDES AND WEATHER.**

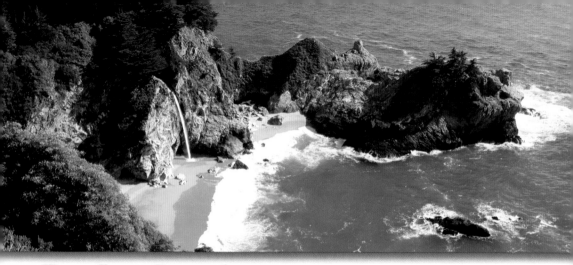

Big Sur Coastline

This scenic stretch of coastline has a breathtaking beauty that invites many stops for pictures. **ONE MINUTE YOU'RE STANDING ATOP A HIGH CLIFF LOOKING DOWN AT A CRASH-ING SAPPHIRE SEA, AND THE NEXT YOU'RE HIKING THROUGH A MISTY REDWOOD FOREST.** The Big Sur coastline begins just south of Monterey, California, where Point Lobos Reserve encompasses a group of headlands, coves, and rolling meadows. Hiking trails follow the shoreline, where you'll probably catch a glimpse of sea otters floating on their backs and snacking on abalone. **Between the months of December and May, migrating gray whales are a common sight.**

Another must-see is Jade Cove, accessible by a rugged, rocky pathway to the beach. Pieces of jade litter the pebbly shoreline, and visitors are allowed to take home what they can carry.

Pioneer Courthouse Square

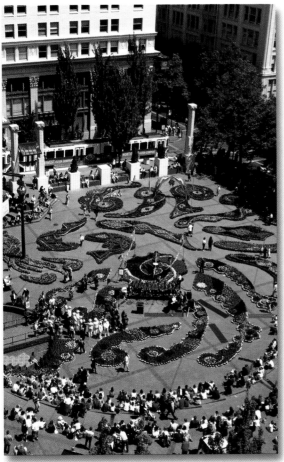

Pioneer Courthouse Square in Portland, Oregon, is **nicknamed "Portland's Living Room."** And like every good living room, the square offers entertainment and plenty of seating space. The square attracts millions of visitors each year, many coming to see:

- The two amphitheaters that host more than 300 happenings every year, including concerts and cultural festivals.
- The annual midsummer Festival of Flowers.
- The fountain; pillars; sculptures; and the astounding Weather Machine, an innovative creation with three symbols that each represent an element of Portland's climate.

Crater Lake National Park

The intense blue of Crater Lake is striking. The vivid color is due in part to the depth of this freshwater lake. **At its deepest, the lake's floor plunges 1,932 feet below the surface, making it the deepest lake in the United States.**

This lake in southwest Oregon was created centuries ago when rain and snowmelt filled a caldera, a huge bowl that was the remnant of a volcano. During some years, the lake is replenished by wintertime snowfalls of 50 feet or more. **Because no water flows through the lake, it remains pure and tranquil.**

Scientists have discovered evidence of hydrothermal vents near Crater Lake's floor, which may play an important role in the lake's ecology. **Green algae grows at a record depth of 725 feet below the surface,** indicating that sunlight may penetrate deeper into Crater Lake than any other body of water in the world.

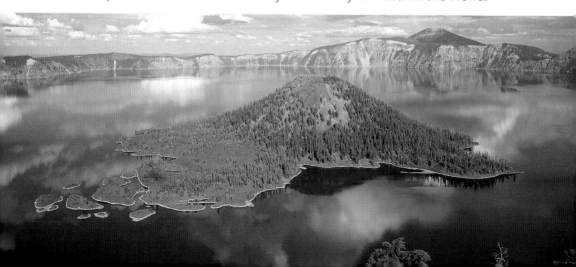

Mount Hood

A picture-perfect mountain, Mount Hood is a visual reminder to city dwellers in Portland that the great outdoors is just a short drive away— only 47 miles east. **At 11,239 feet above sea level, the peak is the fourth-highest in the Cascade Range.**

Like all of its Cascade brethren, Mount Hood is **a volcano, and an active one** at that. It erupted twice in the mid-1800s and has had at least four eruptive periods in the past 15,000 years. The volcanic cone atop the mountain is dominated by snow and ice, with glaciers and snowfields shrouding it year-round.

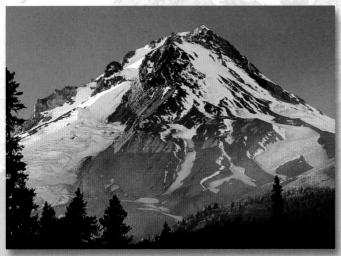

Mount Hood is a **RECREATIONAL PARADISE, WITH POPULAR SKI RESORTS, HIKING ROUTES, AND BACKCOUNTRY TRAILS.** The historic Timberline Lodge is perched at 6,000 feet above sea level and fills to capacity during ski season—which sometimes goes all year long.

Newberry National Volcanic Monument

In the heart of central Oregon's Deschutes National Forest, Newberry National Volcanic Monument sits atop **AN ACTIVE GEOTHERMAL HOTSPOT.** The crux of this hotspot is the huge Newberry Volcano. When Newberry last erupted about 1,300 years ago it created **a devastatingly beautiful caldera.** Located at the summit of the volcano almost 8,000 feet above sea level, the nearly 20-square-mile Newberry Caldera has **TWO IDYLLIC ALPINE LAKES, ONE OF WHICH DRAINS INTO A MAGNIFICENT WATERFALL.**

The striking boundary between spared forest and volcanic devastation in Newberry National Monument is unmistakable.

The volcano's flanks of hardened lava are dotted by hundreds of cinder cones and fissure vents. One especially massive cinder cone, Lava Butte, rises 500 feet above its surroundings and was the source of the lava that flowed over this entire area 7,000 years ago. Today, the once-red-hot landscape can be explored via the Trail of the Molten Land.

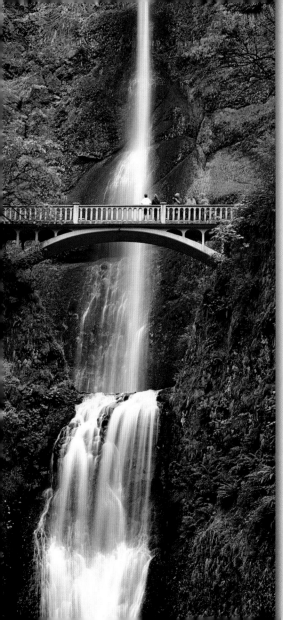

Multnomah Falls

Ancient Multnomah Falls is a sight to behold. Cascading from its origin on Larch Mountain, it highlights the picturesque Columbia River Gorge in central Oregon. **At 620 feet, it's the second-tallest year-round waterfall in the nation.** The falls are fed by an underground spring that provides a continuous flow of crystal-clear water that's enhanced by seasonal snowmelt and spring rainstorms.

Many visitors take the foot trail up to **BENSON BRIDGE FOR ONE OF THE BEST SPOTS TO VIEW THE FALLS.** Look up to see the thin ribbon of the upper falls, or peer down to see the powerful lower cascade as it empties into the Columbia River. From the bridge, a mile-long trail leads to Larch Mountain Lookout at the top of the upper falls, providing a command-ing view of the Columbia River Gorge.

Astoria-Megler Bridge

Critics call it **"The Bridge to Nowhere,"** and the Astoria-Megler Bridge in northwestern Oregon often appears as just that: a bridge snaking into a soggy fogbank, with miles of water on all sides. **It spans four miles across the mouth of the Columbia River near where it empties into the Pacific Ocean.**

The bridge connects Astoria, Oregon, to Point Ellice, Washington. Opened in 1966, it replaced the congested ferry system that had previously linked the communities. Despite the "Bridge to Nowhere" nickname, the Astoria-Megler Bridge has been a success. **It carried a quarter-million vehicles in its first full year and was the last link in U.S. Highway 101, which connects Mexico to Canada.**

Pike Place Market

Pike Place Market is one of Seattle's most famous landmarks and tourist attractions. **MORE THAN 100 FARMERS AND 200 ARTISTS AND CRAFTSPEOPLE OCCUPY THE MARKET'S THREE LEVELS,** which offer the best of Washington's seasonal flowers and produce.

Visitors can shop among the vivid colors of exquisite tulips and daffodils in early spring and enjoy juicy golden Rainier cherries in early summer, blueberries in August, and all kinds of high-quality, locally grown produce year-round.

The fishmongers put on one of the best shows in town. They toss the catch of the day through the air like footballs as they engage the customers in all kinds of banter. They often pick up the largest fish they can shoulder and invite a visitor to pucker up for a kiss.

Seattle Space Needle

Seattle's Space Needle is the most popular tourist attraction in the city, receiving **more than a million visitors each year.** Originally built for the 1962 World's Fair and still the defining feature on the Emerald City's skyline, the 605-foot Space Needle was **THE TALLEST BUILDING WEST OF THE MISSISSIPPI WHEN IT WAS COMPLETED IN LATE 1961.**

The **futuristic blueprints** for the Space Needle evolved from artist Edward E. Carlson's visionary **doodle on a placemat.** His collaboration with architect John Graham resulted in a prototype space-age design that looks a bit like a flying saucer balanced on three giant supports. But appearances can be deceiving—the Space Needle isn't going anywhere. Some fast facts about Seattle's iconic work of art:

- The bolts that anchor it to its foundation are 30 feet long.
- The structure was built to withstand winds of up to 200 miles per hour. Wind does cause the needle to sway, but the top house has only closed once—for an hour-and-a-half in 1993 due to 90-mile-per-hour winds.
- The elevators travel at about ten miles per hour, making the trip from the ground to the observation deck 41 seconds long.
- The world's second-oldest revolving restaurant sits at the top of the Space Needle.

Olympic National Park

Olympic National Park, in northwestern Washington, is **HOME TO ONE OF THE MOST LUSH, IMPENETRABLE RAINFORESTS ON THE PLANET.** Some areas in the park get up to 167 inches of rain a year—more than any other spot in the continental United States. The rain supports a landscape covered by moss, lichen, and fern, giving the forest a vibrant green glow.

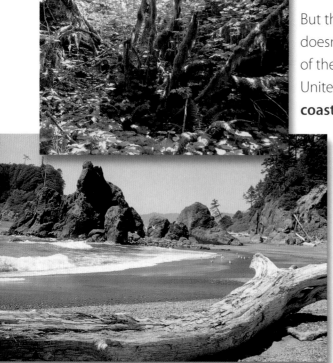

But the beauty of Olympic National Park doesn't end with the rainforest. It is one of the most diverse national parks in the United States. The untouched Pacific **coastline is ruggedly beautiful, and the majestic Olympic Mountains rise from the heart of the peninsula.** Although the western side of the park is deluged by rain, the eastern side is just the opposite—it's one of the most parched spots on the West Coast north of Los Angeles.

Remarkably diverse, Olympic National Park is home to dense rainforests (top) and isolated beaches (below).

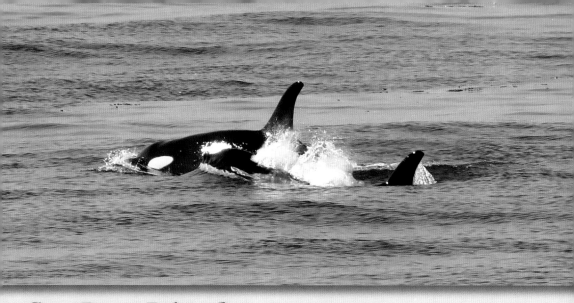

San Juan Islands

North of Seattle in Puget Sound sits the San Juan Archipelago, **a collection of 172 named islands and another several hundred rocky island outcroppings that appear at low tide.** Although about 40 of these idyllic islands are inhabited, most people living here reside on the four that have ferry service: San Juan, Orcas, Lopez, and Shaw.

The islands' **SHELTERED WATERS ARE HOME TO HARBOR SEALS, SEA LIONS, SEA OTTERS, DOLPHINS, AND ORCAS.** Whale watching is a popular pastime, particularly around Friday Harbor on San Juan Island. Take a whale-watching boat tour or head to Lime Kiln Point State Park to play in the sand and watch orcas feed just 30 feet from shore.

Mount Rainier National Park

The world of snow and ice atop Mount Rainier, 14,410 feet above sea level and 70 miles from Seattle, never thaws. At times, the annual snowfall exceeds 90 feet on the mountain's slopes. But below Mount Rainier's frosty covering, conditions

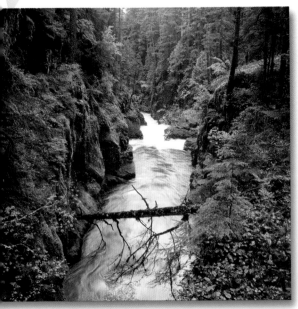

are the polar opposite: Inside, the mountain is **an active volcano, and it's the tallest one in the volcanic Cascade Range.**

Mount Rainier last erupted in the mid-19th century, leaving a small crater near the peak. Although the mountain has been quiet for more than 100 years, **MANY SCIENTISTS BELIEVE MOUNT RAINIER IS DUE FOR AN ERUPTION ANY DAY NOW—GIVE OR TAKE A FEW THOUSAND YEARS.** Mudflows from past eruptions snaked right through what is now downtown Seattle.

The frigid climate at Rainier's peak fuels a number of glaciers. In winter, snow and ice accumulate, and the summer warmth then melts some of the ice. The glaciers currently cover 36 square miles on Mount Rainier, amounting to about a cubic mile of ice and snow. Rainier has **more glacier cover than any other mountain in the**

continental United States. However, the glaciers have been receding since the early 1980s, and all the water from that melting feeds the vibrant wildflowers. Come summertime, Rainier's subalpine meadows explode with color as lupines, monkey-flowers, asters, and myriad other species bloom. **THE KALEIDOSCOPE OF MULTIHUED FLORA IS A STARTLING CONTRAST TO THE STARK BLUE AND WHITE OF THE LOOMING PEAK.**

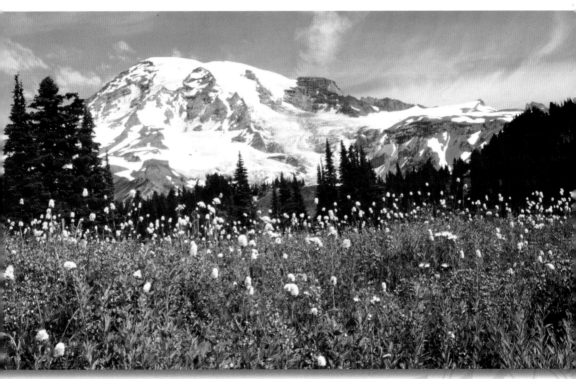

Mount St. Helens

Washington's Mount St. Helens is **perhaps the most famous volcano in the United States.** It earned its reputation the morning of May 18, 1980. The mountain shook, and **ITS NORTH FACE CASCADED INTO A LAHAR, A MASS OF WATER AND STEAM COMBINED WITH VOLCANIC DEBRIS.** This created a towering mushroom column of ash that blotted out the sun and drifted into Idaho and beyond.

Two years later, President Ronald Reagan signed a bill making Mount St. Helens a National Volcanic Monument, allowing the ecosystem to respond naturally to the eruption. Mount

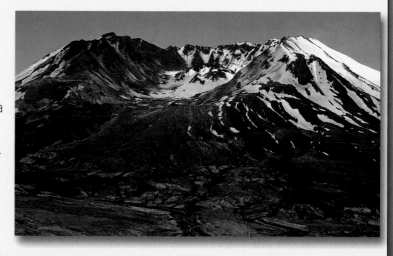

St. Helens National Volcanic Monument attracts scientists who use it as **a living laboratory,** as well as hikers and other outdoors buffs. In recent years, Mount St. Helens **HAS SHOWN NEW SIGNS OF ACTIVITY, WITH A LAVA DOME GROWING UNDER THE CRATER LEFT FROM THE 1980 ERUPTION.**

Museum of Glass

The Museum of Glass is Tacoma, Washington's splashy contribution to the contemporary art world. Its works in different media have one thing in common: They all incorporate glass.

Visitors can browse permanent and temporary **EXHIBITIONS OF ALL KINDS OF CONTEMPORARY GLASS ART.** The museum's Visiting Artist Collection is permanent, featuring works created on-site in the Hot Shop Amphitheater. The Hot Shop has hot and cold glass studios and seating for 138 visitors.

The Chihuly Bridge of Glass connects the museum to downtown Tacoma. The 500-foot steel-and-glass pedestrian bridge is adorned with colorful glass spires. It serves as not only a walkway but also as a display providing a preview of the stunning glass art masterworks in the museum.

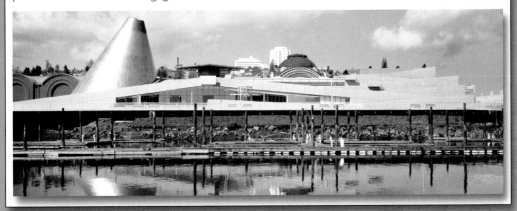

Denali National Park and Preserve

Denali means "The High One" in the native Athabascan tongue. It's an apt moniker, considering that the 20,320-foot-tall mountain—also known as **Mount McKinley**—is North America's highest peak. It's also one **of the most striking mountains in the world**—when it's visible from the surrounding subarctic plateau.

Because the park is so far north—240 miles north of Anchorage, Alaska—its mountains are not forested like the Rockies and the Sierra Nevada. At Denali's northern latitude, the timberline falls between 2,000 and 3,000 feet. Below the rugged high country are tundra-covered lowlands. Immense glaciers connect the two, creeping down Denali and the neighboring peaks.

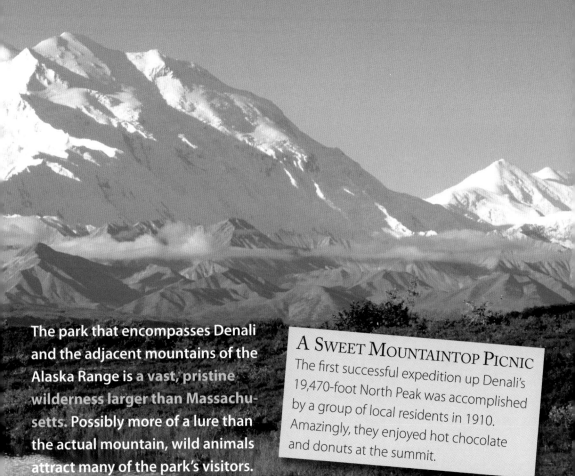

The park that encompasses Denali and the adjacent mountains of the Alaska Range is a vast, pristine wilderness larger than Massachusetts. Possibly more of a lure than the actual mountain, wild animals attract many of the park's visitors. Denali has earned the nickname "The Subarctic Serengeti" for its thriving wildlife population. Denali's "big five" mammals are grizzly bears, gray wolves, **caribou, Dall's sheep, and moose.**

A Sweet Mountaintop Picnic

The first successful expedition up Denali's 19,470-foot North Peak was accomplished by a group of local residents in 1910. Amazingly, they enjoyed hot chocolate and donuts at the summit.

Glacier Bay National Park and Preserve

Glacier Bay is Alaska's southernmost national park. It is also **A LIVING LABORATORY WHERE SCIENTISTS STUDY GLACIAL RECESSION.** The ice in and around Glacier Bay is melting at a remarkable pace; in fact, the phenomenon is **the fastest glacial retreat on record.**

When Captain George Vancouver first charted these waters in 1794, what is now the bay was little more than an indention in a vast sheet of ice that extended for hundreds of miles. During the next 200 years, the glaciers receded more than 60 miles, creating a masterpiece of rock, ice, and water.

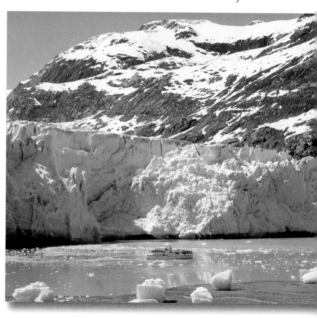

Today, **massive glaciers and majestic mountains, some of which have peaks 15,000 feet above sea level, ring Glacier Bay.** The bay is also a critical wildlife habitat, sustaining humpback whales, orcas, porpoises, seals, and sea otters in its waters and moose, black bears, brown bears, wolves, and deer on the surrounding shore.

Saxman Native Totem Park

This is **the world's largest totem park, consisting of two dozen ornate totem poles** in Saxman, near Ketchikan in southeast Alaska. Most of the poles are not dated and were reclaimed from abandoned Tlingit villages in the 1930s by the Civilian Conservation Corps and the United States Forest Service.

Each totem pole at Saxman Native Totem Park is unique. **THE COLORFUL CARVINGS SHARE THE STORIES OF THEIR MAKERS AND THE STORIES OF THE VILLAGES WHERE THEY ONCE STOOD.** Among the fascinating totems in the park are:

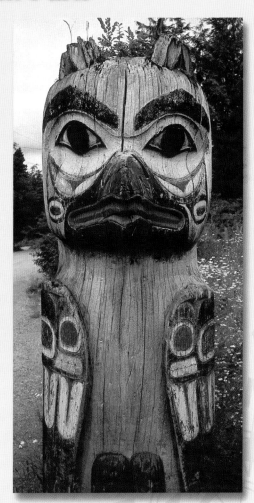

- The "Sea-Bear Pole," which has a bear-figure base capped by the long fin of a killer whale
- A memorial pole to a man who died fishing for octopus
- A totem that relates to the Tlingit legend, "The Princess and the Frog Clan People"

Mauna Loa

Part of Hawaiian Volcanoes National Park, Mauna Loa (meaning "Long Mountain") rises 13,677 feet above the blue surface of the Pacific Ocean. Although many mountain peaks rise higher than Mauna Loa, its actual size is nothing short of astonishing. **Measured from its base, which is 18,000 feet underwater, Mauna Loa exceeds even Mount Everest in height—by a full 2,000 feet.**

Atop the summit of Mauna Loa, a caldera called Mokuaweoweo features a number of craters that have previously erupted. The caldera floor is covered with lava contorted into otherworldly formations, daunting pits, and towering cinder cones. **CURRENT-DAY ERUPTIONS WITHIN THE CRATER OF THE VOLCANO ARE RELATIVELY HARMLESS. VOLCANOLOGISTS HAVE BEEN ABLE TO RELIABLY PREDICT ACTIVITY.** Because of this, an impending eruption typically draws thousands of people to the crater's rim.

Haleakala National Park

As legend has it, a long time ago the god Maui captured the sun in a great mountain's summit basin on a Hawaiian island. The mountain came to be known as Haleakala, Hawaiian for "House of the Sun."

Haleakala is actually an enormous volcano that—although dormant since 1790—is a striking reminder of the power seething below the Earth's surface. Impressive cinder cones and lava sculptures on the upper slopes of Haleakala are lasting remnants of furious, tumultuous moments in its past.

At the base of Haleakala, the lush, green Kipahulu Valley unravels to the coast. This tropical ecosystem is a distant memory from the volcano's 10,000-foot summit: Guava trees and ferns below give way to yellow brush known as mamane and the silversword plant, unique to the volcano.

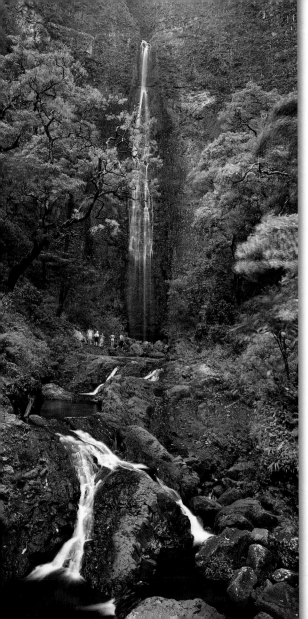

Hanakapi'ai Falls

Named for a Hawaiian princess, Hanakapi'ai Falls on the northwestern side of the island of Kauai is **THE PICTURE OF TROPICAL PARADISE.** The beautiful, 300-foot ribbon of water delicately cascades down a rugged volcanic wall, tumbling into an idyllic pool.

The falls are **a popular destination for experienced hikers.** The four-mile Kalalua Trail, which leads to the falls, begins at Ke'e Beach. From Ke'e Beach, follow the trail upslope to the Hanakapi'ai Valley, a lush cradle of greenery dotted with a vibrant array of wildflowers. From there the trail continues down to the secluded Hanakapi'ai Beach and the start of the final two-mile leg to Hanakapi'ai Falls. Once you reach the falls, you'll be rewarded with breathtaking views and a relaxing swim in its tranquil pools.

Waimea Canyon

Dubbed **"The Grand Canyon of the Pacific"** by Mark Twain, Waimea Canyon's sharply eroded cliffs reveal layers of vivid colors that seem to change in the sun. Unlike the Grand Canyon, plentiful rainfall keeps this canyon and its surrounding area thick with vegetation, and visitors are frequently treated to the sight of vivid rainbows. At ten miles long, one mile wide, and more than 3,500 feet deep, this landmark on the Hawaiian island of Kauai is **THE LARGEST CANYON IN THE PACIFIC.**

Waikiki Beach

THIS FAMOUS TWO-MILE STRETCH OF SAND in Oahu is home to scores of family-friendly beach hotels and all kinds of action-packed excitement. Kids will enjoy strolling along the beachfront promenade, stopping for shaved ice or an ice-cream cone, taking a dip in the ocean, and checking out the parade of people passing by.

Be sure to take an exhilarating ride in an outrigger canoe, where you paddle out beyond the breakers and are carried back to shore by the ocean's cresting waves. Waikiki is **an excellent place to learn to surf,** and lessons are available at just about every hotel or water sports center on the beach. If you can tear yourself away from the water, hike the landmark volcanic crater Diamond Head, visit the indigenous animals of Honolulu Zoo, or tour the Bishop Museum to view an interesting collection of Polynesian artifacts.

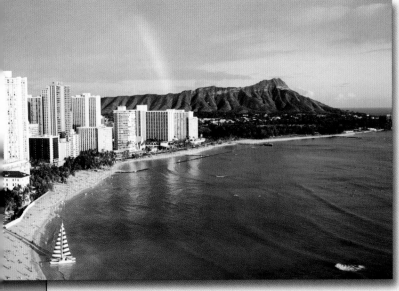

CANADA AND MEXICO

Niagara Falls

Niagara Falls is **THE BEST-KNOWN GROUP OF WATERFALLS IN NORTH AMERICA AND QUITE POSSIBLY THE WORLD.** Tourists have flocked here for more than a century, to take in the overpowering sights and sounds of water in motion as it courses over ancient rock.

Niagara Falls is where Lake Erie drains into the Niagara River, Lake Ontario, and beyond. The falls were born about 10,000 years ago when a slow-moving glacier dammed the river's route and forced it over the low point in the area, a north-facing cliff.

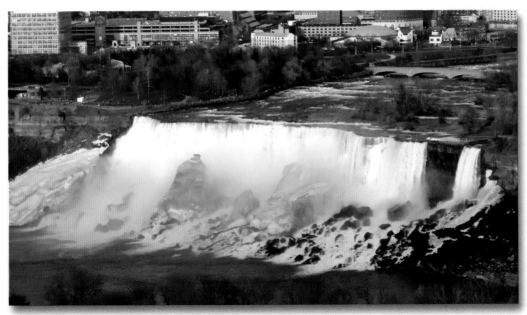

Niagara Falls actually **consists of three splendid waterfalls** on the Niagara River:

- Horseshoe Falls in southeastern Ontario (also called Canadian Falls)—the largest of the three at 177 feet in height and 2,200 feet wide
- American Falls in New York
- Bridal Veil Falls in New York

More than six million cubic feet of water pour over these three falls every minute, making for **the most powerful group of waterfalls in North America.**

For an up-close view of all this water, take a boat ride on The Maid of the Mist tour. These brawny boats take you through the churning waters around the American Falls to the foot of Horseshoe Falls. And don't miss seeing Niagara Falls at night, when spotlights bathe the water in ever-changing colors. The light catches the mist, giving the entire area an otherworldly glow.

Like all things, Niagara Falls is temporary. The falls have moved several miles southward during the past 200 years due to erosion, and a rockslide in 1954 altered the flow of the American Falls forever.

Banff

Perched at the gateway to the Canadian Rockies and about 80 miles from Calgary, the little town of Banff (population 8,200), Alberta, is **KNOWN TO SOME AS THE HIKING, HORSEBACK RIDING, SKIING, MINERAL SPRINGS-SOAKING, SNOWBOARDING CAPITAL OF CANADA.** At an elevation of 4,537 feet, Banff is **the highest town in the country.** The

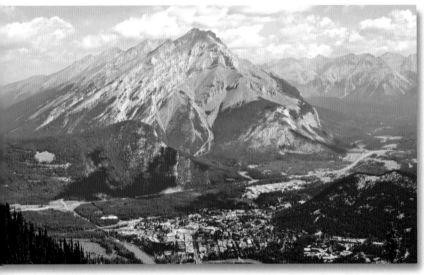

spectacular region rewards visitors with ice walks, snowshoeing, snowmobiling, dogsledding, and sleigh rides in the winter and hiking and rafting in the summer.

The town marks the **entry to Banff National Park, Canada's first national park.** Mount Forbes is a spectacle here, reaching 11,850 feet. More than four million people visit Banff National Park each year: The mild summers make July and August prime time for tourists. In the northwest corner of Banff is Castle Guard Cave, part of the longest cave system in Canada.

Lake Louise

Snowcapped mountain peaks and formidable glaciers cradle Lake Louise's emerald depths in a natural, icy amphitheater. Situated in Banff National Park, it **offers one of the most breathtaking views in the world** and is a popular vacation site. Lake Louise is a diamond in the wilderness, and its crystal clear waters, glaciers, and waterfalls make it Canada's most famous lake.

Teatime amid the splendor of Banff National Park awaits those who make the 4.5-mile round-trip hike along Lake Agnes Trail, which begins at the shores of

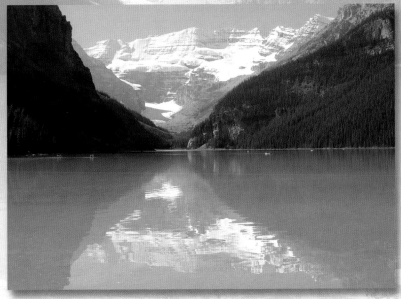

Lake Louise. The trail leads you through **A MAGNIFICENT OLD-GROWTH FOREST** past Mirror Lake and Bridal Veil Falls (a different falls from what converges at Niagara) before reaching the Lake Agnes Tea House.

Prince Edward Island

Pastoral Prince Edward Island is **Canada's smallest province.** Ringed by sandy beaches, the island's quiet countryside features gently rolling hills and scenic farms. It was **HOME TO AUTHOR LUCY MAUD MONTGOMERY AND SERVED AS THE SET-TING FOR HER POPULAR *ANNE OF GREEN GABLES* BOOK SERIES.**

First, pay a visit to Avonlea Village, which creates a turn-of-the-century island setting. The Anne of Green Gables Museum is a popular attraction, as is the musical based on the book. But even if you haven't read *Anne of Green Gables,* you'll still enjoy a visit to the island.

Visitors seeking outdoor adventures can **TAKE HARBOR TOURS OR GO SEAL WATCH-ING, KAYAKING, DEEP-SEA FISHING, OR CANOEING.** There are trails to hike, clams to dig, lighthouses to climb, and beaches to explore.

Campobello Island

Campobello Island lies off the rugged northeast coast of Maine at the mouth of the Bay of Fundy. Discovered by French explorers around 1607, the island's **MAIN INDUSTRY IS FISHING.** Locals harvest lobster, scallops, sea urchins, clams, herring, cod, mackerel, and pen-raised salmon.

The island has also enticed tourists. Beginning in the 1880s, Campobello Island **WAS PROMOTED AS A SUMMER RESORT AND VISITED BY MANY WELL-TO-DO FAMILIES.** In 1881, James Roosevelt and a group of businesspeople from New York and Boston formed the Campobello Company, bought property on the island, and built luxury hotels. Roosevelt brought his wife, Sara, and infant son Franklin to Campobello in 1883. Today, **a joint U.S./Canadian Commission administers the 2,800-acre Roosevelt Campobello International Park.** The park welcomes more than 100,000 visitors each year who come to see its historic cottages, flower gardens, and beaches and to stroll its quiet trails.

Originally a getaway for the Roosevelt family, Campobello Island is now an international park managed in concert by the United States and Canada.

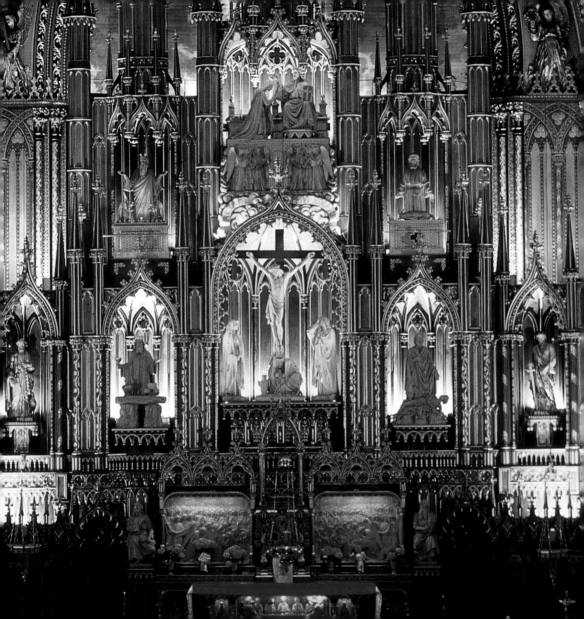

Montreal

Montreal is **one of the largest French-speaking metropolises in the world.** Following Québec's laws, all signs are posted in French, but services are available in English in the parts of the city most visited by tourists.

Many visitors start in Old Montreal, the Vieux-Port, which contains a collection of historic buildings that rivals most cities in North America. The cobblestone streets lead to the great square, Place Jacques-Cartier. A promenade along quaint shops and fine restaurants takes you past Montreal City Hall. The Château Ramezay, which was built in the 1700s as a home for the governor and is now a museum, lies along rue Notre-Dame, the oldest street in the city. Don't miss the nearby Place D'Armes square.

The **Notre-Dame Basilica is one of the most stunning buildings in Montreal.** The Neogothic-style church (opposite page) was built in 1829. The interior is lavishly beautiful, featuring stained glass windows, **an elaborate altar-piece,** a Casavant organ, and the largest bell on the continent, le Gros Bourdon.

Visitors seeking outdoor recreation are in luck. Montreal's Mount Royal Park sits on a dormant volcano. (The mountain is the origin for the city's name: Jacques Cartier referred to Mount Royal on his voyage there in 1535. At that time, *réal* was a variation of *royal,* and the contraction yielded Montreal.) At 761 feet, the overlook gives a dazzling view of the city.

Old Quebec

Historic Old Quebec, **the only fortified city in North America,** features an abundance of 17th- and 18th-century buildings and is located on a steep hill, overlooking the St. Lawrence River. A three-mile-long wall of ancient stone surrounds Old Quebec and separates it from Quebec City. Old Quebec is divided into Upper Town and Lower Town, but a tram railway connects the two sections. If you need a workout, you can use the sharply angled Breakneck Stairs to get from Upper to Lower Town.

Lower Town is a maze of winding streets, many of which have been restored to their **ROMANTIC 18TH-CENTURY APPEARANCE.** The pedestrian-only Rue du Petit-Champlain is lined with quaint shops and restaurants, and street performers entertain crowds in Place Royale, the restored main square. **Upper Town** is filled with **OLD STONE HOUSES, FAMOUS CHURCHES, AND MAJESTIC HISTORIC BUILDINGS.** Above Old

THE ICE HOTEL

Check out the Ice Hotel for some unusual accommodations. Located about 30 minutes from Quebec City on Lake St. Joseph, this hotel is constructed of ice, and each year its architecture is unique. The seasonal structure takes about five weeks to build and requires 4,500 tons of snow and 250 tons of ice. It is open during the winter and closes in late March.

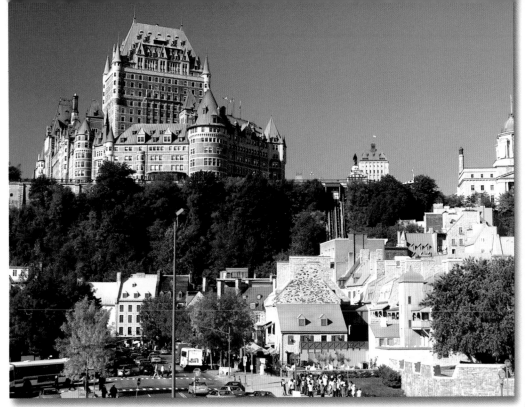

Quebec rises the distinctive **Chateau Frontenac** (above)**, a spire-topped hotel that is one of the signature buildings of the skyline.**

Set aside some time to visit the impressive Museum of Civilization and its exhibits on civilization, art, and society. A permanent addition to the museum in Quebec City features a fascinating multimedia exhibit on growing up that children are sure to enjoy.

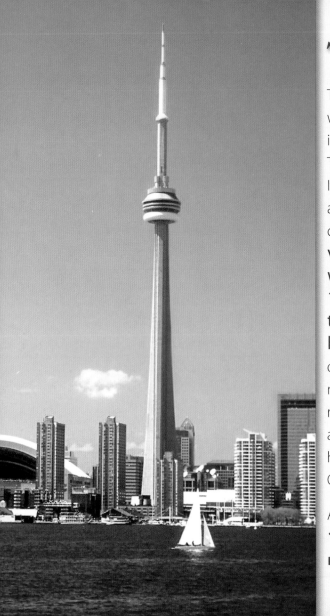

Toronto

Toronto is **Canada's largest city,** with about five million people in its metropolitan area. The name Toronto comes from the Huron Indian word for "meeting place," and it rings true in this multicultural city. It is **one of the most diverse cities in North America, with people from more than 100 cultures speaking more than 100 languages and dialects.** After the official languages of French and English, the five most-spoken languages are Chinese, Italian, Portuguese, Punjabi, and Tamil. The ethnic neighborhoods of Greektown, Little Italy, and Chinatown are a special treat.

A must-see is the **CN TOWER; AT 1,815 FEET, IT'S THE SECOND-TALLEST FREESTANDING STRUCTURE ABOVE**

WATER IN THE WORLD. The St. Lawrence Market in historic Old Town Toronto is one of the world's top 25 food markets. Tourists can explore Eaton Centre, a premier shopping destination with more than 320 shops, restaurants, and cinemas. And there's the **Toronto Zoo,** which at 710 acres is **one of the largest in the world.** More than 5,000 animals representing 450-plus species inhabit the zoo, and six miles of trails wind among the exhibits.

Hockey fans will want to stop by the **Hockey Hall of Fame.** You'll see videos of big games and their highlights, goalie masks, skate and stick collections,

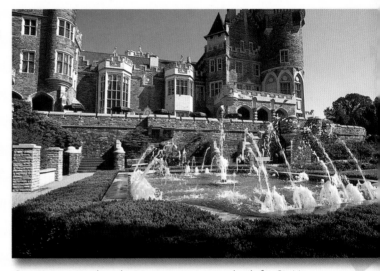

Casa Loma is a lavish, 98-room mansion built for Sir Henry Pellatt in the 1910s.

jerseys that belonged to some of hockey's greatest stars, and a replica of the Montreal Canadiens' locker room. You can also test your skills with interactive exhibits. **THE ORIGINAL 1893 STANLEY CUP RESIDES** at the Hall of Fame, along with other legendary hockey memorabilia.

Vancouver

Vancouver—Canada's third-largest city—is **the urban cornerstone of British Columbia and the nation's gateway to the Pacific Rim.** The city glistens where the mountains seem to vanish into the coastline and then rise again on Bowen and Vancouver islands. From a distance, the city can look like a diamond cluster rising from the Strait of Georgia to the rolling Coast Mountains and the Fraser Valley beyond.

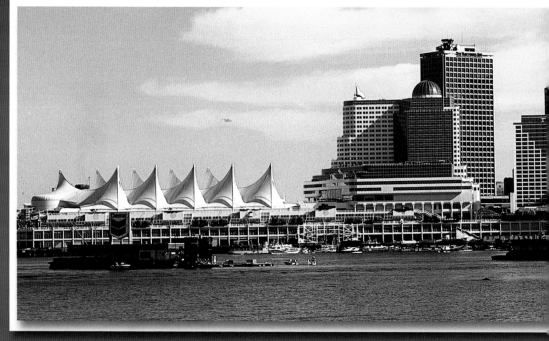

As Canada's west coast counterculture capital, Vancouver is **AN URBAN EXPLOSION WITH AN ENVIRONMENTAL-MINDED STYLE.** The city is also known for its urbane thrills, its acceptance of alternative lifestyles, and its vigorous club scene.

Great green forests surrounding Vancouver lead to getaways up the fjords and rivers to adventures in Pemberton, up the Chilliwack River, in Cypress Provincial

Park, and in the Skagit Valley Recreation Area. There are three ski resorts within a half-hour drive of downtown—Mount Seymour, Grouse Mountain, and Cypress Mountain. And the Capilano River, Seymour River, and Lynn Creek provide whitewater thrills come spring meltdown.

The **Vancouver Aquarium** in Stanley Park is a terrific attraction for anyone. It was **the first public aquarium in Canada and has now grown to become the fifth-largest aquarium in North America,** with 154 displays in 2.5 million gallons of water. Young aquaphiles will love Aquaquest–The Marilyn Blusson Learning Centre, a 52,000-square-foot environmentally smart building that has an interactive gallery, a theater, a wet lab, a children's play area, and classrooms.

Chichén Itzá

Chichén Itzá is **THE LARGEST AND MOST-RESTORED ARCHAEOLOGICAL SITE IN MEXICO.**
It lies 75 miles from Mérida, which was probably the most important Mayan city in its time. The ancient relics are anything but ordinary, and many visitors take daylong bus tours to see the ancient cities that make up Chichén Itzá. You won't want to miss:

- The **cenotés,** or wells, some of which still yield skeletal remains. Visitors today are told lurid tales of the sacrifices of virgins, children, and the elderly tossed down the wells. These tales are true, although scholars say human sacrifices

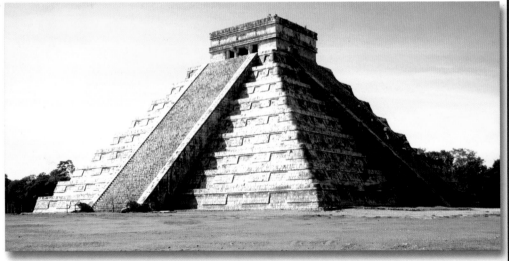

The amazing Kukulcán Pyramid is the defining feature of Chichén Itzá.

probably numbered far fewer than some people believe.

- The **Kukulcán Pyramid,** called El Castillo del Serpiente Emplumada, meaning "The Castle of the Feathered Snake."
- The **Group of the Thousand Columns,** a forest of columns that proceeds into the jungle.
- **Caracol,** known as the Mayan Observatory.

About one football field's distance from the Kukulcán Pyramid is **the Great Ballcourt of Chichén Itzá. It is 545 feet long and 225 feet wide, open to the sky, and a whisper at one end can be heard clearly at the other.** This is where the Mayans played their sacred game of *pok ta pok,* in which teams tried to put a natural rubber ball through a stone hoop without the use of their hands. The losing captain was sacrificed, either by decapitation or by removing the heart.

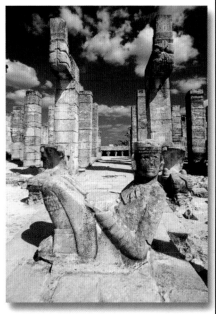

Reclining amid a forest of columns, this statue of the Toltec god Chaac-Mool atop the Temple of the Warrior was the altar on which ritual sacrifices were placed.

Cozumel and Isla Mujeres

These two islands offer a quiet departure from nearby Cancún's fast-paced activities and busy beaches. Both islands offer plenty of amenities and are worth a visit in order to combine a relaxing, warm-weather beach vacation with a destination that has true Mexican character.

Cozumel is Mexico's biggest island and can be reached by a 40-minute ferry ride from the mainland's Playa del Carmen, or via air, because the island has an international airport. It's famous for idyllic soft white sand beaches and calm turquoise waters on its western shore. Isla Mujeres is just seven miles from Cancún but is still a serene and peaceful retreat. Isla Mujeres is a popular spot for divers and snorkelers because it is bordered by two reef systems that create a natural aquarium.

Xcaret and Xel-Ha

Xcaret and Xel-Ha in Cancún's Riviera Maya **represent the latest innovation in theme parks:** They incorporate the assets of their tropical surroundings into activities that introduce Mexican heritage and history.

Xcaret is noted for its **UNUSUAL UNDERGROUND RIVER PASSAGES.** The Mayans used these passages for stealth warfare. The coral-and-limestone ceilings of the passageways have been chiseled a bit higher and wider to allow for the easy passage of visitors bobbing through with life jackets. You can also snorkel in a lagoon, swim with the dolphins, see animal exhibits, and visit Mayan ruins and a re-created Mayan village.

Mayan statues remain in the archaeological sites at Xcaret, a destination that provides adventure and insight into the ancient people who once lived there.

Although smaller in acreage, **Xel-Ha** offers a full day's activities. It features **a large lagoon for snorkeling, ruins to explore, hidden beaches with hammocks for relaxing, and a Mayan cave.** If you're looking for an authentic lazy river ride, you'll find it here in a spring-fed river that has just enough current to take you on an easy trip downstream.

Los Cabos

The southernmost tip of Mexico's 1,000-mile-long Baja Peninsula is called *finisterra*, which translates into "the end of the Earth." The striking finality of the rocky desert isthmus, set against a vast, open backdrop of saltwater and sun, is punctuated by El Arco, "The Arch." Towering 200 feet above the azure waters, **the magnificent granite arch is the most spectacular rock formation on the west coast of Mexico.** Visitors can boat past it, swim and snorkel under it, or even walk under

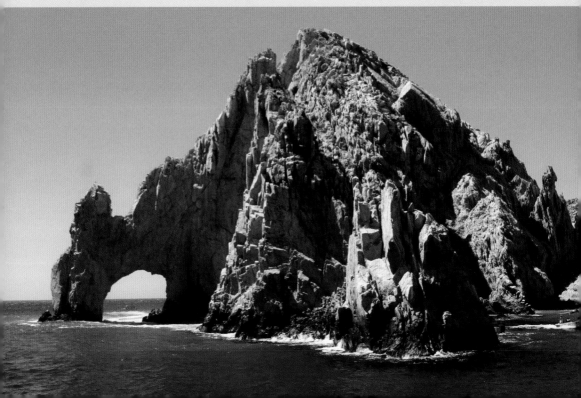

it at low tide. Climbing the rock, however, is against the law.

Surrounding the striking arch are the equally striking sands of **La Playa del Amor, or "Lover's Beach."** The Sea of Cortez lies along the east side of the beach, which features an **IDYLLIC COVE THAT IS POPULAR FOR SNORKELING AND SWIMMING.** The sea is also home to a diverse ecosystem of aquatic plants, birds, and even sea lions. The Pacific side of the peninsula beach, nicknamed "Divorce Beach" by locals, is considerably rougher, pummeled by the perpetual surf of the ocean.

The nearby resort town of Los Cabos has become **a tourist hotspot and is now the seventh-most popular tourist destination in Mexico.** In the 1940s, entrepreneurs built upscale hotels for the rich and famous. Because there was no highway at that time, celebrities and wealthy tourists came by yacht or private plane, making for one of the most exclusive resort towns in the world.

In 1973, the Transpeninsula Highway linking Tijuana and Los Cabos was completed, paving the way for further development along the Baja Peninsula, especially at its tropical tip. Luxurious hotels and condos, retirement homes, and golf courses are now common just outside the city limits.

Sierra Tarahumara

The Sierra Tarahumara is an immense area of linked canyons and forested plateaus in the northern Mexican state of Chihuahua. **The extensive canyon system is the largest in North America and is nearly four times the size of the Grand Canyon.** There are six major canyons that wind through the region. Of these, four are about as deep as the Grand Canyon: Urique Canyon is 6,136 feet deep, Sinforosa and Batopilas canyons are each more than 5,900 feet deep, and Copper Canyon IS ALMOST **5,800** FEET DEEP.

The canyons are **a hiker's paradise and paradox.** Most trails are not marked or mapped, and novice hikers are advised to stay near the outskirts or hire local guides. The climate is temperate along the mile-high canyon rims, with cold winters and mild summers. Summer is the rainy season, and wildflowers flourish from the end of September through October. Rivers wind along the bottom of the canyons: Many are impassable due to great boulders and massive waterfalls. THE CLIMATE IS TROPICAL ALONG THE BOTTOMS OF THE CANYONS, PROVIDING A HABITAT FOR MANY THREATENED ANIMAL SPECIES, including jaguarundis, jaguars, and ocelots.

The area is home to Mexico's Tarahumara Indians. They call themselves Rarámuri, which translates to "the Runners," and are known for their supreme endurance when chasing game and traveling throughout the canyons. The Tarahumara have maintained many tribal customs and traditions living in remote parts of the Sierra Tarahumara.

Guadalajara

Guadalajara is a city of monuments, parks, and historic tree-lined streets that's nearly a mile above sea level. The city has been dubbed the **"City of Roses,"** Mexico's **Pearl of the West.**

THE HEIGHT OF SPANISH COLONIAL ART AND ARCHITECTURE IS EVIDENT THROUGHOUT THE CITY. Sterling examples include the University of Guadalajara, founded in 1792, and the historic district. At the city's heart is its Centro Histórico (right), where visitors can get acquainted with local history and colonial ar-

chitecture. There's also the **Catédral Metropolitana de Guadalajara,** the city's Metropolitan Cathedral. Begun in 1561 and completed more than a century later, the cathedral is **capped by distinctive twin yellow-tiled steeples.** Nearby is Plaza Tapatía, Guadalajara's largest plaza, which covers seven square blocks.

Geographical Index